Empty the Ocean
with a Spoon

D0055135

Empty *the* Ocean *with a* Spoon

*Growing up with the customs,
traditions and superstitions
of a Jewish Home*

by

Rosalie Sogolow

illustrations by Jan Golden

FITHIAN PRESS · 1999 · SANTA BARBARA, CALIFORNIA

Published by Fithian Press
A division of Daniel and Daniel, Publishers, Inc.
Post Office Box 1525
Santa Barbara, CA 93102

LIBRARY OF CONGRESS CATALOGING-IN-PUBLICATION DATA
Sogolow, Rosalie, (date)
 Empty the ocean with a spoon : growing up with the customs, traditions and
superstitions of a Jewish home / by Rosalie Sogolow.
 p. cm.
 Includes bibliography.
 ISBN 1-56474-293-8 (alk. paper)
 1. Jews—United States—Social life and customs. 2. Sogolow, Rosalie, (date).
 I. Title
 E184.36.S65S65 1999
 892'.4073—dc21 98-36895
 CIP

*This collection of remembrances is dedicated to the
memory of my grandparents,
Sophie and William Tarantur,
and to my parents,
Edith and Jack Krulan,
who gave me a love of life and a sense of who I
am. May their example give my own children
and grandchildren pride in
themselves and their
heritage.*

*It is also dedicated to the memory of
two very dear friends—*

*Betty Rinsler, a little lady with a giant heart, who
encouraged and inspired me with her
goodness and zest for living,
and
Phyllis Omel, who lifted my spirits on
wings of song. Both were women of valor*

—their price far above rubies.

Contents

Acknowledgements

Memory has a momentum of its own. This book could not have become a reality without the contributions of many people. The fragments of their memories came together with my own to form the mosaic of our inheritance. There was no other way to tell it. It could only be pieced together from the flickering images of what had been. From these spartan clues we have reinvented the past.

I am especially indebted to Rabbi Joseph Gitin for his invaluable advice and support and the sharing of his own insights and childhood memories. I am also most appreciative of my husband Sid for his support, patient listening, reading and valued opinions, and my good friend Michelle Gabriel for her literary advice, along with the helpful critiquing by my Irish-Catholic friend Mary Lou Taylor, who wondered why I didn't use the term *farblonjet*, which she remembered from her youth in Chicago. (It just never came up, I guess.) And to my dear children, Wendi Fast and Larry Sogolow, goes my deep affection and gratitude for allowing me to talk about them, exposing their inner secrets to the world. I hope they know that it was always with love and respect.

My heartfelt thanks go to the wonderful people who shared their recollections with me: Rabbi Joseph Gitin, Rabbi Mark Schiftan, Cantor Itzak Emanuel, Leo Rinsler, Betty Rinsler, Michelle Gabriel, Joseph Gabriel, Mel Gordon, Addie Kopp, Murry Frymer, Sylvia Meltzer, Margie Cahn, Eileen Gitin, David Gitin, Sylvia Metz, Vivian Herman, Ruth Schwartz, Patricia Markman, Rosa Feldman, Nurit Sabadosh, Feigie Rosen, Carol Gopin, Rosa Levit, Marsha Geeser, Evelyn Turkus, Sam Engel, Alan Engel, Dvora Kogan, Mark Kogan, Ilene Hoffman, Sofia Zadkovsky, David Zadkovsky, Raya Fast, Gisya Shvartz, Rem Menshikov, Marilyn Phillips, Grayce Bergman, Manya Reyziz, Minna Vaistikh, Esfir Dynkina, Inna Eydus, Ruth Ross, Mary Nadler, Jenny Khorol-Sharal, Daisy Gelb, Rita Gorlin, Sondra Goldberger, Michelle Schneiderman, Elaine Kahn, Lois Kalchman, Gloria Melmon Ascher, Sonya Slutsker, Leonid Segal, Judith Gelb, Aleksander Gelb, Raisa Volkhover, Pnina Levermore, Berta Trilesnik, Diane Calmis, Nora Dreyzner.

This has been a joyous undertaking. My sincere thanks to all who made it possible.

R.S.

Introduction

So, who are we really? What makes us the people we turn out to be? From birth, our eyes take in everything around us. We soon learn who is family, and who is not; what's okay to do, and what is not; when you say something, and when you don't. These are things we absorb, like giant sponges, filling us with ways of thinking and behaving from one generation to another. All of us, from the day we are born, carry deep within ourselves emotional baggage packed full of responses to situations and events. Growing up in my grandparents' Jewish home in a Jewish neighborhood in Chicago during the 1940s and 1950s gave me a particularly distinctive perspective on life. If I got too impatient about something, I was told, "You can't empty the ocean with a spoon." This is an old Yiddish proverb and typical of the kind of Jewish wisdom I heard in their home every day. How did they get so smart?

Catapulted through time and space, across the ocean and into the melting pot of the *goldene medina* (the golden land), immigrants brought with them into American life a cornucopia of cultural practices. With Jews, like my grandparents, this included the Yiddish language and proverbs, as well as traditions, manners, customs, expressions of speech, cooking, religion, festivals, morals, clothing and history. They also brought folk tales, dances, myths, songs and superstitions—*bubbe meises.* Along with all the purely American customs that were my way of life, all these other things, too, were important ingredients that went into the mix that created the person that turned into "me."

Born in America, my parents' and my generation not only inherited old world ways, but we were also steeped in the culture of our own country. American Jews tend to think of themselves as American first—and Jewish second; but we all know that Judaism is much more than a religion. It's music and literature and food and expressions of speech and a great deal more. Even those who don't consider themselves religious at

all may very well "feel" as Jewish as the next person. The mere taste of certain foods, or a remembered turn of phrase, can reinforce the sensation. Judaism is a way of life.

In my grandparents' home, the rich traditions of Judaism were infused into our daily life. These traditions are still relevant today. All of us who grew up loving our traditions, and even those who grew up hating them, outside of them or not influenced by them at all, might benefit from looking back and, with the perspective of hindsight and maturity, re-evaluate and discover something of value to pass on.

Listening to some rabbis discussing the early Jewish immigrants who crossed over to the golden land, I heard it said that the first generation tried to preserve. The second generation tried to forget. And the third generation wants to remember. I belong to the third generation. More and more, I see myself and my generation as a link—a bridge from the old to the new. If we don't remember, and pass on what we remember, how can we expect our children and grandchildren to hold that connection?

There is great value in generational continuity. A person cannot go after what he does not know. American Jews, experiencing a brand-new sense of time, geography and community, fashioned a consummately American approach to their "Jewishness"—an approach that reflects the diversity and inventiveness of Jewish life at its core. As a society we have the freedom to observe, as well as the freedom to neglect, our traditions. The question is with such freedom can our modern Jewish identity succeed?

When all is said and done, the basic foundation, the values upon which we have built our lives will ultimately tell the tale. The abiding and deeply felt belief in the centrality of family, for example, transcends all differences of status or ideology. Knowing where we came from is an important ingredient in building our identity and figuring out where we want to go. Each of us has his or her own unique life story. Not all grandparents or neighborhoods match the ones in our past; but whether we come from Chicago, New York, Israel, London, Venezuela or Timbuktu, we are still the heirs of a precious heritage and share an age-old connection. Of course we want our children to feel it, too.

Times have certainly changed; whatever our background, the old way of life will never come back. But the beauty of tradition is that we have the power to keep it alive by remembering the old customs and telling our children about them. By honoring our culture and our heritage in this way, perhaps we can in some way impart a sense of history and meaning of "family," thereby linking our children to their roots.

They, in turn, can then carry the genetic thread forward, beyond us and beyond our time.

Even though this is very much my own family's story, as well as that of the many wonderful people who shared their recollections on the following pages, it could also be the story of millions of other immigrant families who left their Old World towns to begin anew in a free land. Each group brought its own customs and superstitions and went searching for its own fortune in America's melting pot. We, their offspring, are seeking something, too. We already enjoy many of the benefits our parents or grandparents sought. But now many of us also wish to recapture the past—our roots. In this pursuit, each of us must find his or her own way.

Upon arriving at the midpoint or more of our lives, we begin to feel the need to pass on something of ourselves...a basic idea of what our lives and times were like. But, as satisfying as nostalgia is, there is another important reason for recording something of this cultural history. In attempting to recall our families' pasts and the values which were passed on to us, it is our hope that our children and their children will find a beacon to illuminate their own way to a better understanding of who they are, so that they can live more meaningful lives and hopefully take their place in a spiritual community whose faith has echoed through time.

And while remembering "the old days" will hopefully bring smiles to those who have been there and understanding to those who came after, it is also interesting to explore some of the superstitious customs and *mishegoss* (craziness) that we experienced along the way. These, too, are part of our history.

As an avid observer and student of human nature, I have always been interested in the customs and rituals that people follow, not necessarily because of logic—but born of habit. So where is it written that we should wear wedding rings? Or that baby boys should wear blue and girls only pink? Why do we automatically lower our voices when we mention the dreaded word "cancer," or say "God bless you" when someone sneezes?

As with so many everyday things in our lives, there is usually an explanation within Jewish tradition.

Some of our traditions and customs come from religious beliefs; some come from old-country behaviors; some come from the way our family or friends did things, or even from movies or literature; and some come from age-old superstitions that may have no rhyme or reason, except that they just are.

Some traditions are universal and cross religious or ethnic lines. The varieties are endless. People everywhere have their own special traditions involving weddings, funerals, the birth of a child or celebrating holidays. These are events that all cultures experience. Like breathing in and out, they are part of living. But where you do that living, and the way you were brought up, determine how these universal themes are played out.

For the past twelve years, I have been involved with some of our new immigrants through Jewish Family Service of Santa Clara County. As a teacher of English as a Second Language, working primarily with elderly Russian emigrés, I have, in a sense, come full circle. Life in the former Soviet Union bore little resemblance to my grandparents' existence in the *shtetlach* of the Ukraine, but these people came from the same stock. Their roots were my roots. Their parents held many of the same beliefs as my ancestors. No wonder I have felt so comfortable with them from the beginning; they remind me of my own grandparents.

But the world they grew up in was vastly different from that of my parents or myself. And just as I have been curious about their lives and the experiences that might have been my own had my grandparents not left when they did, they too have a great curiosity about our lives and the country that is now their new home. Some of their recollections, along with those of several others, are related in the following pages. They shared their remembrances with me, and I have tried to share mine with them.

Each of us has his or her own family rituals and ways of celebrating our life's events. Of course, new traditions are born every day, and individual practices also change with the times; but memories of our own growing up come back to haunt us. So many things in our lives we do because that is just the way we have always done them.

Not all our ritual are religious, by any means. In my family, and that of most of our Jewish friends, going to the movies on Christmas Day has become a tradition, too. This, by the way, includes dinner at a Chinese restaurant, because we discovered long ago that these were the only restaurants open on Christmas Day.

When I look back at my own childhood, I remember the rituals that filled my days and upon which my life was built. There is no doubt that the lessons imparted through these experiences have affected every aspect of my existence. My children will, no doubt, have their own memories of family traditions which will affect the way their lives will evolve. And what they pass on to their children will carry on into the next generations.

I want to say at the outset that this book is not a scholarly attempt

to explain all these behaviors. Others have done this far better than I ever could. I have attempted to recall and discuss some of the customs and traditions and moral values that were imparted, through personal accounts from my own life and from others who have been gracious enough to share their recollections with me. Here people from all walks of life, from across the United States and around the world, talk about their family traditions and the Jewish influences in their lives. Despite diverse geography and background, common threads miraculously shine through. We don't live in the past, but, hopefully, the vast ocean of our heritage will continue to live on in us, and through us into the future.

Can we empty the ocean with a spoon? We can try.

Prelude: The Catalyst

Last year, for the first time, I heard my grandson Joseph sing the ancient Hebrew blessing as his grandfather lit the Hanukah candles. He was so proud of himself as his sweet voice rang out with the rest of the family. At nearly five years of age, he didn't know what he was singing; but he already understood that this was an important event, and he wanted to make sure that every word was right. His younger brother, Jacob, watched with big eyes, mesmerized as the orange flames danced on top of the candles in the menorah. It was one of those moments that you file away forever.

As the children tore open their presents, Joey broke out in a great big grin as he uncovered the newest addition to his dinosaur collection. "Nana, did you ever see a real dinosaur?" "Dinosaurs lived thousands of years ago," I informed him. "I know...but did you ever see one?" "I'm not quite that old, Joe, but things were a lot different when Grandpa and I were growing up. We didn't live in a nice big house like this for one thing, and we didn't have so many things to play with as you lucky boys. We didn't even have T.V." "You didn't have T.V.?! What did you do?"

What did we do? Too much to squeeze into a simple reply. "We played with our friends or read books, and we listened to the radio...." "Oh. Did you light the Hanukah candles?" "Oh yes, we sure did. When I was a little girl my mother and father and I went to my grandma and grandpa's house. The whole family came—all the aunts, uncles and cousins—and we played with *dreidels* and ate *latkes*, too."

The fact that his grandparents were once young and also had grandparents took a moment to digest. Satisfied that at least Hanukah hadn't changed, he ran over to see what his brother was up to. As I watched them play, I suddenly wondered.... Would they someday want to know how their grandparents lived and who we really were? How could I

make them understand that they were not only part of an immediate family, but of a much larger one, with a wonderful history and a wealth of traditions? That we were all links in a long, unbroken chain echoing back through time.

As we sat down at the table to eat our *latkes*, my mind flashed back to a similar scene a lifetime before. A flood of memories and emotions swept over me. History was repeating itself. Later that night I closed my eyes and tried to sleep. But flashes of my own childhood memories rushed into the darkness, and I began to think about the people and events that had shaped my life and made me the person I am....

Empty the Ocean
with a Spoon

Over the River
and
Through the Woods

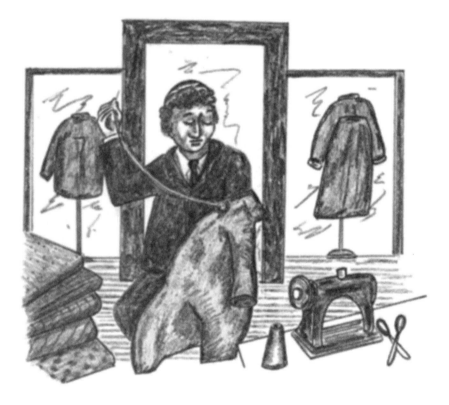

Ot azoy neyt a shnayder,
Ot azoy neyt er geet;
Er neyt und neyt a gantsah vach,
Und hot a nudle—mit a loch!

(This is the way sews a tailor,
This is the way he sews so well;
He sews and sews a whole week long,
And has a needle—with a hole!)

 —Yiddish folk song

BEFORE THERE WAS tradition, there were grandmothers and grandfathers. Volumes have been written about the early immigrants who came to America at the beginning of the twentieth century. The poverty of these early families, especially in places like the lower east side of New York, is well documented. But by the time we and our slightly younger cousins the "baby boomers" came along, things had improved considerably. The middle years of the twentieth century presented a very different picture from earlier years....

The rumble of the train on the elevated tracks next to our apartment building on Chicago's near north side gave a familiar rhythm to the days and nights of my young life. Not that I was ever really aware of it. It was just there—a background noise, forever weaving in and out of every morning, noon and night. There were other noises too, of course, since we lived on North Avenue, a very busy street. There were trolley cars clacking and clanging and impatient drivers tooting their car horns. People were always about, doing their daily shopping or whatever.

Across the street was Humboldt Park—a virtual kingdom to play in and explore. There was even a lagoon, which froze over in the winter. Expanses of grass and trees and shrubs provided the setting for family gatherings, birthday parties, picnics or just plain walking, and endless games of hide and seek. My father liked to play softball here with his friends during the warm weather. (They used the big softballs, rather than the small hard ones—somebody said it was a Midwest thing.) And there were plenty of hills for sledding or playing in the snow, too.

Our building was actually on the outer edge of the park. Several blocks away on the other side was where my grandfather had his tailor shop. It was near California Avenue, not far from the old *Galicianer shul*. It always struck me as funny to see people strolling out of the park, where they had parked their cars so that it would seem as if they had walked to synagogue on the High Holy Days rather than driven, which was not allowed. They came from all over to hear famous cantors like Richard Tucker sing.

Even though to my child's mind it seemed far away, my mother and I often walked the distance to their shop, and this was where I felt that I really lived. My actual home was a one-bedroom apartment on the third floor of a large building which took up almost half a block. Storefronts occupied the street level along the busy avenue. I shared the tiny bedroom with my parents until I was ten years old. They always worked, and so most of the week I was at Grandma's house all day, every day, until I started to go to school. After that, I went there in the afternoons.

Grandma and Grandpa lived behind the store in what could loosely be described as four rooms. I say "loosely" because there really weren't actual walls dividing the space. They were more like partitions. The tailor shop with its big worktable, which I called "my house," the heavy sewing machine and counters laden with trousers, shirts and caps were, of course, in front. Bolts of cloth hung on rods along the walls. Immediately behind this was a tiny cubicle with a curtain which was used as a dressing room, and then the pressing room.

This was the room where I loved to watch Grandpa work on finished garments and where he would occasionally let me "help" him by pulling out the "basements"—my word for the basting stitches that were used for the initial stages of production. He often sang as he worked, or spoke to me about the things that he thought it was important for me to know. Since I was a little child, these discussions weren't on a high level. But generally, they dealt with matters like respect and consideration for other people. He always spoke with kindness and love, and the things I learned in that little room began to fill me with a sense of who he was and who I would someday be.

He spoke to me with a conspiratorial air, as his hands kept busy, his needle deftly flying through fabric or his heavy iron gliding purposefully over the browned ironing cloth. "*Shabbos* is coming. Did you help your Bubbe get ready for dinner?" "Yes, Grandpa," I replied. "Good. What would she do without your help?"

He was a small man with prematurely graying hair, twinkling eyes, a smile always hovering, ready to spring forth. He spoke softly, his sense of humor often catching me by surprise. I felt safe here…and warm.

After the customer was fitted and necessary adjustments made, the actual permanent sewing could be done. And then the "basements" had to be removed. Grandpa was an expert. He had been a custom tailor since he was fourteen years old in Russia, and he could make anything: coats, suits, pants…you name it.

And whatever Grandpa didn't make, Grandma did. She was a seamstress. She worked mainly on women's clothing and also did

alterations. She was also an expert in matters of the heart. She not only cooked and sewed, but she looked after her family with a protective fervor. She was not only the chief cook and bottle washer, but also the doctor, the philosopher and the eyes and ears of the neighborhood. Grandpa ran the store, but Grandma ran the house. A cheerful woman, pleasantly plump, her rounded cheeks framed by soft, naturally curling salt-and-pepper hair, she always seemed to be rushing about, cooking, cleaning, fussing over her family—all the while exuding a maternal benevolence.

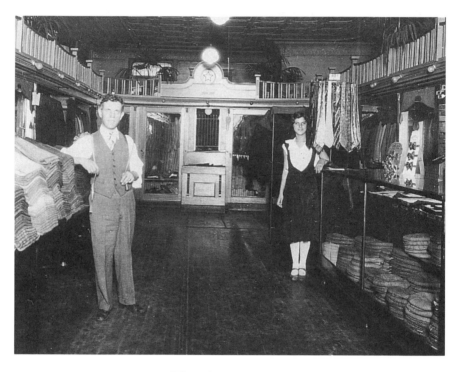

The tailor shop, 1929

In this pressing room there was also a bed where my Uncle Sol slept. He had shared this space with his brother, my Uncle Sam, until Sam got married. Sol was my mother's youngest sibling and like a big brother to me. He was only twelve years older, and I adored him! He had a warm smile and happy eyes (one was green and one was blue from being hit in the head with a baseball bat during a game). He always treated me like a princess, and since he was still in school, he was often around. My mother was the oldest (an older sister had died of pneumonia as a child), and then came Sam.

Next to this pressing room was a large open space which constituted the living/dining rooms. Faded Persian rugs designated one from the other. The ceilings were very high, with an elaborate pattern repeated over and over as if rolled on, except it was raised. I spent many hours gazing up at this ceiling, imagining all sorts of shapes in its intricate design. An old Victrola sat in the corner—the kind you had to wind up—with a big horn-like thing attached. Scratchy tunes were happily cranked out as we sang along or just sat and talked. It whirled out polkas, waltzes, cantatorial chants, songs from the Yiddish theater or favorite hits like "Bye-Bye Blackbird."

There were a dining table and chairs on one side of this big room. It was around this big mahogany table that the family gathered for *Shabbos* and holiday dinners and for festive Passover *seders*, and where the feeling of togetherness was most prevalent. Here ideas and plans were discussed and problems mulled over. Here were shared the hopes and dreams of everyone in the household.

On the other side was a sofa, a fireplace and—most importantly—a radio. This was before the days of T.V., and so the radio was our chief entertainment. I remember everyone huddling around this important piece of furniture, hanging on every word as we listened to Franklin Delano Roosevelt giving his "fireside chats"—never to be missed. And, of course, on Saturday mornings there was always "Let's Pretend," fairytales and stories that transported me to magical lands in distant worlds. Some silly little jingles from those Saturday morning programs still pop into my head from time to time: "I'm Buster Brown. I live in a shoe. Here's my dog, Tige. He lives in there, too."

Many a time I sat in the dark in our apartment, staring at the glow of the little red dot on the front of the radio, listening to programs like "The Green Hornet" or "The Shadow" and seeing all the action in my head in lifelike images. I do believe that, in some ways, children who grow up with television really lose out. Everything is presented to them in such graphic detail. But all my pictures were in my mind. I could imagine people and places any way I wanted. And this early training in mental imagery carried over to books as well.

A cozy kitchen, a small bedroom and a tiny bathroom sat behind the final partition. There was a bathtub, but it wasn't connected. You had to heat the water on the stove in order to take a bath. But we were family, and families shared. We had a tub with running water, and so Uncle Sol and Uncle Sam came to our house to take their baths.

There was only a section of open shelving dividing the kitchen from the sleeping room. But the thing I remember best about this kitchen was

the icebox. Refrigerators were luxuries that only a few could afford yet, and in any event, they didn't own one. So the ice man came twice a week. He came on a horsedrawn wagon down the alley behind the store. The large block of ice was covered with burlap sacking and carried with big metal prongs. His muscular arms carried the heavy cube with ease. He tossed it into the box, where it occupied fully half the space, until it gradually got smaller and smaller as the melting chunk dripped down into a pan at the bottom.

There were many other regular visitors traveling through the alleyways: the milk man, the rag man, the scrap metal collector, the knife sharpener, and the "pop" man with his bottles of soda or seltzer water. There was also the telephone coin box collector; they had a pay phone—a nickel a call. When you picked up the receiver, the operator answered and you gave her the number you wanted to reach. Other regulars at the door were the *pushke* collector and the insurance man. There always seemed to be so much going on. It was a vibrant community. And it was a very rich time. There was sharing going on at all times—sharing of values and sharing of life.

These things I remember aren't all that unusual. I'm sure that anyone living during those days following the Depression and during World War II has similar memories. But I mention my grandparents and the way they lived because everything that came after in my life was so greatly influenced by them.

My grandparents had come to Chicago where other relatives had already settled and become established; and Grandpa also had a trade. There was always work for a skilled tailor. By the time I was born, a whole generation (that of my parents) had come through the Depression and seen the beginnings of a new prosperity. Yes, they worked hard to ensure a good life for me—their only child. Thank God we never knew hunger. But we were always aware that there were others less fortunate. And we also knew that we had to do whatever we could to help. No Friday night passed without each of us putting our coins into the *pushke* (charity box) on Grandma's dining room buffet. It was part of *Shabbos*. My mother volunteered regularly at the City Food Bank and distributed bags of food to families who could not otherwise afford to buy groceries. We lived modestly, but we never wanted for the necessities of life.

I am fortunate to have had the opportunity of spending so much time with my grandparents during my early years, thereby giving me a better idea of just who they were. Coming from Russia in the early part of the 1900s they brought so much of the old country with all it's richness and customs—and yes, superstitions—with them. I think of

them always with love and gratitude, and feel very privileged to have had this wonderful chance to taste their world. There isn't a day that goes by that I don't do something, say something, or think something that has been influenced somehow by this early exposure. Their traditions are their legacy to me.

Where would we be without tradition? It's who we are....

The Sabbath

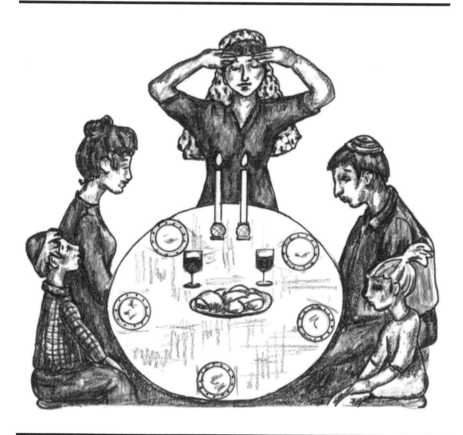

All Jewish holidays begin at sundown, because the world began in darkness....

HOW CAN I BEGIN to talk about tradition without mentioning *Shabbos*? No matter what went on during the week, Friday night was a special time. Grandma took out the candlesticks, placed a scarf on her head and lit the *Shabbos* candles. She made a circular motion over the flame, as if to draw the spirit of the flickering light towards her, and then she placed her hands in front of her eyes as she recited the special blessing. The whole house had a wonderful glow. And it always smelled so good. Friday night meant chicken soup, and delicious foods that she had been preparing all afternoon. Grandpa said the blessing over the wine, but it was really Grandma's time to shine. She worked hard to get ready for this evening, and we all enjoyed the fruits of her labor. Long after the stars had ushered in the Sabbath and the candles had burned down to small mounds of wax at the base of the candlesticks, the sweet smells and warm feelings lingered on into the night.

When my children were young, I enjoyed seeing the look in their eyes when I repeated this age-old ritual. I don't know if it seemed as magical to them as it did to me in those days, but it always gave me a thrill, knowing that I was doing something that my own grandmother and generations before her had done for centuries. It made me feel "connected" to my heritage.

I didn't spend the day getting ready for *Shabbos* as my grandmother had done, but I could have if I had wanted to. I was too busy with the things that I felt were important to me at that point in time. We didn't always have homemade chicken soup to go with our dinner; but our candles welcomed in the evening nevertheless.

In today's world most mothers work. It is more often a necessity than a choice. My daughter may not get home after working all day and picking up her children from daycare until long after the sun has gone down. But when she lights the candles and hears her boys join her in the ancient prayer, she remembers her old feelings and knows that they are

absorbing something precious. Without even knowing it, they too are feeling the connection.

When we left Chicago in 1967 and moved to California, I was nervous and frightened at the prospect of leaving our family and friends behind. Of course, at that time we had no choice. Uncle Sam (the United States Government, that is) decided it needed us, and that was that! This was during the Vietnam war, and my husband's medical services were required. Neither of us had ever lived anywhere but Chicago.

We both had very closely knit families, and taking our parents' only grandchildren away didn't sit too well with them either. But, at the same time, we were excited at the prospect of experiencing other worlds. We had both lived rather sheltered lives. We were sure we would miss all the family and holiday celebrations, where the entire *mishpochah* was always present to share the occasion. But, after all, it was still the same country. There were airplanes and telephones. We weren't going to the moon!

The funny thing is, it almost felt like the moon. Twentynine Palms, California, boasted the largest Marine Corps base in the world. The Marines didn't have a medical corps, and so the Navy supplied the doctors, as well as clergy and dentists. Coming from a big city, after having driven across the country in a stationwagon with two little children, we immediately experienced culture shock.

Sid had finished his residency in June, and we arrived at the base the beginning of July. Our first breath upon opening the car door told us we were in for a rude awakening. It was about 110 degrees. This was the Mojave Desert. Not only was the pavement too hot to walk on without burning the soles of our feet, but nobody ever went out until after sundown. The men were busy with their routines, but every woman, upon arrival, experienced acute depression. We hardly saw anyone until October!

And besides that, as far as we knew, we were the only Jews on the base. The town newspaper would call *us* and ask us to tell them about the Jewish holidays. I never felt so "Jewish" in my life! Coming from a place with ethnic neighborhoods and a high school that was probably a good 99 percent Jewish, this was a strange sensation. But it also showed us how much these traditions and rituals had meant to us. Together with the assorted Jews from neighboring towns, we made our own little "congregation" and conducted our own services on the high holidays, and our own Passover *seder*. And, of course, on Shabbos, in the sanctity of our own home, we lit our candles to remind us that this night was still special—no matter where we were.

In 1969 we made a monumental decision. We decided to stay in

California. Our parents weren't happy, but after two years they were resigned to the idea that our lives were someplace else. Shortly after, they followed us and settled near us in San Jose. We were thankful that they made this decision. Both of us had been particularly close to our grandparents, and we wanted our children to have this wonderful bond, too. Since our children were their only grandchildren, it didn't take them long to make this move. Leaving the city where they had spent their entire lives and leaving their family and friends wasn't easy for them. But the draw of the grandchildren was greater.

It was at this time that we joined Temple Emanu-El in San Jose, and had the privilege of meeting Rabbi Joseph Gitin. We felt "at home" right away. Rabbi Gitin was the epitome of what we felt a rabbi should be. He was warm and inspiring, and has been our family rabbi for nearly thirty years now. In his nineties, he is still vibrant and active, and a veritable treasure of experience and wisdom. He recently shared some of his recollections of his own family traditions and observance of this holy day of the week.

"The house looked spic and span as though we were expecting an honored guest," remembered Rabbi Gitin. "In Jewish tradition, we were expecting the arrival of the Queen of the Sabbath, bedecked in royal raiments, and it was no wonder that everything had to be befitting such a royal personage. The food was prepared with special care and exactitude, and there was a feeling of joy and pride in my mother's heart as she exhibited her culinary art on this holy occasion.

"On Friday, the poor people who did not have enough food to partake on the Sabbath would come to our home and receive a portion of poultry, eggs, candles, fruit which helped fill their empty baskets. There was no shame attached to this custom. The poor felt that it was part of a tradition, an act which gave the donor another *mitzvah,* a blessing and moral credit in the eyes of God; to the recipient, it was an act of justice. In Judaism *tzedakah* was not called charity or alms-giving; it was justice. Everyone was responsible for the health and welfare of the other person. No man can live unto himself alone. One of the more serious sins a Jew could commit was to act selfishly with no concern for his fellow man. And so it was with a feeling of gratefulness and thanksgiving that my mother would greet these unfortunate poorer people and give them succor and the means to honor the Sabbath fittingly and properly.

"The Sabbath in Jewish life is associated with happiness and holiness. The Sabbath was a day of rest, and yet it meant more to the Jew than just a day on which toil was prohibited. It was a day, especially to father and mother, in which they lived in the Kingdom of God. Having

received from God a *neshomah yeserah*, an added soul, in which to enjoy the blessings of the Sabbath, they pushed aside the burdens that afflicted them during the week days and enjoyed every moment of the peace and spiritual atmosphere of this holiest of days in the Hebrew calendar.

"The weekdays may have been full of the ugliness of poverty and the burden of worry that furrowed the brow and distressed the heart, but the Sabbath shone with ineffable beauty, the beauty of ceremony, of the psalms, of holiness. Indeed, for six days of the week, the Jew may have been poor, but on the Sabbath he was rich. He ate the appetizing food, wore fine garments, tasted wine, and filled the house with the fragrance of spices. I can understand now why my father's voice was so filled with emotion when, at the close of the Sabbath he recited the blessing, 'Blessed art Thou, O God, who distinguishes between the sacred and profane....' The Sabbath was to him and Mother an island of rest in a surging sea of oppression and sorrow.

"I remember Friday night after services when Father returned from the synagogue. In our home there was an indescribable luminance that permeated the entire atmosphere and pervaded our own hearts. Life in our home at that moment was full of tenderness and piety and love. Mother had lit the candles and blessed them, as she shielded her eyes so that she did not accept the Sabbath before the precept. Her head was covered in memory of the persecution in Persian days when the lights of the candles had to be shielded because of the restrictions imposed upon our harassed forefathers.

"Father recited the *Kiddush* prayer over the wine and then he blessed mother and all the children. We all gathered about him, according to age, and father placed his hands on our heads and blessed the boys with the prayer, 'May God make thee like Ephraim and Manasseh.' And he blessed my sisters, 'May God make thee like Sarah, Rebecca, Rachel, Leah'; to mother he recited Proverbs—*Ashes Chyil*— 'A woman of valor, who can find? Her price is far above rubies....' After the sumptuous dinner, we sat around the festive table and sang *Zmiros*—the Song of Songs. I remember the delightful and enchanting chant which even now escapes from my lips as if to remind me of those happy years when I first heard and sang the haunting melody of that scriptural romance—the idyll of love.

"Quite often Father would bring home a guest. For the Sabbath meal everyone sought a special guest. If he were a learned man, it would be the good fortune of the household to hear a novel interpretation of a portion of Torah, and nothing could give father a greater joy than to listen to an original exposition of the Law. The Sabbath meal would have

the quality of a special feast. When a famous rabbi was once asked by a Roman noble how it was that the Jewish Sabbath food was so tasty, the rabbi replied: we have a certain spice which we put into our food. This spice is called *shomar ha Shabbos,* the observance of the Sabbath. There was *gefilte fish,* poultry, *cholent* and *challah.* Even now, the mere mention of such food reminds me of the traditional Jewish home and of our family that lived in an entirely different world on this holy day.

"When the Sabbath drew to its inevitable close, father returned from the synagogue to conduct the *Havdallah* ceremony, the ceremony of departure of the Sabbath. We all gathered around to participate in this hallowed tradition. Father chanted sweetly the various blessings. My sister Ethel held the candle as high as she could, hoping that someday she might be able to find a tall *bocher* to become her husband. As soon as mother blew out the candle we all cried out, '*A gute vach,* a good week, a full week, upon us and upon all Israel.' It was a beautiful ceremony. And mother's face, lined with care and struggle and unending sacrifice, glowed with irrepressible joy as she looked upon her large brood of eight children—standing together in a circle that held all her own happiness."

Some Other Traditions Concerning the Sabbath

Rabbi Gitin noted that no mourning is allowed on the Sabbath. "My father died on the Sabbath," he said. "It wasn't until after the sun went down that we could show our emotions and weep for him."

He mentions that during the *Havdallah* service, at the close of the Sabbath, his sister, Ethel, held the candle high. According to tradition, if you have a daughter who isn't married, she is the one who holds the candle. If she wants to have a tall *bocher* (boyfriend), she stands on a chair and holds the candle as high as she can.

One more interesting thing Rabbi Gitin pointed out: "You're not allowed to worry on the Sabbath—unless you have a daughter who's not married. Then you are allowed to worry."

And many Orthodox Jews looked forward to the Sabbath for still another reason. It was considered a *mitzvah* for married couples to have sex on this holy evening of the week.

Rabbi Gitin is now Rabbi Emeritus of Temple Emanu-El. Today Rabbi Mark Schiftan leads our congregation with the same love and compassion as his predecessor. He, too, shared several of his thoughts.

Rabbi Schiftan's parents met in Shanghai during World War II. Originally from Germany, they came to California in 1947. He was a first-generation American who grew up in an immigrant environment.

Though there were relatively few Jews in San Francisco where he lived and went to school, he had no trouble learning to love Judaism and the richness of its traditions.

While attending a *Havdallah* service conducted by Rabbi Schiftan, I was especially moved by the beauty of the ritual.

"There is a power in ritual," he said. "Any time you do it, you are evoking a timelessness. It makes you think of all the other places and times this very same ritual has been performed—in all the different centuries and all the various political and cultural climates.

If there was ever a moment when Jews tried to seal themselves off from the hardships of everyday life, it was during the Sabbath. For this twenty-four- to twenty-six-hour period, problems are put aside, and we try to remember that we are a unique part of God's creation.

"The Sabbath begins with a joyous spirit. And when it is time for it to end, the *Havdallah* service marks the separation—the reality that the week is going to begin again, and the realization of what it means to be a Jew.

"There are three symbols which are used for the *Havdallah* service:

"The first is a cup of wine. It represents a cup of joy. The second is the spice box. I like to imagine it like the sweet smell of *challah* which has been freshly baked for Friday night. By the end of Shabbos, the *challah* has been eaten, but the sweet smell lingers, with the fragrance of the spices, to remind us of the sweetness of the Sabbath. And the third is the candle. This candle is different because it always has at least two different wicks brought together to form a brighter flame and a brighter light. On Friday night we light two separate candles, but at the end of the Sabbath, this brighter combined light symbolizes the bringing together of the Jewish family and the Jewish people.

"But the *Havdallah* service really ends with the singing of *Eliahu Hanavi*. The only other time this song is sung is during the Passover seder. It is symbolic of a return to the Garden of Eden, and a yearning to make every day beautiful and like the Sabbath."

Rabbi Schiftan and his wife, Harriet, continue this tradition withtheir children every week. It is a tradition that they will always remember.

Something happens when people are cut off from their traditions. We saw that in the former Soviet Union, when religious practices were not only frowned upon, but downright dangerous. Ilana Stern, editor of the 1995 report of the American Jewish Joint Distribution Committee, described the emotion of some of these Jews who were finally able to rediscover some of their heritage.

"In Kishinev on Rosh Hashana, Bronya cried as she put the sweet apple and honey to her lips. It was the first time she had celebrated this tradition since she was a young girl. In another apartment on the other side of town, Yuri used his grandfather's *kiddush* cup for the first time. His hands trembled as he read the blessing, evoking memories of his long-ago childhood."

To be cut off from your heritage is to lose a big part of your identity. In the USSR, an entire generation grew up without the privilege of learning the language or customs of their ancestors. Now that they can learn and observe the old traditions, they are hungry for them.

Meanwhile, in some places the old traditions were an integral part of life.

Ashkenazim and Sephardim are considered the two main branches of Jewry. Ashkenazic refers to Jews from Eastern or Central Europe. Sephardic Jews are those who live in, or trace their origins to, Spain, Portugal and southern France. In modern Israel, this has been extended to include Jews of the Middle East.

Sephardic Jews differ from Ashkenazic Jews in many customs, their prayers and chants, style of living, language and foods. Their vernacular is Ladino, as opposed to the Yiddish of the Ashkenazim.

Itzhak Ben Meir Emanuel is a *chazzen* (a cantor). He was born in Israel. In fact, he is a seventh-generation Israeli, a *Sabra* (native born Israeli), of Sephardic descent. He has lived in the United States since 1966, but has never lost his love of his native country or of his heritage. I was enthralled and profoundly moved listening to Cantor Emanuel speak about his family and his beloved homeland. He spoke with emotion of his parents and grandparents, and his gratitude for the values which they instilled in him:

"My family originally came from Spain, through Greece. They came to Israel in 1830. Seven generations of my family have lived in the holy land. We were the new generation of Israelis—*Sabras*. We were so proud to be a *Sabra*. It was a very special feeling. We were the new breed of the new Israel, and this is where I came from.

"Only when I came to America did I realize the importance of maintaining the heritage of our ancestors, in order not to lose it. In Israel, it was there all around me; but here I found out that you have to really make an effort to preserve what you are.

"My best recollections were with my grandfather, more than my mother and father. With my parents, it was a daily life—struggling for existence. But with my grandparents, it was a pleasure. It was a privilege,

even, to be with them so much.

"My father's father had cataracts. He couldn't see very well for many years. And as a child, I used to take him to the synagogue. I was his eyes, his light…everything. Every day, every evening, every Sabbath, every holiday, I took him to the synagogue and I sat by him. He held my hand and he made sure that I repeated the prayers. I thought he did it because he couldn't read them himself. Later on I found out that he knew everything by heart. What he wanted was for me to know the prayers.

"For years I did it. I learned the prayers; I learned the melodies, the Sephardic chants—in Hebrew and in Ladino. Especially, I became an expert in reciting the psalms—because of him. And in high school, I became the reader of the psalms. Every morning I read the 'psalm of the day' and I was very proud of this honor.

"When my grandfather was about ninety years old, he was dying. All the family was around him. They knew he was going to die, and they were talking about how beautiful a person he was and about his life. But I remember—and I'll never forget it—I sat by his bed and started reciting the psalms. He did not move. It is a Sephardic and Jewish custom to recite the psalms in case of illness or impending death or danger. So, I did it.

"And suddenly, I had a thought. I began to make a few little mistakes—on purpose. And a beautiful thing happened. He started moving his fingers. He touched my hand. He opened his eyes, and he moved his head slowly from side to side, telling me, 'This is not the way that I taught you.' And the beauty was that he lived another five years after that. This is a memory I'll never forget.

"In my family, everyone was a cantor, but without a title. We all chanted—all the family chanted. Friday night and Saturday after coming back from the synagogue, we chanted the traditional songs. Grandfather blessed the children, and then we ate our Shabbat dinner. And we never left the table before my father or my grandfather. Never. We always sat until the end of the meal. We used to sing all kinds of songs, including Sephardic melodies. That's how I learned most of the melodies I know."

Another interesting story comes from Sylvia Meltzer, who was born in Uruguay, South America. Her story represents still another example of people taking their traditions with them.

Her father's family had lived in Germany and been in the cattle business for generations. Life had been pretty good there—until 1937. It

was the rise of the Third Reich which startled them into a monumental decision.

Sylvia's uncle had been picked up by the S.S. They came to get him one night, and dragged him out in his night clothes. One of his captors happened to be an acquaintance of his. When the car slowed down, he jumped (or was pushed) out and got away. That frightening experience made them realize that Germany was no longer a safe place to live.

"One brother made his way to Palestine, and another to Australia. My father had a small inheritance, and he looked around for a place where he could carry on the business he knew and make a living. He and my mother were engaged at that time, and they hurriedly crossed over the border into Switzerland, where they booked passage on a ship bound for South America.

"My parents were married on the ship by the ship's captain. I don't know if it was a Jewish ceremony, but I have a picture of them which was taken that day, and it was under a *chuppa*. They started their married life on a cattle ranch which my father purchased in Uruguay. As soon as they were settled, he brought my mother's father and sister over to live with them.

"They didn't know a soul, but it didn't matter where my father lived—it could have been on a desert island. He had been raised in an Orthodox family, and his faith was very strong.

"It was difficult being Jewish in such an environment. There was only one little *shul*. It was in a house. They would beg to get enough men for a *minyan*, so that services could be held. My parents were probably the only German Jews in this small congregation. Their isolation was compounded by the fact that they didn't speak Spanish, English, Polish or Russian, which most of the others did.

"Although it was hard not having any Jewish friends, I think it also strengthened my Jewish identity. Every Friday night, my mother lit the candles. We had our big meal and celebrated *Shabbat*. When *Shabbat* ended, we had our *Havdalah* service. My father always laid his *tefillin* and always observed his rituals. There were prayers when we woke up, prayers to wash our hands, prayers before I went to sleep at night.

"I was proud of being Jewish, but a little self-conscious. No peanut butter on white bread for me, like the other kids. I always had sausage or hot dog on rye bread, or something like that. It was a different childhood—very unsophisticated, very sheltered, but with a lot of love and a lot of character building and high morals. I couldn't help but absorb all that.

"I was seven when we left a ranch in the country in South America

and moved to a farm in the country in Lebanon, Connecticut, in the U.S. Again, no Jewish community. It wasn't easy being Jewish there either, but at least I was able to join USY (United Synagogue Youth) in a neighboring town while I was in high school, and could socialize there.

"So I grew up in an unusual way—surrounded by people whose faith was different from my own. But in our home, wherever it was, we never forgot our traditions."

In Hebrew, *Shabbat* means "rest" or "cessation of labor." *Shabbos* begins at sundown on Friday. It has been traditional for the woman of the house to light the candles. This sacred ritual was one of the few *mitzvahs* given to Jewish women. And before this was done, it was customary to put "a little something" into the *pushke*, the charity box, that was invariably found in every Jewish home. As I mentioned, my grandmother kept hers on the buffet in the dining room. Acts of charity were considered a privilege and an honor—never a burden.

In *Memories from a Russian Kitchen,* a collection of stories of life in Russia from pre-revolutionary times through the communist era (Fithian Press, 1996), Rita Gorlin recalls her mother-in-law's account of her mother's *shtetl* tradition of baking an extra loaf of bread to give to a passing beggar on Friday night. If no one passed her door to whom she could give this gift, she asked, "What did I do? Why did God get angry?"

The importance of the concept of *tzedakah* in the Judaic tradition cannot be emphasized enough. I referred to our *pushke* as a charity box. This is really a misnomer. The word *"tzedek"* means righteousness. A person who acts righteously is a *"tzaddik."* Someone who is a *tzaddik* goes out of his or her way to do the right thing. From the same root (in Hebrew *"shoresh"*) we get the word *"tzedakah"* which actually means righteous act, which is a very different meaning from "charity," as it is sometimes interpreted. *Tzedakah* is not just the giving of money, it is also the giving of time, giving of one's self. *Tzedakah* is doing the right thing.

According to Maimonides, there are eight degrees of charity:

1. The highest form is giving the person the means to help themselves—like a job or a skill. If you give a man a fish, he will have a good meal; but if you teach him to fish, he will always be able to feed his family.
2. The next highest is when the person who gives and the person who receives do not know each other.

3. The third degree is when the giver knows the recipient but the recipient does not know the giver.
4. The fourth—the recipient knows the giver, but the giver does not know the recipient.
5. The fifth—the giver gives to the poor without being asked.
6. The sixth—he gives after being asked.
7. The seventh—he gives less than he should but does it cheerfully.
8. And the lowest form of charity is to give resentfully.

The Talmud says that a person's relations with others will determine his or her relations with God; and therefore, if you have good relations with other people you will have good relations with God. We are responsible for each other.

The first Jewish immigrants to come to America were primarily from Germany, rather than Eastern Europe. For the most part, they were businessmen or from well-to-do families. They generally lived in different neighborhoods than their Eastern European counterparts and enjoyed a higher standard of living, which included their own clubs, synagogues, fraternal organizations and community centers. There was a tendency, in fact, to be embarrassed by these poverty-stricken, less-cultured Jews from Russia and Poland who had begun pouring onto our shores around the turn of the century.

But German Jews realized that they had to help the Eastern European Jews out of sympathy for their plight as well as for self-protective reasons. They had to take care of their own. They consequently embarked on an extensive program of financing and running a number of educational, health and social service institutions which would help feed, clothe and educate these people, while also raising their standard of living. They may have had other ulterior motives, but their actions were fundamentally a result of this important, deeply ingrained concept of *tzedakah*.

Rosalie Gitin, our *rebbitzen* (Rabbi's wife), has worked alongside her husband as a beloved religious school teacher, community resource and life partner throughout their long and happy marriage. Rosalie also has strong memories regarding the Sabbath tradition of *tzedakah*.

"As a girl growing up in Niagara Falls, New York," she remembered, "I watched my mother put food, bread, wine and candles on our kitchen table every Friday afternoon. Then she would leave the house. The door was always left open so that anyone who needed nourishment could come in and help themselves for the Sabbath. Helping those less fortunate was just part of our life."

Well, going away and leaving the door open in today's world would hardly be prudent. The age of innocence has, unfortunately, passed. As honorable as our intentions might be, we would most likely come home to find far more missing than some food and candles. So we need to find other ways to do our *mitzvahs*. My mother's work at the Food Bank comes to mind, or volunteering to serve a meal at a homeless shelter. Visiting the sick to give comfort is considered a great *mitzvah*, too. Concern for others...giving of oneself...doing the right thing.

It was also a time-honored custom to invite a stranger, a traveler, a student or a poor person to join in the *Shabbos* meal. My grandparents seemed to "adopt" people who never wanted to leave. One young man, a real estate agent who was living alone far from his family, was invited for one of our Friday night dinners. He felt so much at home in my grandparents' house, that he kept coming back to "visit" on a regular basis. For a while it seemed as if he was going to be a permanent guest. Recognizing his intrusion for the loneliness it was, they were ever gracious about his frequent dropping in.

Vivian Herman, a Yiddish teacher, remembers her mother's customs: "My mother, the good *balaboosta* that she was, when she got ready for *Shabbos*, she washed all the floors and covered them with newspapers so we wouldn't get them dirty. And when she *benched licht*, she used a five-branched candelabra. In the Jewish tradition, you're supposed to light two candles, but my mother lit three. When I asked her why, she told me that two were for the mama and the papa, and the third was for the children. So when I started to *bench licht* in my own home, I also lit three candles. It's our family tradition. And also, after lighting the candles when someone said, '*Gut Shabbos*,' instead of giving the same reply, we answered, '*Gut Yor*.'" (This is an unusual response for *Shabbos*. It means "Good Year," and is traditionally spoken following the greeting "Good *Yontif*" or "Good Holiday" on Rosh Hashana—the Jewish New Year.)

On the Sabbath, you weren't supposed to do work of any kind, cook, clean, light a fire, extinguish a candle, write or even ride. In America, Orthodox Jews might ask a non-Jew to press an electric light switch for them if necessary.

My husband, who is an avid golfer, likes to tell this joke about a rabbi who loved to play golf. He played as often as he could, usually with members of his congregation. But he usually couldn't take more than four or five times a year out of his busy schedule.

One sunny Saturday morning, after services, he saw that his calendar was clear, and he felt a powerful craving to play golf. So he begged God to forgive him and sped off to a golf course thirty miles away, where he was certain no one would recognize him.

As he teed off, Moses looked down from heaven and spotted the rabbi on the first tee. "Lord! Lord!" he cried, "Do my eyes deceive me? Over there—beyond the clouds—it looks like Rabbi Korshak! Playing golf! On your holy Sabbath!" "Dear me," sighed the Lord. "Such a transgression!" said Moses. "From a rabbi yet! How will you punish him?"

"I," sighed the Lord, "will teach him a lesson." With that God cupped his hands over His mouth, and just as Rabbi Korshak teed off for the second hole, the Almighty One, King of the Universe, let out his breath in a long, mighty, cosmic "Whoooosh!" that caught the rabbi's ball in midair, lifted it three hundred yards, flipped it around a tree, over a stream and against a rock, where it ricocheted into a miraculous hole in one!

Moses stared at God in bewilderment. "That you call a punishment, Lord?"

"Mmnh," smiled the Lord. "Whom can he tell?"

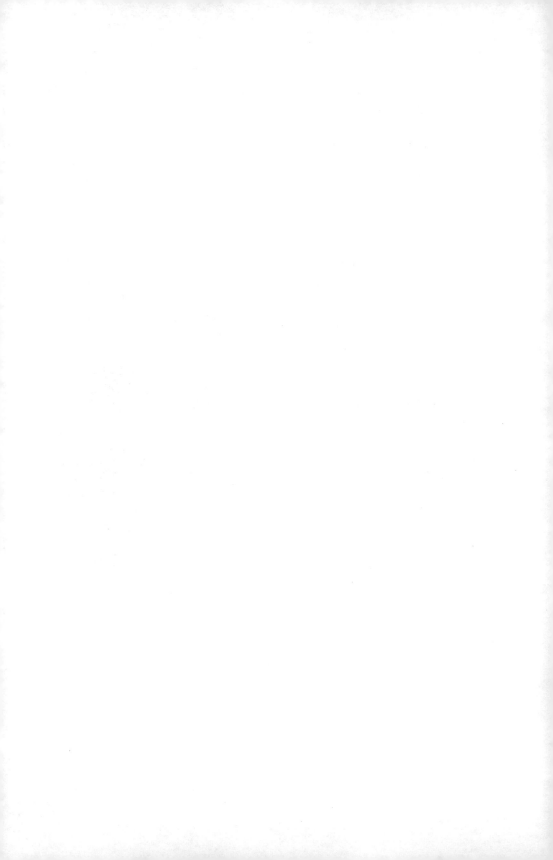

"Children in Europe Are Starving..."

Jews and Food

As my grandmother Shifra liked to say:

"If everything in it is good…what could be bad?"

THEY SAY THAT A JEWISH MOTHER sits with half a *tuchiss* (behind). She's always so busy jumping up to serve her family that she can't allow herself to actually sit and enjoy her meal. It's an apt expression. Food has been a preoccupation for as long as mothers have been in existence. "*Ess, ess mine kind!* [Eat, eat, my child!] Children in Europe are starving!" Who doesn't remember hearing those words at the dinner table during the 1940s and beyond! I haven't been fighting the battle of the bulge my whole life for nothing! Alan Sherman, the comedian–songwriter, used to say that whenever you saw a fat person you should put your hand over your heart because they ate so that children in Europe wouldn't starve. Was there anybody who didn't wonder why *our* eating helped anybody on the other side of the ocean? "Why can't we just send our food to them?" I asked. Grandma never gave me a good answer. All she would say was that I had to finish everything on my plate. My cousin Susan, ten years younger than I, was the first one to rebel against this admonition....

"Where are you going, young lady? You haven't finished your lunch," Aunt Florence began her all-too-familiar refrain. "I don't want any more," Sue called out as she jumped up and readied herself for flight. "Sit down and eat, and then you can go outside with your friends. It's a shame to waste your food when so many children are going hungry!"

Always thin and wiry, Sue scrunched herself up in her chair, incredibly making herself seem even smaller than usual, elbows on the table, her chin perched defiantly in her hands. With a wad of food stuck in her cheek, she would sit at the table for hours if she had to, resigned to staying in her place but stubbornly refusing to swallow the offending morsel. After a while, they finally gave up. She has always been thin. Where she got the courage to defy them, I never knew. It was something I could never fathom. I always enjoyed the wonderful things my grandmother put in front of me, and usually had no trouble pushing in the last few crumbs. But watching my cousin, I vowed that this was something I

would never do to my children, if I ever had any.

Rabbi Gitin has his own fond memory of this well-known phrase. "My mother never said to me 'I love you,' seldom kissed me once I entered adolescence. But her love was manifested in two ways: by constant and solicitous feeding and overfeeding, and by great solicitude about every aspect of my welfare.... 'Are you warm enough? Put on another muffler. Have you had enough to eat? Take just a little more of this good soup. *Ess, ess mine kind!*'"

Like Pavlov's dog, our mouths remember the flavors and odors that were part of our traditional Jewish past; the taste sensations that permeated our everyday lives. Food is such an emotional trigger. Certain tastes and smells awaken our memories and burst upon our senses with instant flashes that can magically transport us to another dimension.

Even the thought of certain foods can make our mouths water and take us back to another time. Recently, at a party, the hostess passed around some homemade *knishes*. One of the guests, Margie Cahn, who had grown up in Philadelphia, took a bite and closed her eyes. "These remind me of the times when I would stop at the corner grocery on the way home from school for a warm cheese *knish*—my favorite," she sighed. (Mine, too, Margie. They were a *machaya*—a pleasure, a treat.)

My mother was too busy working to do much cooking, but my grandmother's kitchen was always filled with the most enticing aromas. And spending as much time at my grandmother's house as I did meant, naturally, that much of that time was occupied with watching her at work in this magical place. This warm, cozy room was always the gathering spot. This is where neighborhood gossip was shared, memories recalled or future plans discussed.

Grandpa would sit at the table with a glass of tea often flavored with preserves, sipping the steaming liquid through a sugar cube held in his mouth, as Grandma's hands kept constantly busy. She made her own herring and stuffed her own *kishke*, when she wasn't dilling pickles, making wine, chopping, grating, baking or just generally cooking up a storm. When her sponge cake was in the oven, we couldn't make a sound. God forbid someone should drop something or slam a door. We wouldn't have dared.

And how did she learn to manipulate the dough like she did? She deftly rolled it out with a broom handle for her homemade *lokshen* (noodles) or *kreplach* (something like Jewish ravioli). And when she made her famous *strudel* or *knishes*, the circle of dough was stretched so thin you could read a newspaper through it. Round and round the table she went as she rolled and pulled and created just the right thickness for the flaky

pastry wrapper. As a new bride, when I tried to recreate one of these wonderful dishes, the stubborn glob would continue to rebel. As soon as the proper thickness was almost reached, huge holes would appear.

I'm sure that impatience was part of it. We are so used to "instant" and "convenience" and "frozen" foods that we don't have the time or patience to do it properly. Grandma, on the other hand, had it down to an art. She was a *balaboosta*. This is a household expert. Wearing her ever-present apron she would work her way around the house, until every inch met with her approval.

The Yiddish actress Molly Picon, in her book *So Laugh a Little,* (Julius Messner, 1962), talked about her grandmother's fetish with aprons. Reading it brought back the image of my grandmother in her apron, but not the advice....

"My grandmother carefully wore her apron wrong side out when she was cleaning. That way, she used to explain the facts of life to me earnestly, if someone should "fall in" she would whip her apron on right side out, and thus face the world with a clean apron. She spent years trying to convince me to wear an apron in the first place, and on the occasions when I yielded, to wear it wrong side out and save the good side for company."

Well, my grandmother always wore her apron right side out, but she must have had several because they always looked fresh and clean, no matter what action they saw. And nobody's lace curtains were any crisper than hers. She would actually get down on her hands and knees and stretch and pin them to the proper shape on sheets of brown paper on the carpet, after hand washing them in the sink. I wore hand-sewn, knitted or appliqued clothes, the house was always spotless, and her meals were prepared with dedication. Eating everything on the plate wasn't so hard to take.

Shopping

Even shopping for food was an all-day affair. There weren't any supermarkets then. That marvelous invention was far in the future. Shopping was all done in the neighborhood in small Jewish-owned stores, all within walking distance. This was always an interesting outing for me. Grandmas needed "helpers" even then, and I was ready and willing.

For meat, we went to the butcher shop. The sawdust on the floor made me sneeze. I guess it was there to help absorb odors, but I never figured out how that worked. The butcher always knew what Grandma was looking for, and after the usual polite conversation and inquiries he wrapped up the best cuts in liver colored paper. For fruits and vegetables

we went to the green grocer; for bread, we went to the bakery; for spices and other things we went to the grocery store; for fish we went to the fish market.

And on Thursday afternoons, we visited the *shochet*, for our Sabbath chicken. The *shochet* was the man who did the ritual slaughtering of the chickens, so that they would be considered *kosher*. Everybody knew my grandmother, as well as every other housewife in the neighborhood. These weekly rounds were a well-established routine. Everybody knew everybody. (And everybody's business, as well.) I really hated going to the *shochet*. Anybody who's ever been to such a store will know why. The chickens were killed with a single slice to the throat, but sometimes they didn't die right away. This is where the expression, "running around like a chicken without a head," came from. No joke...it wasn't a pleasant sight.

Not one to let anything go to waste, Grandma would take the freshly killed chickens home and pull out their feathers. You could buy them already plucked, and sometimes she did, but when she wanted to make pillows and comforters, these were her source. I later found out that I was allergic to feathers, besides pollen and a few other things, but at that time we didn't think about allergies. My mother always thought I just had a bad cold every year around my birthday, which was in August. The words "pollen" and "ragweed" weren't even in her vocabulary. Meanwhile, we always had soft feather pillows for our beds.

My friend Leo told me a funny story about his mother and buying chicken. In his neighborhood, the *shochet* worked in the back of the butcher shop. "My mother would go to the butcher to buy her chicken. To test whether the chicken was fresh, she'd stick her finger inside the rear end and move it around. If it didn't feel right, she would throw it down and take another one. Finally, the butcher came over and said, 'Lady, could you pass that test?' Now, I've heard that told as a joke, but it really was true. She really did that!"

Symbols of Our Faith

What's so special about Jewish food? There is something comforting about it—and not only chicken soup. And so many of these foods have also come to represent symbols of our faith. Through our foods, we are also ingesting our history. Food must traditionally be a part of each holiday observance in order to fully "digest" the experience. There is historic precedent for this. From the earliest times, on a variety of occasions when individuals or society as a whole faced emotional or spiritual upheaval, in times of joy as well as grief, Israelite culture required an

offering of food in order to connect with God. Man depends on food for his very existence, and by making these offerings he signified its importance.

Food definitely played an important role in our lives. There were special foods associated with every holiday, such as *charoset* (chopped apples, nuts, wine and cinnamon) for Pesach, or dairy dishes (like *blintzes* or cheese *knishes*) for Shavuot. For *Shabbos*, of course, there was always freshly made chicken soup in which a little unhatched egg floated like a tiny ball of sunshine—a special prize that only one lucky person could enjoy each week, followed by chicken and often a *kugel* (noodle pudding). Now that chicken comes in packages, the little *ayeleh* are no longer to be found, but I still make *kugel* often. It's one of my family's favorite dishes, and a regular part of our annual Thanksgiving dinner, another tradition. One year I tried to eliminate the *kugel*, thinking it might be a little too much with sweet potatoes and stuffing, etc. There was such an outcry that I have never made that mistake again.

And, of course, *challah* (braided egg bread) has always had a traditional place on the Friday night table. Usually it is baked in a long shape. But for the new year, the shape is always round, sometimes with raisins inside and served with apples and honey for a sweet new year.

Rosh Hashana and Yom Kippur after the fast always meant *gefilte fish*, and soup with *kreplach* (similar to Chinese wonton, but with beef), honey cake and other traditional foods. Ruth Schwartz prepared her *gefilte fish* differently in England....

"We'd fry our *gefilte fish*—deep fry it, and serve it cold. It was crispy and delicious. Grandmother would put the fish through the grinder and add onion and a slice of damp bread. This is so popular in London, you can still go into a deli and buy it that way."

A *bris* (the ceremony of circumcision) invariably featured herring and mounds of chopped liver, chock full of onions and *shmaltz* (chicken fat). On Purim, there were *hamantashen*, three-cornered pastries filled with poppy seeds, apricot or prune filling, which symbolized the three-cornered hat that the villain Haman wore in the biblical story about Queen Esther. And it wouldn't be Hanukah without our potato *latkes*. On Passover, instead of bread there was the inevitable *matzah* and *matzah* ball soup. The *seder* table is always the same, according to ritual. Passover with its traditional *seder* is such a big subject that it will be described in detail in the chapter "The Holidays."

My daughter has a bread machine (the newest craze), and she uses it to make *challah* for her family. I still order my fresh *challah* from the bakery every Friday. I don't have the time or inclination to bake my own,

but my friend Michelle Gabriel does make her own—from scratch. It's an all-day affair. We love her tradition of dropping off a beautiful golden loaf, complete with a small container of honey, for our family to enjoy during *Yontif*.

Michelle has her own memories of *challah*:

"As a young child growing up in the forties and fifties, I remember watching my grandmother bake *challah* for our *Shabbat* dinner. She'd pour the flour into a large, white *schissel* [bowl]. Then she'd create a little well in the middle into which she'd place the yeast. She'd add water, mix it with the yeast, then add a drop or two more water, if needed. Next came the sugar and the salt, a little of this, a little of that.

"Without a recipe to follow I always wondered how she knew exactly how much was enough. Somehow she knew. She baked by touch, intuition and an innate knowledge that confirmed when each ingredient was 'enough.' No *challah* baked by my grandmother was ever too heavy, too salty or too dry. Every *challah* taken out of the oven was perfect in shape, in size and in taste.

"After I married I was determined to make my grandmother's *challah*. I knew it would require a great deal more than a sense of touch and intuition to make it work, so the next time she started the process, I was right beside her with a measuring cup, a note pad and a pencil. Each time a handful of flour, sugar or salt was about to descend into the *schissel* it was first diverted into a measuring cup. Gradually, every pinch of this or handful of that added up to measurable amounts with which I felt I could work.

"And it actually did work. My first attempts to make *challah* on my own were successful, though it wasn't until years later, long after my grandmother had died, that I really got the hang of it. By then I had developed her ability to tell, by looking, feeling and even occasionally 'sniffing' the dough, that it needed more flour or a tad more salt.

"For me, baking *challah* represents more than the fulfillment of the Sabbath. It is the continuation of a tradition. For a brief moment, as I prepare the *challah* for my family, I am my grandmother and all the generations of women who came before her preparing the Sabbath bread for their family. And when the braided, golden bread is taken from the oven, covered with the Sabbath cloth and placed on the table, I think of my grandmother. I hope she is pleased that not only have I kept the tradition of the *challah* alive, but that I have kept the innate taste of her *challah* intact as well."

Bread is known a the "staff of life," and people all over the world depend

on some form of bread to fulfill their basic food needs. That may be the reason that bread, perhaps more than any other food, is surrounded by symbolism.

Nurit Sabadosh, a teacher and business owner whose parents originally came from Czechoslovakia, was born in Haifa, Israel. She remembers her family's custom of kissing the bread before throwing any of it away. "Bread is the essence of life," she says, "and if we must discard it, we show respect and love by bringing it to our lips with the hope that this wasted food will not be regretted and that we will always have food to sustain us."

People of all cultures socialize by "breaking bread" or eating together. It's also been associated with good luck, and not just in Jewish lore. In the 1700s in Scotland, for example, the eldest villager was always selected to carry a plate of small shortbread pieces into the home of a new bride. As a good luck gesture, he then dumped the pieces over her head as she came through the doorway. If any bridesmaid waiting outside could capture one of the scattered pieces, she would be lucky in love and would quickly find a husband. In some parts of Europe, it was the custom to put a piece of bread in the bride's shoe as a symbol of fertility. Italians have a near sacred bond with bread. Nearly every city or village boasts its very own specialty. In the Jewish tradition, a newly married couple is met at the door of their new home with a loaf of bread by friends or family with the wish that their home should never know hunger.

My grandparents kept a *kosher* home. Keeping *kosher* means abiding by Jewish dietary laws. Basically, it means that you can't mix *milchiks* (dairy) and *fleyshiks* (meat). And only meat from four-footed animals that chewed their cud and had cloven hooves was considered *kosher*. Any animals that didn't meet those criteria were considered *trayf* (not kosher). They also had to be slaughtered in a prescribed way. Cows are okay, pigs aren't. Only fish with scales and fins are *kosher*. Shellfish and scavengers and birds of prey are on the forbidden list. Food that is neutral, like fruit, vegetables or eggs, is called *pareve*. They can be eaten with either milk or meat. And keeping *kosher* not only pertained to the foods themselves. It was necessary to have separate sets of dishes, one for milk and one for meat, not to mention two different sets of silverware. (This also included pots and pans.) Of course, this really meant that you had to have four sets of everything—not two, because during Pesach (Passover) you had to use completely different ones.

"In our house," said Feigie Rosen, Seniors Director at the Addison-

Penzac J.C.C., "we had *milchiks*, *fleyshiks* and Chinese. With my mother, Chinese food was *pareve*."

Ruth Schwartz remembered the first time she stopped using separate plates. "I practically scrubbed the pattern off, trying to make sure they were extra clean." Keeping *kosher* was definitely a commitment, but to my grandparents, there was no question. That's just the way it was.

It is interesting, however, to note how the word *"kosher,"* like so many other Yiddish words, has found its way into the English language. If somebody says that something isn't *"kosher,"* it usually means that it's not on the up-and-up, or not quite right. I have to smile every time I hear one of my non-Jewish friends use this expression.

Sometimes this tradition business can be carried too far. My friend's sister was visiting from New York, and we got to talking about the things we do just because they were what we grew up with. She related this story:

"My mother always cut the end off the roast before putting it in the oven. I never knew why, but that's how she always did it. When I got married and began cooking for my own family, I remembered this and thought that this was the way it had to be done. I did it this way for years. My daughter saw me doing this one day and asked, 'Mom, why do you and Grandma cut the end off the roast?' 'I don't know, honey,' she said, 'but why don't you ask Grandma when she comes over?' That night as we sat down to eat dinner, my daughter asked, 'Grandma, why do you and Mom cut the end off the roast before you cook it?' My mother looked at her for a moment, and then started to laugh. 'I don't know why your mother does it, sweetheart, but I always did it because that was the only way I could make it fit in the pot.'"

Leo Rinsler remembered this about his mother and food: "We lived on the fourth floor. I'd be in the street playing, and my mother would call down to me, 'Are you ready for your snack?' When I said yes, she would get a piece of rye bread, spread it with *shmaltz* and *gribbines* [fried cracklings from chicken fat—nobody cared about cholesterol!] and wrap it up in paper. My father was a tailor, so we always had big spools of heavy thread in the house. My mother would tie up the rolled sandwich and lower it out the window all the way down to the street. That's how she would give me my snack."

Rosa Zaks Felman was born in Russia, but spent most of her growing-up years in Wisconsin. She has many fond memories which are tied into the sights and smells of her *mamele*'s kitchen....

"My mother's life was full of excitement, dealing with a crisis here and there, busy with her clubs, and raising her four children. Of course, the major task of the week was to purchase the finest chicken at the corner butcher store on Thursday mornings. It was an ordeal making sure the butcher gave her the freshest chicken. Sometimes he would give her a good deal on the rest of the meats and would offer some extra soup bones as a kind gesture. The more bargains she received that day, the more enthusiastic she became. Thursdays at the butcher became a fun and challenging ritual.

"Preparation for *Shabbos* took two days. Cleaning of the chicken started on Thursday night. Mamele would soak the chicken and all its parts in hot salted water for several hours. After she thoroughly rinsed the meat, she would spend another hour inspecting the chicken carefully, checking for any remaining chicken feathers. She would be hunched over the kitchen sink at all hours plucking the microscopic hairs off the bird. My *mamele* knew that this detailed precision operation was a crucial factor in producing the finest chicken soup. After she was satisfied in her attempt at plucking the bird completely hairless, she covered the bird and set it overnight in the refrigerator for the next stage in preparing the Friday feast.

"First thing on Friday morning, before we went to school, Tatele (my father) would set out two pounds of butter to soften for Mamele's baking. Then he would purposely set the tea kettle to boil so that it would whistle and wake my brother and me for school and alert us to the first call for breakfast. The continuous, urgently piercing sound didn't seem to bother him as he shaved in the bathroom downstairs. We took turns getting ready and headed towards the kitchen. After breakfast was eaten and lunches prepared, we took off for school.

"Mamele would crawl out of bed and head for the refrigerator, dressed in her nightgown and bathrobe. The chicken was waiting and ready for its fateful journey to begin. Minutes later it was immersed in a big pot of boiling water. And while the precious soup was simmering on the stove, she would prepare the ideal *matzah* balls—not too hard, not too soft...just right! Mastering the perfect *matzah* ball was essential, and she welcomed the challenge.

"Not only was my mother a witty *balaboosta*, but she was also a clever politician, a mathematical whiz and a lay psychologist. However, her greatest gifts were her cooking and baking abilities. She never minded having flour all over her burgundy bathrobe, on the floor, in her hair or on the telephone receiver. This was my mother's haven, a sandbox full of white flour. She would *patcharim (*play around) for hours, creating her

delectable specialties: *strudel*, apple cake, cheesecake, her famous *yadne kehala* (blueberry turnover) if blueberries were in season, and of course, her special *zista* (marble bundt cake). And we enjoyed them all. But her greatest pleasure was sharing all her wonderful foods with her family and friends. She loved to invite people over and serve them a sumptuous meal, followed by a cup of tea or coffee and a sweet dessert."

Our foods help to define who we are. They help us identify ourselves with our ethnic heritage. One of the things we do miss is having a really good delicatessen around. At one point, my husband even considered finding an experienced partner and opening his own, so nostalgic was he for this food. We didn't go to restaurants as we were growing up; who could afford it? Delis and hot dog places were our idea of "eating out." Chopped liver, tongue, corned beef and pastrami were staples at all gatherings.

When we lived in Twentynine Palms, this was particularly frustrating. We bought a used freezer, which we kept in the garage, and whenever we had the chance to drive into San Diego or Los Angeles, we stocked up. It didn't taste quite as good, but beggars can't be choosers. (Or as my grandmother would have said, "If you can't do what you want, you do what you can.") When my mother flew out for a visit, she always carried two suitcases—one big one and one small one. The small one held all of her clothes and necessities. The big one was packed full of salami and French onion rolls!

Recently, my grandson Joey requested a hot dog for lunch, and so, like the obliging grandma that I am, I added this item to my shopping list. Hebrew National now has a "low-fat" version of their *kosher* beef frank, so I felt a little better about making this purchase. Whoever would have thought that something like a hot dog could trigger such an emotional response? It's been years since I indulged myself with such a high-fat, high-sodium food. But, I admit it, I broke down and made one for myself, too. Not quite the same, but inside a bun, wrapped up in a napkin and popped into the microwave for about thirty-five seconds, it was a pretty good facsimile of the ones I remembered from my youth.

My mother-in-law used to rave about Flukey's on the old west side. Sylvia Metz told me, "In Coney Island, we always went to Nathan's instead of Hebrew National, because Nathan's made the best *knishes* and the best hot dogs." In our area, it was Moishe Pippiks on Division Street. This was a popular hangout in my parents' day, and we continued to frequent this hot dog place as I was growing up.

Although we still have some family there, we don't often get back to

Chicago unless there's a special occasion, like a wedding or a *Bar Mitz-vah*. But when we do, guess where we always make a stop.... A deli where we can stock up on salami and bakery goods, and a hot dog place to satisfy the craving. The old places aren't there anymore, but we can always find their counterparts in the suburbs, where we can indulge ourselves with a taste of the past—pastrami on rye or a "real" *kosher* hot dog, (the packaged ones just aren't the same!), complete with french fries and all the trimmings.

During World War II, there were a few other rituals involving food that many families I knew observed. One of these was the planting of victory gardens. There was a special section in Humboldt Park that was set aside for these. I often tagged along beside my grandmother, carrying a spade or the watering can. People were encouraged to grow their own vegetables, since much of our food was being sent overseas. Our plot was marked off with wooden stakes connected by pieces of string. Grandma planted green onions, carrots, tomatoes and cucumbers, which were not only eaten raw, but also made into dills. With Chicago's harsh winters, we only had this garden during the warm months, but I do remember helping to tend it. My job was to water with the big metal watering can. When I look at the vegetable garden in my own back yard, I sometimes think of that time.

Another ritual was sending packages to the troops. We made choco-late chips or Grandma's special carrot cookies, which we packed in boxes lined with wax paper. Usually we put other things in the package, too, like a big salami. It didn't matter if the salami got hard *en route*. Our family thought it tasted better that way anyway. There was always a *kosher* salami hanging up in the kitchen. The harder it got, the better.

I remember something else we did during wartime. When we brought our milk money to school, three or four cents, we could bring a few cents more each time to put into an account for savings bonds. When I mentioned that to a friend who is just a little older than I, she said that they brought money to school, too. But they put theirs into an envelope that was saved for deposit in a savings account. This kind of thing did teach us something about saving our money. With the limited amount most families had, this was a pretty good lesson. It was a lesson that carried over.

When a new baby is born—we bring food; when somebody dies—we bring food; for weddings, *Bar* or *Bat Mitzvahs*—of course, food. Our foods are tied into every life-cycle event we experience. One thing I

know for a fact is that Jews always eat well. I have never been to an occasion planned by a Jewish woman where there wasn't too much to eat.... God forbid you should run out!

It is also a way that we show our love. My husband teases that the only time he gets his favorite foods is when we have company. It's not true. Some of the more elaborate ones, maybe. But I do go out of my way to prepare the dishes my family enjoys whenever I can. My daughter knows that when she and her family come for a visit (they live in another part of the state), I will always try to serve their favorites. And when my son was still single, and gave us the pleasure of his company for dinner, he never failed to leave without a "care package" for the next day or two. A nice, neat little package of motherly love. It was usually filled with leftovers plus any other things that I knew he liked. It made me feel good to know that he would enjoy it long after he left our house. A little reminder that we love him. And besides, a little nourishment couldn't hurt!

Love and Marriage

"Many waters cannot quench love,
Neither can the floods drown it."
 —The Song of Songs

•

"Sex has never been considered a sin. Sex has
always been considered a blessing."
 —Dr. Ruth Westheimer

•

"I am my beloved's, and my beloved is mine."
 —The Song of Songs

AUNT FLORENCE AND THE WEDDING DRESS...now there's a memory that makes me smile. It was 1943, and I was only four years old, but I have a definite image of my then future aunt standing in front of the mirror in the big room behind the store, trying on this gown. My mother and I talked about that dress many years later, when I was looking for one of my own....

Florence had just graduated from nursing school at Mt. Sinai Hospital on the west side. We had all gone, and I was awed by all those ladies in their white uniforms and little starched caps perched on top of their heads. Uncle Sam was still going to school at the University of Chicago, but he was also in the Army Reserve.

With a war going on, and him about to be transferred, they decided not to wait to get married. The arrangements were made for them to have the ceremony a week later at the Blue Something Inn on Roosevelt Road. Everything was fine, except that Florence didn't have a wedding dress. That wasn't so unusual during wartime when so many couples chose to marry quickly without much fanfare, and she was content to wear a very nice, simple dress on this momentous occasion.

That's when fate intervened. A few days before the wedding, a young woman came into the tailor shop, carrying a big box. When Grandma saw what was inside, her eyes lit up. It was a beautiful wedding gown, and it even had a long, lacy train. The woman wanted the dress altered and cleaned for her own wedding the following week. Grandma took her measurements and wrote up the ticket. When the woman left the store, Grandma looked at the dress in front of her. "Hmmm..." she thought, "they're about the same size. What could it hurt?"

She ran in back and picked up the telephone. When Florence answered, she only said, "Can you come right over? I want to show you something." When Florence saw the dress, she didn't know what to say. "I don't feel right about it. What if something happens?" "Just try it on. Let's see if it fits."

I was sitting on the floor watching the goings on, as Florence carefully lifted the dress over her head. As it fell over her body, a transformation took place. In front of my eyes, she turned into a princess. It fit almost perfectly. Grandma circled around and around, nodding her approval, as she smoothed the silky material, pinching some excess with her skillful hands and deftly sticking in a pin here and there. After some coaxing from Grandma and reassurances that it would be all right, Florence reluctantly agreed. It did feel wonderful. And she would look like a real bride!

That Sunday, we drove to the restaurant in my parents' black 1939 Plymouth coupe. I was going to be the flower girl. Grandma had made me a brand-new dress, and I felt pretty special, too. I wasn't sitting in the narrow back seat, but up on the ledge over the seat, right inside the back window, clutching my basket of rose petals. Nobody worried about safety back then. There were no such things as seatbelts, and they didn't drive that fast either.

The private room was set up for the party, with a *chuppa* and all. When the ceremony began, I slowly walked down the aisle dropping one petal every few feet. (Nobody said I had to throw them all!) They were a handsome couple. Florence made a beautiful bride, and the wedding was a big success.

The next day, Grandma made the necessary alterations, sent the dress off to the cleaners, and when the lady came to get it a few days later, she never even knew what had happened.

I have to wonder what my grandmother was thinking as she looked at her daughter-in-law in that lovely gown. Her own wedding had taken place in a very different setting. She also had a *chuppa*, but the wedding picture I have sitting on the dresser in my guest room shows Grandma and Grandpa as a very young, solemn couple in simple, tailored attire. He was sitting ramrod straight, looking very serious. She stood beside him with her hand on his shoulder, a typical pose of the time. Grandma was wearing a shirtwaist with a wide collar. It hugged her figure, showing off her slender waist. It was a far cry from the rather fancy gown Florence wore, but she looked lovely and serene as she gazed towards the camera's lens.

Matchmaker, Matchmaker, Make Me a Match!

My grandparents' marriage was arranged by a matchmaker. That was the way it was done in their part of the world in those days. A suitable person was suggested, and the parents decided if such and such a person would be a good match for the family. Love had nothing to do with it.

In fact, most of the time, the young couple involved had never set eyes on each other before.

In Grandma and Grandpa's case, both of their families were in the horse business. They lived in small Jewish towns in the Ukraine, about a day's ride away from each other by horse and wagon. The fact that Grandpa was a tailor and Grandma was a seamstress was the frosting on the cake. It looked like a perfect match.

Considering the fact that they were complete strangers when the arrangement was made, it's amazing that it turned out so well. I'm sure that this was not always the case. But there was never any doubt in my mind that these two loved each other deeply, and belonged together. Maybe my mother or uncles heard them argue occasionally; but I spent most of my young life under their roof on a daily basis, and I seldom heard a harsh word spoken. Grandpa never lost that twinkle in his eye!

Family friend Sam Engel smiled as he recalled some of the criteria used by families in Minsk when selecting a match for their sons: "They would give a prospective bride a ball of tangled thread. If she could untangle it, it showed that she was good with her hands." Apparently a bride's desirability was party determined by her dexterity in untangling threads of lamb's wool. "Of course, if she was a good cook, that was very important, too," he added.

Matchmaking has been practiced among many peoples, and has had a venerable history among Jews. It was an honorable tradition for countless generations and served a socially useful purpose besides. As a profession, matchmakers were already in existence among European Jews during the twelfth century. The *shadkhan*, as he was called, was considered an important personage even then. It was the Crusades which spurred the growth of this practice throughout Europe. Massacres, persecution and constant dispersions made normal social life impossible. So the *shadkhan's* job became vital for the preservation and survival of the Jewish people. He traveled from town to town to conduct his holy task. With the growth of permanent settlements in ghettos or towns, his status changed. But until modern times, he remained an important part of family life.

This practice of arranging marriages carried over to American life, too. Young couples today would never hear of such a thing. But in the early decades, when so many immigrants flooded to our shores, this old custom was still practiced when love needed a hand.

Rabbi Gitin remembers the environment during his young days in Buffalo, New York:

"Those were pleasant years on Pratt Street. Jewish people crowded the streets of the east side of Buffalo. The synagogues were filled to capacity on the Sabbath and holy days. The street corners after the daily evening services found worshippers congregating, conversing in classic Yiddish about everything in particular....

"People came together to discuss their intimate concerns: their jobs, their homes, words of Torah. Women covering their *shaytals*, straggling wisps of stray hair obscuring their eyes, congregated on the sidewalk talking animatedly about matters of mutual interest. 'My daughter Sarah is already eighteen years old, and she doesn't have a beau. I've asked Mr. Rosenbach, the *shadkhan*, to get busy!'

"It was natural for mothers to dream and pray for fine young men to take unto themselves wives recruited from the ranks of the daughters. Since family life was the most exalted and most beautiful facet of Jewish living, it was expected that mothers would concern themselves with the prospective marriages of their children."

This custom of arranging marriages is still practiced in some cultures around the world. In modern America, many young people could use the help of a *shadkhan* today. Many are finding it increasingly difficult to meet "Mister or Miss Right." A recommendation from a parent is like the kiss of death. The modern version has become the "Jewish Singles Group" or a "Matchmaking Service." Most are still unwilling to leave such a choice to others. While the computer has become a matchmaker of sorts in the nineties, most people still hope for that magic bolt of lightning called "chemistry" to strike. And then they hope that once they're married, and this initial reaction wears off, they'll end up actually liking the person they've chosen.

An old proverb says that "marriages are made in heaven." This proverb is popular in every language. The Chinese version states the the Old Man of the Moon unites male and female with a silken, invisible thread, and that they cannot afterwards be separated, but are destined to become man and wife. The yin and the yang.

In Yiddish we called this *beshert*—predestined. According to Jewish tradition, forty days before a child is born, his or her *kalleh* (bride) or *chassen* (groom) is already determined. Some call these couples "soul mates." I don't know if there really is such a thing, but I have always felt that my husband and I were *beshert*. We have been together since we were thirteen years old—childhood sweethearts, I kid you not. It wasn't exactly a bolt of lightning, but it *was* raining at the time. My girlfriend was having a party for her thirteenth birthday. Somebody had dared Sid

to kiss the first girl who came through the door. I had just swung the soaking wet umbrella out of the doorway when I was startled by an awkward peck—on the nose. At five-foot-three and all of 110 pounds, he really was kind of cute. That little dare sealed my fate. What can I say? I was smitten. And nearly half a century later, plus a few inches and pounds and a lifetime of ups and downs, I still am!

Well, it took about seven and a half years after the initial encounter before we actually tied the knot. We were quite young by today's standards, twenty and just barely twenty-one, but that was pretty common then. In 1960, couples didn't live together before they were married, and they didn't have birth control pills either. So, working like the dickens to graduate from the university in record time so I could begin teaching, so I could get married and support my husband as befitted a Jewish spouse as he finished medical school, we looked forward to a joyous wedding.

Which brings me to the subject I want to talk about next: weddings and wedding practices.

Something Old, Something New, Something Borrowed, Something Blue

The "something old" should belong to a happily married woman. This ensures the transfer of happiness to the new bride.

The "something new" is usually the wedding gown, shoes or other apparel.

The "something borrowed" should be an object of value to guarantee good fortune in the future.

The "something blue" is symbolic of the heavens, and also of true love.

Our wedding was a traditional Jewish ceremony, only instead of a rabbi we had a cantor perform the rituals. (One of the famous Lind brothers.) This was considered "*kosher*" if he was so licensed by the state. My grandfather had died the summer before our wedding. It was the one thing that saddened me on this day. He had been so important in my life, and I wished he could have seen his Rosele on her wedding day.

Grandma was happy for me, of course. She called Sid "a prince," and was as excited as the rest of us as we did our shopping and made all the arrangements. But she had a slightly sad and wistful look as she walked down the aise on Uncle Sam's arm. Around her neck, on a slender gold chain, she wore a medallion. A circle of rubies surrounded a small photograph—of me. On the other side, in gold script, was the word "Love." This had been a birthday gift from my mother. She wore it proudly, like

her finest piece of jewelry, as a fitting embellishment to her wedding attire.

When Grandma died, my mother began wearing this necklace. She never took it off until just before she died. And now it belongs to me. It now has pictures of my grandchildren inside the ruby circle. I don't wear it often, but when I do, I'm reminded of her. Some day my daughter will have this keepsake. It may not be her "style," but I hope that when she looks at it and holds it in her hands, she, too, will feel the bond.

The room was filled with all the relatives and friends from both sides. It was decorated with flowers as befitted the occasion. The most distinctive thing, of course, was the *chuppa*. In our case it was covered with flowers and supported by four poles. Sometimes the covering is made of silk, satin or velvet. It is supposed to represent a sanctuary in miniature. We were so young, and nervous, but so full of love and hope. We felt as though we had stepped into a magic place, and that what was about to happen was not only solemn, but historic.

As we stood under a similar canopy thirty years later and watched our daughter in her flowing white satin and lace gown stand next to her bridegroom and recite the same ancient prayers, our hearts were bursting with emotion. Yes, our little girl was leaving us to become someone's wife, but it wasn't really a sense of loss we were experiencing. I don't know if I can even explain it at all. It was love…and pride…and hope…and fear…and expectation of all the wonderful things we wished for this young couple. If our children are extensions of ourselves, then this symbolic ceremony was the embodiment of what we envisioned for ourselves and our progeny. They were the next generation. They and their children would carry us, along with our heritage, into the future.

The cantor chanted the ancient melodies, the rabbi recited the prayers, the wine was sipped, and then the groom stepped on the glass, followed by a joyous *"mazel tov!"* from the congregation. Again, history was repeating itself.

Beauty and Symbolism

There are many beautiful and symbolic aspects to a Jewish wedding ceremony. First and foremost is the *chuppa* and all it represents. Nuptial canopies are found in many cultures. Greeks used a *thalamos*, or bridal bower; in Spain and Scotland, newlyweds pass under a bower of leaves or branches; in Sweden, bridesmaids hold a covering of shawls over the bride to ward off the evil eye. In many cultures the wedding couple is protected from the evil eye by covers, cloths or enclosures. In Tahiti, the couple is surrounded by—or rolled into—a mat. The *chuppa* is not

unique to Jews, nor was it invented by Israelites. But in the Jewish tradition, this structure represents the home, and its very special meaning in Jewish life—sanctuary of peace and love.

Before the ceremony, a beautiful wedding contract, called a *ketuba*, which is usually written in Aramaic and spells out the legal obligations of the husband to the wife, is signed by the bride and groom and witnesses not related to the family and later read out loud while under the *chuppa*. The Jewish custom of decorating marriage contracts has been in practice since the tenth century.

In olden days, a procession circled the couple seven times, seven being considered a sacred number. This evolved into the custom of the bride walking around the groom seven times. Superstition told that this was to protect the groom from demons who might harm him. The religious significance has more to do with the association that the number has with the days of the week and so on. The number seven actually appears in Jewish tradition and lore many times.

Rabbi Gitin adds, "By circling around her future husband under the *chuppa*, the bride suggests the vow that she is too modest to state aloud: I will try to surround you all my life with grace, kindness and love."

With more modern, gender-conscious Orthodox and Conservative couples, this is sometimes split up, with the bride circling the groom three times, the groom circling the bride three times, and the two of them completing the final circle together.

In Orthodox and Conservative families, the bride and groom often fast on their wedding day. Since marriage represents the beginning of a new life together, this is a way to ask for forgiveness for past transgressions so that they can start this new life with a clean slate.

On the Sabbath morning preceeding his wedding, the bridegroom is honored by being called up to read the Torah in the synagogue. This is called the *aufruf.* In some synagogues it is customary for people to throw candy or nuts on him, probably as an omen of a sweet life and fertility. These days, this custom is also extended to the bride.

At the end of the wedding ceremony, the bridegroom traditionally stomps on a glass, wrapped in a cloth. There are many explanations for this. Since it's supposed to create a loud noise, many rabbis use a light bulb rather than an actual glass because it is easier to break and makes a louder noise. It is a reminder of the destruction of the Temple in Jerusalem and of past sorrows. It is also considered a warning to the couple of the frailties of life. Just as one blow can shatter a glass, so the sanctity and harmony of the home can be destroyed by a single act of intolerance, unfaithfulness or infidelity. Rabbi Gitin usually adds that just as it

would take forever to put the pieces back together, that is how long their union should last.

After the groom breaks the glass, the guests usually shout out *"mazel tov!"* In biblical times, *mazel* meant star, constellation or planet. In those days it was believed that man's fate depended on the position of the stars. *Mazel tov*, "good star," later came to mean "good luck!"

It was also a tradition for the bridal couple to go into a private room immediately following the ceremony. This was supposed to be a time when the marriage could be consummated, but today it just gives the couple a few minutes to themselves to savor the first moments of their new relationship.

Every culture has its own customs and superstitions concerning weddings and brides and grooms. Some of these are variations of similar themes. Some practices like wearing wedding rings or veils are traditional symbols that cross religious or ethnic lines. It's interesting to explore some of the vestiges of this sacred ceremony and their origins.

The Veil

My wedding dress was borrowed. It belonged to Sid's cousin Elaine. The headpiece was my Aunt Tobey's (Sol's wife), but my veil was brand new. I wore it beause it completed the outfit, but also because it was part of the wedding tradition.

The veil itself is of eastern origin. It was introduced into Europe by the returning crusaders. Eastern women wore it to ward off the evil eye. It protected not only her face, but the entire body as well. It was a sign that the bride was pure and innocent. Moroccan brides are expected to shut their eyes throughout the ceremony, and in Korea they used to cover their faces with the wide sleeves of their robes. Among Oriental Jews, the bride's veil is made of opaque material so she can't see, symbolizing her complete faith and trust in the man who is to become her husband.

In the Jewish tradition, before proceeding to the *chuppa*, the rabbi, family and friends escort the bridegroom to a room where the bride is seated. The groom lifts the veil and recites a blessing. This tradition is called the *badecken* and stems from the biblical story about Jacob, who was tricked into marrying the older sister, when he had expected to marry the younger one. (It was generally expected that the older daughter was to marry first. This upset many a plan when younger siblings were involved.) This ceremony was intended to insure that no such deceptions had taken place.

In the old days, this was primarily for the man's assurance. In

modern times, in deference to the equality of the sexes, both bride and groom are now supposed to "check each other out" and satisfy themselves that they are, indeed, marrying the person they expected.

The Wedding Ring

I was married with a simple gold band. According to custom, the wedding ring wasn't supposed to be adorned with stones of any kind. I wore this ring to work every day. But my very special wedding ring, which I wore only for dress and special occasions, carried a diamond from my grandmother's own engagement ring. She knew that Sid was still in school and couldn't afford to buy me a nice ring, so she gave us this gift, which I cherished. I could kick myself now that I didn't wear it all the time without ever taking it off. But it was so precious to me, in spite of the fact that it was neither big nor perfect, that I felt I had to "save" it. When it was stolen several years later, I was devastated. Since then, I *never* remove my ring, except to clean it or to knead dough.

The wedding ring is traditionally worn on the fourth finger of the left hand. It was believed that a vein ran from this finger directly to the heart. Since the heart controlled both life and love, this finger was the most honored. This is a custom that goes back a thousand years. It originated in the East, and was copied by the Greeks and then the Romans. Finally, it became a custom all over the world.

In Egyptian hieroglyphics a circle represented eternity. Now a small band worn on a finger, it developed from bands that encircled the wrist, the ankles or even the waist. Primitive man believed in magic. He tied a rope around the woman he wanted, believing it to be a magic circle that would bind her to him and couldn't be broken. Another belief was that a ring was an amulet that could ward off evil spirits. The wedding ring evolved from the engagement ring—an old Roman custom confirming betrothal and warning others to keep away.

Among the Jewish people, the ring was first worn in the eighth century A.D. It replaced the custom of giving the bride a small coin as a "promise" of a prospective husband's ability to support his wife. Yemenite Jews still use a coin in their wedding ceremonies.

Symbolizing harmony and perfection, a ring's lines are endless and so represent the continuity of the sacred bond, reminding the couple that their mutual love and commitment should flow from one to the other in a circle—continually and forever.

There are many different superstitions and customs surrounding weddings and courtship. People in every country add their own flavor to this important phase of life.

Sofia and David Zadkovsky proudly displayed the photos taken at their granddaughter's Yemenite wedding in Israel. Sofia *kvelled* as she spoke about the affair:

"My granddaughter Leeza came to Israel with her parents from Almati [the capital of Kazakhstan], in October 1979. She was six years old at that time. After several days, she began to go to school in the first class. Several other Russian students attended with her. She learned Hebrew very quickly.

"When she was eighteen, she joined the National Ensemble of Dance, where she met a Jewish man named Yaacov. Yaacov was a native of Israel from a Yemenite family. He was ten years older than Leeza. They had been friends for about a year when, at the beginning of 1992, she was to begin active service in the Israeli Army. Within three to four months, he asked her to marry him. She took leave from the army, and the wedding was held on August 22.

"It is the custom in Yemenite families to have a special party one week before the regular ceremony, only for the family members and close friends. At this party, the bride and groom dress in the traditional robes of the Yemenite people. During these prenuptial festivities, my granddaughter wore a long, heavy gold-and-silver-embroidered Yemenite ceremonial gown. She also wore heavy silver-and-red-beaded necklaces which hung down nearly to her waist. On her head she wore a very high cone-shaped hat, decorated with chains of red and white flowers and very ornate hanging tassles of filigreed gold, which were also draped under her chin. A delicate gold veil hung from the back of this tall head covering. Only her beautiful smiling face peeked out from her colorful costume. Yaacov wore an embroidered ceremonial robe, too.

"This was all very interesting for us. We had never seen costumes like this before. It was a very happy gathering. There were all kinds of interesting Middle Eastern foods on the tables, and everyone enjoyed lively music and singing. A week later, both the bride and groom wore more familiar clothing. Leeza wore a plain white traditional wedding gown, and Yaacov wore a dark suit. The whole wedding was a mixture of the old and the modern—like a wedding of two cultures.

"Yaacov is a very good man. When his father was very sick and required a kidney transplant, Yaacov donated one of his own kidneys to save his father. He is also a good builder. He built a very nice home for his wife and future family. His family took to Leeza very well. Even though she was a very young bride, she was a good housekeeper and could cook Yemenite food very well. His family is religious, but he isn't as much. Even so, he has never eaten at our home because our kitchen is

not *kosher*—only a cup of tea or some fruit. But he is a good husband and a good father. They have a son who is four years old and named Nadar. We hope that Leeza and Yaacov will be happy for many, many years."

In the Orthodox tradition, after marriage the Jewish wife was required to cut or shave her hair and wear a wig, called a *shaytal*, when she went out in public. This custom was designed keep the wife from attracting other men by her beauty. This wig was also a symbol of her status as a married woman. In India, married women place a red dot in the middle of their foreheads to let this status be known.

Not all couples accepted this tradition. Nora Dreyzner talked about her family: "My grandfather and grandmother married in 1887. My grandmother was a beautiful woman. Grandfather didn't want her to cut her wonderful hair and wear a *shaytal*. So he took the wig and threw it in the oven. I saw my grandmother for the last time in 1939. She was seventy-two years old, and she still had wonderful hair!"

This practice of wearing the *shaytal* also went along with other practices designed for the same purpose. Rabbi Gitin told me, "Father never walked next to Mother. He always walked ahead, so he would not be tempted to look at her." In the Orthodox synagogue, men and women don't sit together, basically for the same reason. Sitting with women was thought to be too much of a distraction. In the synagogue I attended with my grandparents, the women sat upstairs. In other places, they are seated at the back of the sanctuary, sometimes with a curtain to separate them from the men's section.

The Honeymoon

Couples everywhere observe the time-honored tradition of going on a "honeymoon" or wedding trip following the festivities. If you lived in Chicago, this usually meant a trip to the Bahamas or Miami Beach. We chose Miami, and it was Sid's very first time on an airplane. I had been on a couple of trips with my parents before this, but it was such an occasion for my new groom that his watch mysteriously stopped as soon as we left the ground. We never could figure out why, but we like to think that it was his way of making time stand still.

Of course, when we arrived at the hotel which his aunt and uncle had so highly recommended, we discovered that the average age of the other guests was somewhere between sixty and eighty! Not that it mattered, since we were very busy with other traditional things.... When it was time to return home, we arrived at the airport around midnight,

where we were greeted by all four of our parents. They escorted us to our new apartment, for our first night in our own new home, making sure to give us bread and salt and a brand new broom.

Opinions vary about the origin of the honeymoon. On the Jewish calendar, the duration of the month coincided with the revolution of the moon. A new moon always signified the first day of a new month. So the honeymoon came to symbolize the first month of a new marriage, when, hopefully, all was sweet.

According to the Talmud, Jewish husbands who were merchants and would normally travel great distances were supposed to stay at home for the first year of their marriage. Dr. Ruth Westheimer, speaking about sex in the Jewish tradition, uses this admonition as an example of the wisdom of the Talmudic scholars. She says that they must have realized the importance of "bonding." And she also uses this example to demonstrate her theory that sex was considered more than just for procreation. She states that "if they meant it to be only procreational and not recreational, they would have said he should stay home for only nine months, and not a year."

The *Get*

Obviously not all marriages are "made in heaven." Sometimes relationships, for one reason or another, just don't work, and people find they are unable or unwilling to continue. When such an emotional change occurs, the act of divorce can be a shattering experience. In the case of couples to whom Jewish tradition plays an important role, more than a civil action is required. This involves a ceremony called a *get*—a divorce carried out according to Jewish religious law. A divorced Jewish couple seeking to remarry is usually required to have a *get* in addition to a civil divorce if they wish to be married by an Orthodox or Conservative rabbi. Usually the husband must initiate these proceedings, though there are a few exceptions which permit the wife to do so.

A good friend recalled her shock as she underwent this procedure at the request of her former husband, who wanted to please his Orthodox parents. When they agreed to obtain the *get* neither of them had any idea of exactly what was involved. They thought that they would be asked to sign some papers and that would be it. What followed came as a complete surprise.

First, they had to find a rabbi who was authorized to perform this particular ceremony. They discovered that there was only one such person in the entire Northwest who could do this. They arranged the meeting and were ushered into a room where several men were sitting around

a table praying. One of the men was a *sofer* (Torah scribe), who asked their Hebrew names and other pertinent information. Then he began to meticulously write their official document in beautiful Hebrew script. He did it painstakingly, taking a very long time to complete it to his satisfaction.

Then they were told to face each other as the men circled around them, and the official document was read. "It was so emotional," my friend recalled. "Almost like a wedding, but in reverse. It was unsettling, but kind of funny too, in a strange way, because we remembered the circling which had taken place during our own marriage ceremony. Then the rabbi took this beautiful scroll, which had been so carefully written, and began to tear it into a million tiny pieces—literally tearing up our marriage. It was actually a very solemn event. Our marriage was officially and completely ended, under the law and in the eyes of God.

"We later learned that some people don't even show up for their *get*, but hire others to stand in for them. But it seemed only fitting that we should be there to finish what we had started. We received our official certificate of proof and left to begin our separate lives."

Some wedding customs are humorous, or based in superstition. In Israel, for example, it was a custom to bring a rooster and a hen to the bride and groom so that they would "be fruitful and multiply." And in Safed, Israel, people would serenade the couple every Saturday night.

It was considered bad luck to fall in a doorway. Since doorways generally had some sort of crack between inside and outside where evil spirits could dwell, and this was a place that the bride could easily misstep, it became a tradition for the groom to carry his bride over the threshold, thereby avoiding this misfortune. (Thank goodness Sid didn't try this one!)

We've all seen shoes tied to the back of the bridal couple's car. It's supposed to express good luck to the newlyweds. But who would have guessed that shoes used to be considered a magic means of ensuring plenty of children? The shoe was believed to be an ancient symbol of fertility. Eskimo women used to carry a piece of an old shoe to make themselves prolific. I'm glad it doesn't always work beause I have a closet full, and am quite content with our two wonderful kids.

In Scotland, December 31 is the most popular day for weddings. Everybody celebrates with you, and by the following morning, you will have been married for a whole year!

One of my favorite pieces of advice that Rabbi Gitin gave to my daughter and son-in-law during their marriage ceremony, to remind them to

keep things in perspective when deciding what was important and what wasn't, was this quote from Benjamin Franklin:

"When you go into a marriage, you should do it with your eyes wide open; but afterwards, always be sure to keep them half shut!"

Children

When they're little you have little problems, and when they're big....

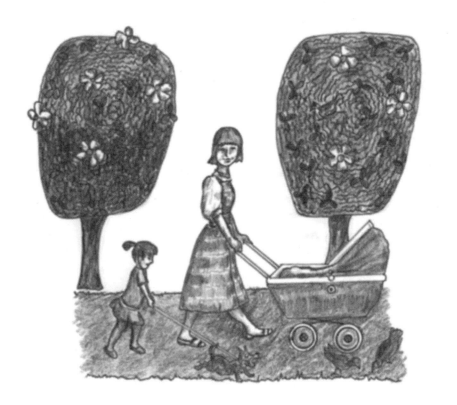

"Youth is a time of rapid changes. Between the ages of twelve and seventeen, a parent can age thirty years."

 —*Sam Levenson*

•

"You can be anything you set out to be; but first you must set out."

 —*Margaret Mead*

RAISING CHILDREN IS ALL ABOUT TRADITION. In my family, we had one of our own. My grandmother was twenty-three when she had my mother; my mother was twenty-three when she had me; and I was twenty-three when my daughter was born. When my daughter turned twenty-three, she came to me crying, "Mom, I'm breaking your tradition. I'm twenty-three and I don't even know who I'm going to marry yet."

"Don't worry, sweetheart," I told her. "You'll start your own tradition."

One other amazing thing: my parents, my husband, both of my children, my son-in-law and I were all born on Fridays. I wonder what to make of that. My grandparents never even knew the date of their birth, much less the day, so I have no idea if the Friday thing goes back any farther than that. My oldest grandson followed suit. He, too, was born on a Friday, but Jacob, the youngest, began marching to his own drummer from the beginning—he was born on a Monday!

We didn't have ultrasound when my children were born. We had to wait until the baby came to find out if it was a boy or a girl. Oh, there were lots of people who swore that just by looking at your stomach they could tell. If you were carrying "all in front," they said it would be a boy. If it looked more distributed from side to side, then it surely was a girl. One person even said to pull out a strand of my hair and thread a needle with it. Then they held it over my protruding abdomen as I lay on the floor. If it swung one way, it would be a girl. If it swung the other way, then it would be a boy. Well, they had a fifty-fifty chance of being right! There was some disagreement in my case, so we just had to pick out both male and female names and wait to see.

Without advance knowledge, we didn't know if we should be looking at pink or blue things. Which brings me to the question…where is it written that boys should wear blue and girls only pink? This custom of dressing boy babies in blue and girl babies in pink is found all over the

world. Since I was interested in this puzzlement, I did a little research.

Who would ever guess that an ancient fear of evil spirits hovering over the nursery would have promoted this color scheme. It was thought that the evil ones (the old "evil eye" again!) were allergic to certain colors, the strongest of which was blue. The association of blue with the heavenly sky was thought to render these forces helpless and drive them away. So blue on a young boy was considered a necessary precaution. Girl babies, unfortunately, were regarded as "less valuable" and so it was assumed that these spirits wouldn't be interested in them. Later generations may not have been aware of this primitive fear, but they were conscious of the slight, so the color pink was chosen as the color for females.

It's interesting how we still adhere to this color selection, although we are much more flexible than we used to be. Today, little girls wear any color of the rainbow that Mom likes, but I have never seen anybody dress a little boy in pink.

There were lots of superstitions regarding babies, too. God forbid a pregnant woman looked at a monkey—her baby might take on simian characteristics! The funny thing is how serious some people used to be about things like this. And we absolutely never have baby showers ahead of time either, so as not to jinx the child in any way. After the baby is born, of course, we bring gifts like everyone else.

The strangest baby gift I ever heard of was one that Pat Markman's mother had told her about: "After I was born, an elderly uncle came to the house with a gift for the new parents. My mother opened the door to see him standing there with a big, live carp! They proceeded to put it in the bathtub, where it swam around until they were ready to cook and eat it." I know that fish are supposed to be symbols of life and considered good luck, but to give one as a baby gift was new to me. I later heard more fish stories like this. (See "The Holidays.")

The day my daughter was born, it was raining cats and dogs—a regular deluge. It was a big day for my husband. He was scheduled to take his medical board exams, for which he had been preparing for two years. This was an all-day affair. As he got ready to leave, he inquired how I was feeling. "Just a little stomach ache," I told him. "Don't worry about me. I'm fine." I wished him good luck, and went back to sleep.

As the morning progessed, my little stomach ache started to come at regular intervals. During the lunch break, Sid called home to check on me. At that point, he was half finished with his exam. When I told him my pains were five minutes apart, he went back inside, finished the sec-

ond half of the exam in about twenty minutes, and dashed home. He said that the proctor had looked at him in astonishment as he handed in his finished exam just as the other test takers were settling in for the rest of the afternoon. (He passed his boards, by the way.)

I had never held a baby in my life until my daughter was born. It would be an understatement to say that I was scared stiff. What if I wasn't a good mother? How would I know what to do? As excited as we were at the prospect of having our own child, I still worried about my inexperience. Fortunately, human nature usually takes over. All those things that we don't consciously remember are still filed away deep inside somewhere; but nothing could have prepared me for the actual experience of holding my baby for the first time. The tears came unbidden. Tears of joy, to be sure. Relief, without question—one, that the ordeal of childbirth was over, and two, that, thank God, she had all the correct number of fingers and toes and looked to be a perfectly normal, healthy, beautiful infant. And besides all that...she was ours!

Suddenly, I had an inordinate interest in how my mother had raised me, and her mother before her. When my daughter became a mother, I was tickled when she started calling me for advice. I understood. I had done the same thing. Now, I actually knew something she wanted to know. All of a sudden, I was an "expert." Little did she know...being a parent is "on-the-job training." My mother, my grandmother and Dr. Spock were my gurus. How many times did I miraculously hear their words spring from my lips?

Grandma told me not to worry. She said, *"Klayne kinder, klayne tsouris.... Groyse kinder, groyse tsouris*—When they're little you have little problems, and when they're bigger, you have bigger problems. You'll handle it."

She was, of course, correct—as usual. We followed their advice. We kept our children warm, dry and comfortable; we gave them nourishment and rules to live by; and we gave them love. We must have done something right, because they both turned out to be great human beings. What more could we ask? (Pooh, pooh, pooh!)

It is impossible to anticipate how having a child will change your life. Before we knew it, our babies turned into little "people" with minds of their own. Sometimes they gave us aggravation, but usually they gave us pleasure. And sometimes they came up with things that made us laugh or shake our heads in wonder. Going through my collection box, I came across an envelope with some of the letters that I simply couldn't part with:

Dear (suppositive) [sic] Tooth Fairy,
Please take my tooth! It has been next to my bed for almost a week! Thank you.
> Your toothgiver (and money maker),
> Larry

And:

Dear Tooth Fairy,
If you haven't noticed, there are two teeth this time, so may I please have 50 cents plus 1 or 2 cents for the unusual tooth (the long one) (optional).
> Love,
> Wendi

Or the one that really had us chuckling:

Dear (suppositive) [sic] Tooth Fairy,
During dinner today, when I was eating my Kentucky Fried Chicken, my tooth fell out. Well, it might sound weird, but I thought it was a chicken bone or something. So I swallowed it!!! Well, the point is, I don't have my tooth with me. But I really did lose it, so can I still have the money?
> Sighned [sic],
> Larry

If you think these are funny, you should have read the two-page missive, folded into the shape of an airplane, that came sailing into our family room one night, describing in detail why our daughter, Wendi, thought she should be allowed to have her ears pierced. We were hysterical. She got her ears pierced! Our children were our best entertainment.

And when your children have children, you enter an entirely new phase of life. As soon as we got the news that our daughter was expecting her first child, I went out and bought the softest white yarn I could find, with little multicolored flecks, so I could begin crocheting a baby blanket. I just wanted to make something for the child with my own hands. It was something that my mother had done. It was something that my grandmother had done. It just felt good to do it.

Becoming a grandmother was another major event in my life. It had no ritual of celebration or rite of passage to honor it, but it affected my life in ways I could not have imagined. Just as the birth of my first child

had changed me from that day forward, holding my grandchild in my arms stirred up a whole barrage of memories and a wide range of emotions. In fact, it was such an emotional event in our lives that I was moved to put down on paper some of the feelings I was experiencing....

To My Darling Daughter as She Becomes a Mother
It seems like only yesterday that you came into my life. You were born during a pounding thunderstorm. I remember looking up at the window and seeing and hearing the driving rain and flashes of light as rolls of thunder greeted the sound of your first cry.

How naive I was...how nervous...how worried that I wouldn't know *how* to be a "good mother." Where would all the wisdom come from? The *right* things to say? The *right* things to do? As I looked down at you in my arms for the first time—exhausted, but strangely elated and at peace—my mind played a movie of you: as a little girl, as a teenager, as *my* daughter. In my wildest dreams, I couldn't have foretold the absolute joy, love and pride this new life—you—would bring into my world. How could I have known that you and I would be so alike in so many ways, and so capable of "pushing each other's buttons" like nobody else!

In the beginning, I could only wonder, "What will she be like? Can we handle being so totally responsible for this so completely helpless and dependent human being?" I needn't have worried. From the very first, you had a personality and—yes!—a will of your own. How can I describe the pleasure we derived from hearing your laughter or seeing your smile?

As we watched you grow, we marveled at your curiosity, your inventiveness, your excitement at discovering new things, how you could carry a tune (at twelve months!) or what an actress you were when reciting a poem. Who could have known how thrilled grown people could be at seeing your first steps or hearing your first words. (In your case, hearing your first paragraphs at a year and a half!) Who could have known that we would actually "feel" what you were experiencing...the joy when you were happy, as well as the pain when you were sad or hurt, or the excitement of each new accomplishment.

You had the power to plunge us into the doldrums with an angry word or a tear, and the power to lift our spirits the next minute with a smile. For *you* we would endure countless recitals, plays and shows...and actually enjoy every minute of it. You have enriched our lives more than we could ever say. I cannot imagine how empty our world would have been without you and your brother to give meaning to our existence.

In what seems like a flash, we watched our bubbly, energetic and

sometimes mischievous little girl turn into a beautiful, talented and very capable woman. Dad and I often look at each other and marvel, "We must have done *something* right!" And now, sweetheart, we are so excited for you! For you are about to enter this new world of parenthood. You are about to experience all these miraculous feelings and discoveries— just as generations before you have done.

From this time on, you will take on a new identity. From this time on, you will no longer be *just* our daughter, or *just* Wendi Fast, or *just* Barry's wife. From this time on, you will have—forevermore—a new name… *"Mom."*

I pray that life will be good for this new child, and that your future family will bring you all the joy and satisfaction that being your parents has brought us.

We love you very much and are now eagerly awaiting *our* new identities—"Grandma" and "Grandpa"—forevermore.

With deep gratitude and affection,
Mom

In the Jewish tradition, you didn't buy any furniture or baby things until *after* the child was born, and you were sure that everything was okay. You could order everything, but the usual routine went like this: After you selected everything you wanted, the store kept the list. Once the child was born, someone would call and arrange to have it all delivered. The old "evil eye" business again—tempting the fates. It was a superstition, but my grandmother would not hear of anything else.

As it turned out, my Aunt Tobey and Uncle Sol had some perfectly good baby furniture that they had used for my three cousins, the youngest of whom was already in school. Since they weren't planning on having any more babies, they offered it to us. So we stored it away for the appropriate time. But, as the saying goes, *"menshen tracht, und Got lacht,"* (people plan, and God laughs!) They had a little unexpected surprise shortly after they gave us the furniture. Our two little girls were born four months apart!

Naming the Baby

By the time a child is born, usually a lot of thought has already gone into the first decision to be made—the naming of the child. Here again tradition plays an important role. Naming a child after a relative who is deceased is common among Ashkenazic Jews (of European extraction). They believe that naming a child after a living person would rob that person of a full life. Sephardic Jews (from Spain, North Africa and the

Middle East) do not share this belief and often do name their offspring after living relatives.

Jews believe that the souls of departed loved ones live on in the memories of the ones they leave behind and in their actions they performed during their lifetimes. One way to keep their memory alive is to name their children after these people. Both Uncle Sol and I wanted to honor my grandfather (his father) in this way. So our daughter is Wendi (with an i), and my cousin is Wendy (with a y), both after William. Actually my Wendi is named after two grandfathers. My father's father was Elias—so she became Wendi Eileen. Aunt Tobey's father was Jack, so their little girl became Wendy Jo.

Eileen Gitin, a speech therapist, told me that in New York, where she grew up, she was warned that you couldn't name a child after someone who had died young, unless you also paired this name with that of someone who was old. In our case, all the people involved were old when they died, so I guess that was okay.

Our son, Larry (Lawrence William), is also named after two grandfathers. My husband's grandfather, Louis and, once again, my grandfather William. The Hebrew names would be the same, though the English version usually only had to start with the same letter of the alphabet.

Boys receive their official names during the ceremony of circumcision—the *bris*. In Hebrew *brit* means convenant. This ceremony is a covenant between God and the Jewish people. This ritual takes place on the eighth day after birth, and can only be postponed for reasons of health. It is such an important event in the male child's life that it is even done on Yom Kippur. Everyone must stand to honor him. He is held by his *sandak* (godfather). The procedure is usually performed by a specialist known as a *mohel*. He could be a physician, but he doesn't have to be. He does have to be familiar with the religious, as well as the surgical, aspects. As barbaric as this custom seems (I couldn't look even when my own son or grandsons went through it), it is a very significant rite in the Jewish religion. It is a symbol of the continuity of Jewish identity being passed on from father to son, from generation to generation.

The *mohel* is often the subject of Jewish humor. An old joke tells about a man walking past a shop and seeing a clock in the window. Since his watch needs fixing, he goes inside and tries to give it to the proprietor, who looks at him with a strange expression. "I don't repair watches," he said. "Then why do you have a clock in your window?" he asks. "I'm a *mohel*. What else should I put in the window?"

I heard another joke involving the *bris*. Question: What is the

technical name for a Jewish child who doesn't have a *bris*? Answer: She is called a girl.

Obviously, girls are left out of this tradition. But baby girls have to be named, too. This is usually done in synagogue, during a Friday night or Saturday morning service a short time after her birth. The parents are called up to the *bimah* and the rabbi gives a benediction, after which he gives the child her official Hebrew name.

They couldn't quite figure out what the feminine equivalent of William (in Hebrew, Zev) would be, so our daughter, Wendi, was given the Yiddish name Zeesah (sweet one) instead. Her middle name, Eileen, became Esther. When she was preparing for her *Bat Mitzvah* twelve years later, she was told that she had to have a Hebrew name—a Yiddish one wasn't enough. So, she chose one for herself: Chaya, for the Hebrew word "life." I was never given a Hebrew name either. When my mother was in the hospital after giving birth to me, my grandfather came to visit. My mother told him that she wanted to name me Susan. My grandfather, in his quiet way, told her that he thought that was a very nice name. But no one had ever been named for his mother. Her name was Rose. So, as you can see, I became Rosalie. I would have prefered Susan, but I wasn't consulted. I was also given a Yiddish equivalent: Rissi.

Talking about names, there was an amusing story about my husband, Sid's, moniker. When he was born, the nurse came in with the forms for his birth certificate. She asked my mother-in-law what she wanted to name her son. She told her, "Sidney Ronald." "Sidney," the nurse exclaimed, "You can't call a baby Sidney!" "Well, he won't *always* be a baby," came the reply.

It wasn't until years later, when Sid needed to supply a copy of his birth certificate before reporting for active duty in the Navy, that he discovered what that stubborn nurse had done. This official document listed his name as "Baby Sogolow." You wouldn't believe the rigamarole. He had to submit affidavits from several different people attesting to the fact that "Baby" and "Sidney" were, indeed, one and the same person before they would believe him.

We've all heard stories about how immigrants' names got all turned around because customs officials misunderstood their pronunciation. Well, this happened frequently at other times, too. People sometimes went through their whole lives thinking their name was one thing, and occasionally finding out only by accident that it was something completely different. My mother always thought her name was Edith. That's how she registered for school, and that's what she was called from then on. But when my grandmother had told the nurse in the hospital what

name to put on the form, it came out sounding like Eeda. It wasn't until my mother decided to take a trip to Israel at the age of sixty-two, and tried to obtain a passport, that she found out there was no record of an Edith being born. Only a "Yeda."

There's one more story our good friend Joe Gabriel tells about wanting to change his name when he and his new bride, Michelle, were about to move to California from New York. His last name at that time was Gabrilowitz. His brother, Lester, had already shortened his name to Gabriel when he made the move a few years before. Since Joe was the last Gabrilowitz to carry on the family name, he was reluctant to hurt his father with this act. He very apologetically explained what he wanted to do and asked if he would mind. His father looked at him and said, "Mind? Why should I mind? Our family name was never Gabrilowitz anyway. It was Cantor." Twenty-three years old, and he first discovered that his father had changed his name when he left Russia just in case the Tsar's henchmen decided to come looking for him in America. What's in a name? You never know!

There is one more baby tradition which involves the birth of a firstborn son. According to the Book of Exodus, the firstborn son of a Jewish mother (the Kohayn or Levite branches excepted), is said to belong to God, or more accurately to the *kohayn* (priest) who represents God. In order to free the firstborn male from this obligation of dedicating his life to the service of God, it was necessary to redeem him by paying five *shekalim* (today we say five silver dollars) to the *kohayn*. This ceremony is called the *Pidyon Haben*, and must take place when the child is one month old. This tradition is still followed today.

The *Bar / Bat Mitzvah*
An old Native American saying goes: "Tell me, and I'll forget. Show me, and I may not remember. Involve me, and I'll understand."

Jewish children don't "automatically" become recognized as responsible members of the community. They have to study and *earn* the right, through the rite of passage called the *Bar* (or for girls *Bat*) *Mitzvah*. In other words, they have to become involved in the process.

The *Bar* or *Bat Mitzvah* is a big deal. In our Orthodox *shul*, Atereth Zion, when I was growing up, only boys went to *cheder* (Hebrew school). It wasn't considered necessary for girls to go. Sometimes the girls went to Yiddish school. There was one in our neighborhood, but I didn't attend.

Sid remembers very well the many hours he spent after school: "We

had to go to cheder six days a week, including Saturday morning services. Only Friday afternoon was off. I hated it, but I had to do it. Not to have a Bar Mitzvah was out of the question."

Our children only had to go to Hebrew School two afternoons a week, and they complained about that, but neither of them wanted to miss going through this big event, so they just did it. Even with all their complaints, they even continued on with confirmation class for two more years. That was their own decision. We never insisted that they go.

Pat Markman, the same one who got the fish as a baby gift, talked about her Hebrew education in Flatbush: "I wanted to go to Hebrew school, because one of my very good friends was the daughter of the cantor at the synagogue. We always got to sit up in front on the women's side. I was treated like one of her family. It was a Conservative synagogue. My friend lived on my street. We lived in an apartment house, and she lived in a private house. We went to school together, and every Saturday we went to *shul* together and then sat out on her porch. I went to Hebrew school for about two years. I learned to read, but of course, I never understood what I was reading.

The thirteenth year, in many cultures, is considered the beginning of puberty and is celebrated with various initiation rites. In Jewish tradition, it is considered an age when the Jewish boy is old enough to understand and take on the responsibilities of being a member of the Jewish community. It's only in recent years that girls have been allowed to participate in this celebration in Conservative and Reform congregations. After several years of attending Hebrew school in preparation for this event, both of my children looked forward to their special days.

To be honest, things have gotten a little out of hand in this regard. What started out to be only a religious milestone has turned into a five-star spectacular. Basically, the *Bar/Bat Mitzvah* includes reading during the Friday night service, followed by an *oneg shabbat* (refreshments), hosted by the family and congregation. On Saturday morning, the actual ceremony is part of the regular *Shabbat* service. The boy or girl reads from the Torah, demonstrating his or her ability to read the Hebrew passages, and delivers a speech about the meaning of the portion read. The child has his day in the sun, and the family gets to *kvell* over them. *Kvell* is a wonderfully descriptive Yiddish word. It means your heart is bursting with pride over their accomplishment. We *kvell* over our children and grandchildren all the time. We also "*shep nachas*," which means "get a lot of personal satisfaction or pleasure"—almost the same thing.

After the service is over, the parties begin, because this essentially is a great big birthday party. In our children's case, we served a buffet lunch

immediately after the service. My mother and I cooked and baked (we actually made four hundred cheese *blintzes* for Wendi's big day!), and all of our friends also prepared their special dishes, too. The tables were overflowing. It was a feast. We had music, so that everyone could get into a festive mood.

But that wasn't the end of it. In the evening, we had a very fancy dinner dance at a big hotel. Now, just so you don't think that this was out of the ordinary, I must tell you that every child in the *Bar/Bat Mitzvah* class had the same routine. In fact, my friend Michelle and I often joked that we had planned and participated in so many of these affairs that we should write a book on how to have one. Somehow, we never got around to it.

We began the evening with the traditional *Havdallah* service, lighting the braided candle, smelling the sweet spices, and ending with everyone joining in singing *"Shavu-a-tov,"* a wish for a good week, a week of peace. It was sweet and beautiful. The whole affair was like the nicest wedding. In fact, Wendi told me that she always knew she wanted a big wedding because she had such a good time at her *Bat Mitzvah* that she wanted to do it again!

There was another candlelighting ceremony after dinner. Our friend Ron Hoffman had made a beautiful, large candelabra, which held fourteen candles—one for each year and one for good luck. Relatives and special friends were called up, one by one (or sometimes whole families would share the honor), to light a candle as the birthday child said something personal about each one—thanking them for the special part they had played in his or her life. It really was a dramatic and meaningful part of the evening's festivities.

The candelabra itself has become a tradition. Ron's wife, Ilene, told me how this tradition had come about: "My sister, Michelle, wanted some kind of a candle holder to use for her son Ira's *Bar Mitzvah* which was coming up. She mentioned it to Ron, and he just took off. He always liked crafting things out of wood, and this gave him an idea. He glued layered pieces of wood together in the shape of the Star of David, and set candle holders along the top. The base was also shaped like a star. The large stained and finished candelabra drew admiring comments from everyone.

"Both of our children and all the children of our family and close friends have used this very same creation for their candle lighting ceremonies since then—to date sixteen *Bar* or *Bat Mitzvahs*. Michelle even carried it to New Jersey *twice*, so that the two children of our close family friends could use it, too.

"Ron also attached a brass plate for each child with their name and the date they had used it. These name plates are all on one side. Maybe we'll add their children's names to the other side. Wouldn't that be something?" Ron is no longer with us, but this very lovely hand-crafted candelabra with all its many memories is an ongoing reminder of his contribution to so many happy events.

Not all Jewish boys and girls choose to go through the years of study required for the *Bar* or *Bat Mitzvah*. And still others, for one reason or another, may have missed this milestone for reasons beyond their control. So importantly symbolic is this life event, they may often see this as a great loss and regret its absence for years. My son-in-law's father (my *machuten*) was such a person.

Due to poor health and extenuating circumstances, Joe Fast never had the satisfaction of having a *Bar Mitzvah*. Once he had passed his thirteenth year, when other youngsters traditionally go through this age-old ritual, he was always occupied with other concerns—like finishing school, getting married, making a living and raising his family—three sons and one daughter. He always felt that he had missed out on something important.

When his youngest son, Barry (our son-in-law), was preparing for his *Bar Mitzvah*, Joe decided that it was finally time to remedy the situation. He was determined to fulfill this life-long dream along with his son. He discussed his wish with the rabbi, who agreed to help him prepare; but it was decided to have the two ceremonies at different times, so that Barry could have his own special day in the sun. Joe's *Bar Mitzvah* was scheduled in October and Barry's in November.

A few days before Joe's big event, he called all his family and close friends, hoping that they would come to the service and join him for a celebration dinner afterwards. Well, to his dismay, everyone was busy! He was so disappointed, until he discovered why they were all so busy. They were all planning to attend a surprise party for him! His wife, Raya, had secretly made all the arrangements, and he didn't suspect a thing. He was a very proud man that day, because after all those years, he felt that he had finally become an "officially" recognized member of the Jewish community. Better late than never!

Matrilineal Descent
According to Jewish law, the faith is passed on through the mother. I've heard it jokingly said that "Maternity is a fact. Paternity is an assumption." Apparently, this must have been the reasoning behind this law which considers the religion of the mother as the determining factor in

the religion of the child. A child is, therefore, considered Jewish if the mother is Jewish.

Rabbi Mark Schiftan, in a recent High Holy Day sermon, wondered if this should always be the case. He told a story about a young man in Russia who was carried away to serve in the tsar's army. It was customary for young Jewish boys to be required to serve up to twenty-five years. The main purpose of this was to absorb them into the traditional Russian Orthodox religion and make them forget the faith of their fathers.

As he was being dragged away, his parents pleaded with him, "Always remember two things: You are a Jew; and marry a Jewish woman." Well, he tried to keep his faith, but he eventually ended up marrying a non-Jewish woman. They had a son and soon emigrated to America.

The son went to Hebrew school, and was looking forward to his *Bar Mitzvah*. During his preparations and talks with the rabbi, it came out that his mother wasn't Jewish. Everything came to a standstill. He couldn't have a *Bar Mitzvah* because, technically, he wasn't a Jew.

"Here was a child who was the only living link to his father's heritage, a child who was carrying on the faith of his grandparents and their grandparents, but he wasn't considered Jewish. Something like this makes me question the justice of this practice," Rabbi Schiftan said. But that's how it is. And it's not a tradition that most religious leaders will even consider changing, though some Reform and Reconstructionist congregations now recognize patrilineal descent if the child is raised as a Jew.

While fathers may have the dominant role in religious practices, the Jewish family has traditionally centered around the mother. The mother is the one who provides the nourishment and sings the lullabies. The mother is the one who usually dries the tears. The mother is usually the one who cries, "Just wait till you have children of your own!" And she is right. It's usually not until we have children of our own that we finally appreciate our parents.

Victoria Farnsworth wrote: "Not until I became a mother did I understand how much my mother had sacrificed for me. Not until I became a mother did I feel how hurt my mother was when I disobeyed. Not until I became a mother did I know how proud my mother was when I achieved. Not until I became a mother did I realize how much my mother loved me."

Whoever Said that Life Is Fair?

Sometimes something happens that is so monumental that it changes the path of your life forever. These are life-altering events. Giving birth

to your first child certainly comes under this category. But not all these events are happy ones. Divorce, a disaster such as fire, flood or earthquake, or the death of a loved one can violently jolt us out of our peaceful existence. Other such cataclysmic occurrences include accidents or life-threatening illnesses that we ourselves endure or that we experience through a parent, a spouse, a sibling or a child.

Life is funny. We never know what's waiting right around the corner. One minute the sun is shining and life is good. A heartbeat later, all that is familiar can drastically change, altering our perception of everything that comes after.

In the fall of 1981, such an event occured in my family. It was the day before Yom Kippur. Our son had just started his junior year in high school. He woke up a happy, active fifteen-year-old boy, as the day that would change his life forever began. Pushing his bike out of the garage on his way to school, he suddenly heard a snap as his leg inexplicably gave way, dropping him to the cement floor in excrutiating pain. Without a clue as to what had happened to him, he called out for help. As the ambulance carried him to the hospital that morning, we couldn't possibly imagine the news about to hit us in the face.

We weren't in our usual seats that Yom Kippur morning. We did our praying in the waiting room of the Children's Hospital at Stanford. His femur was fractured. A biopsy revealed Ewing's Sarcoma—a rare form of bone cancer. The "C" word! I couldn't even say it, much less believe it. This was a word people only spoke in whispers. Saying it out loud might cause the spirits to get the idea and, God forbid, visit it on us.

In an instant life as we knew it came to an abrupt halt. From that moment on, our world revolved around doctors, hospitals, surgery, treatments, blood tests, scans and endless hours of sitting and waiting.

I've learned many lessons in my life, but none so valuable as those I learned from my own child. My baby. The boy who became a man in the space of a day. I learned about courage and patience and sheer determination. I learned to see my child in a completely different light. While other kids his age were trying to decide what kind of car to buy, he was making life-and-death decisions regarding drugs and treatment schedules, all the while unable to eat, hobbling around on crutches, losing his hair and missing friends who just "didn't know how to react." Every third weekend in the hospital didn't do much for his social life either. But giving up was not in his game plan.

Families react to situations like this in either of two ways. Some cannot handle the extreme stress and fear which invariably occur as reality sets in and daily pressures take their toll, and may find themselves

pulling farther and farther apart. Other families draw closer together, forming a protective shell and drawing strength from one another. Fortunately, the latter was what happened in our case. How could we do less, when our son's will to survive and his courage in the face of such a hellish nightmare showed us how determined he was to beat this "thing" and get on with his life?

When something like this happens, it is easy to lose faith or begin to question one's belief in a God who we perceive as having brought such pain and suffering to an innocent child. Why would a benevolent God punish us in this way? Even if we as parents had done some unforgiveable thing, why take it out on our son who had done nothing to deserve such a terrible ordeal?

Rabbi Harold Kushner, in his book *When Bad Things Happen to Good People,* addressed the feelings he confronted at his own young son's illness and early death. His words gave me a different perspective, which did nothing to eliminate the heartache, but did make it slightly easier to maintain my belief.

Rabbi Kushner concluded that in life things happen at random. We are not being punished for our sins. A vindictive diety does not sit up in heaven and decide who should suffer. He doesn't cause mental retardation or cancer or atrocities such as the Holocaust. "He doesn't send us the problem," Rabbi Kushner said. "He gives us the strength to cope with the problem.

"No one ever promised us a life free from pain and disappointment. The most anyone promised us is that we not be alone in our pain, and that we would be able to draw upon a source outside ourselves for the strength and courage we would need to survive life's tragedies and life's unfairness.

"To the person who asks, 'What good is God? Who needs religion, if these things happen to good people and bad people alike?' I would say, God may not prevent the calamity, but He gives us the strength and perseverance to overcome it. Where else do we get these qualities which we did not have before?"

Friends called and gave comfort with meals and encouragement. We clung to each other and told ourselves that this would surely pass. And we prayed. I never considered myself a religious person. But looking to a higher power for help was ingrained. How many times in my life had I heard my Grandmother say, *"Gott vil helfen.* [God will help]." So I prayed. I don't think I have ever prayed so hard in my life. And Larry's spirit, though often tired, never flagged. He made it! He survived. And his will to survive was so strong that through him, we drew strength.

Something like this can't help but make you rearrange your priorities and appreciate the preciousness of life. It puts things in perspective. Things that once seemed important don't seem quite so important anymore. That Yom Kippur day forever altered the way we were to look at life. We are all more compassionate, more sympathetic, more understanding people than we were before. Not that we wouldn't trade this enlightenment in a second for never having had the experience. But we did have it; and as Rabbi Kushner pointed out, life has to go on from where we are. It's how we handle it that is important. There isn't a day that goes by that I don't count my blessings. And we never fail to celebrate every family member's accomplishment or life event.

Larry's experience also changed his life plan. Having endured countless hours of physical therapy, he came to the conclusion that this was something he could do and do well. He went on to graduate school and became a physical therapist, an empathetic caregiver who's "been there" and knows what pain is all about.

During this terrible period, our daughter, who only weeks before had gone away to school for her first semester of college, called regularly for current updates. It was difficult for her, I know, being so far away and realizing how our attention had suddenly focused on her younger brother, almost to the exclusion of everything else. We did our best to reassure her that we still loved her just as much as ever, but she was definitely aware that she wasn't the one on whom our lives had to be centered at that point in time. She also loved and supported her brother, of course, but it wasn't until she became a mother and felt the helplessness of trying to comfort her own colicky or sick child that she fully understood.

When our children are happy, we are happy; when they accomplish something, we *kvell;* and when they are sad or sick or in pain, we feel their heartache and we feel their pain. Our children are extensions of ourselves.

The Way Up
Most parents tend to have high expectations for their children. We want them to be successful and enjoy quality lives. Early Jewish immigrants were no different. To them, education was the key. Maybe it's because they realized very quickly that the only way to get anywhere in this world is to have a good education. It was the way "up" for immigrants in the early part of the century, and it still is the way "up" for immigrants and underprivileged youngsters today. It was also the way to become assimilated, and our grandparents wanted their children to become real Americans as quickly as possible.

In the old country, it wasn't possible for Jews to obtain higher education in the *shtetlach*. They were lucky to be able to study Hebrew and to go to their own local schools. I was the first one in my family to graduate from a university. That was a very big deal. My father had gone to law school for two years, but then the Depression came along and he had to quit. My children always just *assumed* they would go to college. That's how far we've come.

I also had the good sense to marry a boy who was going to become a doctor. For parents to be able to say, "My son (or son-in-law) the doctor" was quite a feather in their cap. The story comes to mind of the woman who was walking down the street with her two young sons. A passerby asks her how old the boys are. "The doctor is three," she answers, "and the lawyer is two."

My husband, the doctor, likes to tell this joke about the first Jewish president. The first Jewish president calls his mother and says, "Ma, I've been president for six months already. The White House...the most prestigious job there is...and you've never visited me. You've never spent the night. You've never even seen where I live. I'll send Air Force One for you...a limo will pick you up...you'll come and you'll spend the night."

So Ma gets packed, and she's waiting outside for the limo to come and get her, when her neighbor, Bessie, walks by. Bessie says, "Rose, where are you going?" and Rose says, "You know my son, the doctor? I'm going to visit his brother."

Mashinka and the Hiccups
And Other Folk Remedies

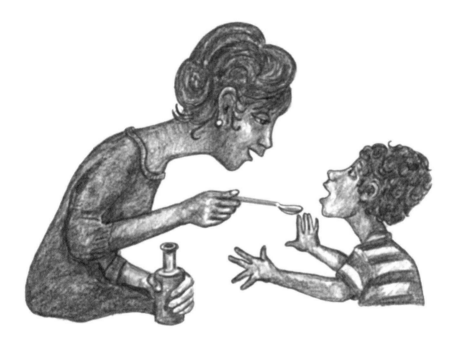

"Your health comes first—you can always hang yourself later!"

—Yiddish saying

EVERYONE LOVES A PARADE, and I always had the best seat in the house. The tailor shop windows faced North Avenue, a main artery and usual path for these spectacles. On VE Day, for instance, the crowds lined the street, waving flags and shouting excitedly at the tops of their lungs. The war in Europe was over, and everybody was out celebrating. Who could forget it? The shop's display windows were in two sections, one on either side of the door, and were raised up on platforms. They were filled with bolts of wool gabardine and headless mannequins wearing suits, shirts and ties which could be purchased or custom ordered. And right smack in the middle of all this, I dragged my chair and watched everything like a queen on a throne, undisturbed by the pulsating throngs outside. This was my favorite place to sit, but Grandpa only allowed me to sit there during a parade.

After the parade was over and the crowds finally dispersed, I got bored and went in back to look at my book. As I sat engrossed on the couch, I realized that I had the hiccups. This didn't concern me particularly. Nobody else was there to hear it, and it didn't interfere with anything I was doing. But, after a while, when they didn't stop, I held my breath and tried to ignore them.

Just then, I heard a "clop—clop—clop." It was Grandpa's cousin, Masha—they always called her "Mashinka" (an affectionate diminutive). I once made the mistake of answering the phone and loudly announcing to my grandmother that it was "Mashinka." She almost bit my head off! "Children don't call grownups by such names," she whispered angrily. "It's not respectful!" How was I to know? That's what they always called her. Her husband was always simply "Gomberg," but *she* was "Mashinka."

I had always been intimidated by this woman anyway, but after that blunder, I was also embarrassed every time I saw her. And there she was…standing over me. She had curly, reddish-orange hair and a white, puckered face peeking around thick glasses which made her eyes look

huge. Her bony fingers were curled around the head of the cane in her hand.

"Where's your *bubbe*?" she asked. "I don't know," I answered. She stood there, looking down at me for a moment, as a stubborn hiccup escaped from my throat. It wouldn't stop, no matter how much I willed it. "What's the matter with your face?" she asked as I struggled to hold my breath. "I…have the…hiccups."

"*Cum, kindt* [come, child], I know exactly what to do," she spoke to me in Yiddish as she took hold of my arm and led me into the kitchen. She picked up a glass from the shelf, went to the sink and ran about an inch of water from the tap. "Here, *mamele*, now hold your breath, pinch your nose, and take only three tiny sips."

It's not easy to hold your breath and drink water at the same time, especially with your nose held shut. I wasn't about to displease her, so I took a deep breath, held my nose with one hand and the glass in the other and swallowed three times.

At that moment, Grandma appeared in the doorway. "*Nu*, what's going on here?" I opened my mouth to tell her and stopped in mid sentence. The hiccups were gone! I waited a minute more, and when they didn't return I spun around and ran back to my book.

I don't know why her remedy worked then, but it's always the first thing I try, even though it usually doesn't work now. I think I was so afraid of this imposing woman that just her presence scared them out of me!

Magical Cures

Of course, holding your breath, sipping water or being scared into gasping for air are well-known tricks people have used to get rid of these troublesome spasms. Breathing into a paper bag or swallowing sugar are some others. But there are many other folk remedies that you may or may not have heard before. Some of them really tickled my funny bone. Just so you realize that I am *not* advocating any of them. They are listed here purely for the sake of preservation (and amusement).

Our Yiddish group is made up of several people who, like myself, had grown up with Yiddish and want to try to refresh our memories. Meeting once a month gives us a chance to practice our conversation and share some old recollections. Sitting around the kitchen table, (where else?) we talked about some of our experiences with some of these old remedies.

Betty Rinsler, a Hebrew School teacher from New York, asked me, "Did your mother ever make you a 'guggle-muggle?'" A what? "A 'guggle-

muggle'" she repeated. "I haven't thought about that for so long, but whenever we had a sore throat, my mother would give us hot milk with sugar or honey, a raw egg and a little bit of whiskey. And she called it a 'guggle-muggle.' It always seemed to help. I wasn't the only one who had this. I've heard other people mention it, too. And we also used mustard plasters. People made their own. It was cheaper than the ones in the store and we used them whenever we had a cold or congestion to make us sweat."

Her husband, Leo Rinsler, a retired engineer also from New York, remembered his father's special remedy: "My father was from Rumania. He told me that as a youngster, if he had a cut, there was a certain spider web—I don't know how they identified that particular one—but they would look around the yard and find one and take it and put it on the cut. It would stop the bleeding and 'cure' the cut. That sounded strange to me, but my father told me that many, many times. I remember asking him when I was a boy, 'Can't we do that here?' He said, 'No, you don't have that special kind of web, from that special kind of spider—from Rumania.' It had to be a Rumanian spider! It worked for him. He said it healed cuts.

"And my mother had some specialties too," Leo said. "For fever and sore throat they would use dried raspberries. A tea was made which you bought in a pharmacy. I might add, since we lived in a predominately Jewish neighborhood, it was called *mulliness*. They made the tea out of the dried raspberries. However, if *mulliness* didn't work, the next step was an enema. Every member of our family had his own black 'bone' for the enema bag. So, as kids, we hated to ever say we were sick.

"Here was the sequence: First you tried *mulliness*, and then came the enema. If those two didn't work, my mother would use *bahnkess* (cupping) for high fever or anything respiratory like colds or congestion. She had her own little satchel with all the cups, and she did it for everybody in the building, except the men.

"We lived in an apartment house. There was a barber in one of the stores downstairs, and he did cupping also, but he charged. My mother did it for free for all the women and children in the building. She had a wand wrapped in cotton. She'd dip it in alcohol and then ignite it to burn the air out of the cup and create the suction. Then she'd quickly turn it upside down on your back. If you had a respiratory problem, you got it on your chest as well. It left round red marks, but it was 'black magic.' It really worked."

Ruth Schwartz, a native of London, piped in, "My aunt had a remedy that sounds very much like Leo's mother's. I once had a boil. She

filled a bottle with hot water, poured the water out and turned the bottle upside down on my boil. It hurt like hell and left a scar, but it did the trick.

"My mother had some tricks, too. She would take a sock, heat up salt in a pan and pour the hot grains into the sock. Then she would put it up to our ear, or whatever ached. It was like a poultice. She also used to rub something called 'Russian tallow' into our backs. It looked like gray lard and had the worst smell. She thought it helped to prevent all kinds of things.

"Also, my mother suffered from very bad migraines. First she would lie down in a darkened room, and then she would have me slice a raw potato. She would lay the potato across her forhead. When it got warm, she sent me back for a fresh one. Vinegar on the temple for a headache was another of her routines.

"But the one we always dreaded came every Friday night, like clock-work. Friday night was bath night, whether we needed it or not. That and a dose of laxative...we were clean—inside and out! My mother would force syrup of figs down me. She would hold my nose and pour it down. I still can't stand figs!"

My mother made me swallow cod liver oil every morning. Talk about smelling bad. Sometimes she put it in my orange juice, thinking it would be easier for me to take. As a result, I had to drink a whole glass of terrible smelling stuff, rather than only a spoonful. And castor oil was a miracle drug. If it was even mentioned, you immediately felt better. Who told them to do those things to us?

Pat Markman, an English teacher from Brooklyn, told us, "My sister told me about this remedy for back pain: Take one pound of golden raisins, put them in a glass bowl and cover them with gin. Let it soak until the liquid is absorbed. Transfer them to a glass jar and then eat exactly nine each day. It's supposed to take away back pain. I tried it. Something was helping, but I don't know if it was that. I just felt better."

Ruth said, "I think it's the gin. Gin comes from the juniper berry, and apparently there's something in this berry that relieves pain. We used to mix gin with water for menstrual cramps. If you drank some a few days before you were due, it would prevent cramps."

We used peppermint water for that. In high school, the nurse gave out that drink on a regular basis. Our gym teacher always told us that exercise was the answer. Somehow I never felt like exercising when I was in pain, but exercise is still recommended for cramps.

Another native New Yorker, Eileen Gitin, asked, "Remember when there was that terrible polio epidemic in the forties? My mother used to

tie bags filled with camphor around our necks. She was so scared that we would get it, and this was her way of protecting us." Oh yes, I remember it well. Things were no different in Chicago. Between the garlic and the camphor, the whole neighborhood had an aroma of its own.

The bags with camphor reminded me of when I had the mumps. My mother tied a long strip of cotton soaked in camphor under my chin. It was put into a long cloth which was tied on top of my head. As if I didn't look funny enough with swollen glands. And, of course, when I had the measles, I had to lie in a dark room all day. The light was said to be damaging to your eyes. These are memories I'd just as soon forget. Thank goodness they have vaccines for these things now. Our children don't have to relive these particular traditions.

A number of vegetables are supposed to be cures for a number of ailments. Some say that corn can cure warts. And if you want another cure for a sore throat, former French teacher Dvora Cogan remembers her grandmother's remedy: "Make a compress with a cabbage leaf covered with honey. But don't eat it, tie it around your neck for several hours. Or you can also rub some lemon juice into your throat or gargle with a mixture of warm water and salt."

Potatoes are supposed to provide some special "cures." Ruth mentioned one of them for migraines. I also heard that after boiling them with their skins on, you can put them on your feet to relieve a cold in the head (honest, I didn't make this up). If you eat the peels (not the ones on your feet, please!), you can, supposedly, even grow hair on your chest, or wherever else you want it. Some people even believe that carrying potatoes in your pocket will prevent rheumatism.

Scrapings from raw potatoes are supposed to heal burns and frostbite. And according to the Irish, water from boiled potatoes is similar to good rubbing alcohol, good for aches and pains and sprains. I've also heard that if you inhale the steam from water boiled with potatoes, this will help clear up congestion and help sore throats.

One more thing: If you lie down and put a compress of grated potatoes over your eyes for twenty minutes, and then wash your face with cool water...like magic the puffiness is supposed to go away. My goodness, and I only thought potatoes were good to eat.

Everybody must have heard about the magical properties of garlic. Our mothers thought that hanging cloves of the stuff around our necks would prevent us from getting sick. People used to think that garlic had supernatural powers. Not only did they think it could cure diseases, but they thought it could also prevent aches and pains, and even help a person develop courage or other beneficial characteristics. And not only

that, but it was sometimes worn as a lucky charm to chase away the old "evil eye." Some still follow the practice of hanging strings of garlic over a doorway as a way of preventing evil spirits from entering. Hung over a fireplace mantel, it's supposed to bring good luck. I personally think garlic around the neck might have been effective as a preventative simply by keeping other people farther away from us.

Onions have also been thought to be effective against a variety of things. Ancient Egyptians believed that the onion represented eternity and guarded against diseases like the plague. Actually, people have believed that both onion and garlic had magical powers to ward off infection and to heal all kinds of things, from earache and nosebleed to snake and insect bites. If you wanted to get rid of a cold, superstition said you were supposed to hang an onion from a string or cord, and give it a knock each time you passed.

Raya Fast, my *machetayneste*, (my son-in-law's mother), has an interesting background. She was born in Baku, but raised in Teheran. While others were fleeing across the ocean, her father decided to escape to the south, which was a little unusual for a Jewish family. There aren't any Jews there anymore, of course, but during the time of the shah, there was actually quite an active, though relatively small, Jewish population in Iran. Raya told me that they used onions for curing all sorts of things there, too. She said that one such folk remedy involved rubbing grated onion into your scalp to cure a cough. Or for a boil, she says, they boiled an onion and tied the inside of it on the affected area with a cloth overnight. Whatever works, I guess.

By the way, this culture-rich word, *machetayneste*, which is pronouced *mah-hah-taynistah* (the first *h* has that back of the throat gutteral sound), is a very descriptive Yiddish word that has no equivalent in English. It describes in one word what it takes four words to say in English. Yiddish really is a colorful language.

A few of my students, recent emigrés from the former Soviet Union, had some memories of their own about onions. Dvora Cogan recalled: "If you were suffering from swelling, they said you should bake an onion and place it directly on the area. If you were suffering from hair loss, you were supposed to grate an onion and rub it into your hair roots. Then you put a cloth around your head and left it on for several hours. Then you washed it out. Another method was to wash your hair with buttermilk and repeat this procedure a few times a week."

Hmmm.... When I grate onions for my potato *latkes*, my hands smell like onions for hours afterwards. I wonder what people must have thought when they came near someone who had used that particular

hair growing method. At least you could cure your cough at the same time.

Gisya Shvarts, a retired bookkeeper from St. Petersburg, told me: "If you have a stuffy nose, grate an onion, and mix it with one half teaspoon of honey and one half teaspoon of cold water. Stir well and put into the nose." I don't think I'll try that one. She had a few other remedies which she remembered for a cold as well. "Put your feet into hot water with mustard. Also you can pour either dry mustard or chili pepper into your stockings, to make you sweat." (Whew!) "Also," she said, "cook an egg and apply the warm egg to the bridge of your nose."

Rem Menshikov, a ship pilot from St. Petersburg, had these helpful hints: "When you have an upset stomach, you need to drink one little glass of vodka with ground pepper. [You can tell he's from Russia.] If you are constipated, you need to eat boiled beet roots."

To get rid of warts, Odessa, born Sonya Slutsker, suggested, "Tie a piece of raw eggplant on the wart and keep it there overnight. Keep doing it until it's gone. It usually takes a couple of weeks." The things I've learned!

Jewish Penicillin

Without a doubt, I left the best for the last. Jewish penicillin. The whole world now knows about our own super-duper, extra-strength magic remedy. Chicken soup. What's the first thing you do when someone you love is under the weather? I don't know about you, but the first thing I do is make a big pot of the miraculous potion. This is a tradition my grandmother and my mother taught me well. It's better than all the tea in China for whatever ails you. Whenever I was even slightly sick, the smell of chicken soup would waft through the house. It even cures the blues. Grandma always knew it was the best medicine, and all of a sudden, doctors are telling us that she was right. (As if we needed them to tell us that!)

Myriad stories and expressions have evolved from chicken soup. Berta Trelisnik, an engineer from Moscow, told me one that came out of a French folk tale about a young man who was in the army.

"The young soldier was hungry, but he only had twenty *sous*. He got an idea. He bought a chicken and went up to a well-kept house. The maid answered the door and he said, 'If you give me ten sous, you can cook my chicken in your soup pot for thirty minutes.' The woman agreed. She cooked the chicken for thirty minutes, and gave the young soldier back his chicken and the ten sous.

"He then went to another house and made the same offer. The

second woman took him up on it and proceeded to cook the chicken in her pot for another thirty minutes. The clever young man left the second house with a cooked chicken and twenty sous back in his pocket. From this story came the expression: 'Two soups from one chicken....' In the American vernacular you would liken it to the expression 'two birds with one stone.'"

Even just the words "chicken soup" conjure up all kinds of images. It has come to represent not only something to eat, but emotional comfort and sustenance as well. People have even written books about "chicken soup for the soul," stories to feed our hearts as well as our bodies. Jewish penicillin.

Well, they may have practiced medicine without a license back then, but they certainly did it with dedication! From my grandmother and my mother I learned the age-old "mother's method" of telling if someone had a fever. Pressing your lips to the forehead of the person in question was practiced long before the advent of the thermometer. Even my husband gets this "kiss," should he look a little pale. And if the lips said, "too hot," something drastic was required. Anything that made you sweat was good, even if it meant a steaming tea kettle next to your face, a mustard plaster on your chest, cupping or a rub-down with some foul smelling gook. The stronger the medicine, the better. Sometimes it took a while just to recover from the treatment!

Oh yes...doctors and house calls. It's been quite a while since doctors actually came to the house. When I was growing up, they still did this. They had to if they wanted to stay in business. It was expected of them. And when they did come, it was often as much a social visit as a professional one. They were usually offered a cup of tea or coffee and something to eat. They were also sometimes expected to deal with heartaches as well as stomach aches.

The wonder is how they were able to practice medicine as well as they did, what with lack of modern diagnostic tests and equipment and given the sometimes ambiguous answers they received. In his book *You Don't Have to Be in Who's Who to Know What's What* (Simon & Shuster, 1979), Sam Levenson described it like this:

"How do you feel?" "How should I feel?" "What hurts you?" "What doesn't hurt me?" "When did it start?" "A better question—when will it end?"

Or, "What's the matter with me? I'm a mess. My head pounds, my eyes flutter, my heart jumps, my stomach gurgles, my ankles swell, my feet burn, and on top of that, I don't feel so good. If I weren't, thank

God, so healthy, I couldn't stand it! Nowadays, the only people who make house calls are burglars!"

Health has always been a major concern, and the sayings and expressions regarding health were (and are) commonplace. I know I'm not the only one who finds herself saying, "Wear it in good health," "Go in good health," "Eat in good health," or, "Use it in good health," when someone gets something new. Also, "Better healthy than wealthy." And people continue to give toasts to life and to health: *"L'chaim"!* ("To life!") or *"Zai gezundt!"* ("Be healthy!")

Another expression I heard all the time as I was growing up was *"Abi gezunt!"* ("As long as you're healthy!") They were wise enough to know that whatever else you had, if you didn't have good health, it wasn't worth anything. *Abi gezunt!*

The Neighborhood

In every neighborhood delicatessen, there was usually a barrel filled with dill pickles....

A woman came in and headed straight for this container. She reached in and pulled out a nice fat pickle. "How much for this pickle?" she asked the proprietor. "A nickel a pickle," he answered.

"Too much," she said, and proceeded to drop the dripping dill back into the barrel as she reached in for another. She fished around for a while and came out with a much smaller one.

"And how much for this pickele?" she asked sweetly. "Also a nickele," came the sweet reply.

•

"There is nothing higher and stronger, more wholesome and good for life than a good memory—especially a memory of childhood."
　　—Dostoevski

THE YEAR 1949 WAS ONE OF MANY CHANGES. That was the year that Grandpa sold his store and went to work as a custom tailor for Maurice L. Rothschild's, a very fine men's haberdashery downtown. This was really a big change. For the first time since the first few years after he came to America, he wasn't his own boss. He bought an apartment building on St. Louis and Pierce, also near North Avenue and within walking distance of Humboldt Park, but on the other side.

This was a residential area, rather than a commercial one like where the shop was. The streets were lined with apartment buildings and single-family houses made mostly of brick or stone. Their building had three floors, with two apartments on each floor. Their apartment was on the first floor, which was actually up half a flight of stairs. The mail boxes were in the small foyer just inside the main entrance. There was a laundry room in the basement, and a coal furnace which Grandpa had to feed every morning and night so that we could have heat. There no longer was an ice man, but now the coal truck made regular stops to pour the black chunks through the basement window to replenish our stock.

I was ten years old when we moved in. Our two doorways faced each other and were the only ones in the building that had *mezzuzah*s. We might be living in a different place, but those little scrolls followed us wherever we lived. A *mezzuzah* symbolized a Jewish home. I always liked the idea that the Ten Commandments were inside, and it meant the people in that house lived according to those laws.

Living right across the hall was not only convenient, but almost like living in the same house. Now I could go home after school, and still pop in whenever I wanted to. (They could also keep an eye on me more easily.) When the television show "Brooklyn Bridge" aired in the mid-nineties, I felt an instant kinship. This was about two young Jewish boys in Brooklyn, living with their parents in the same apartment building as

their grandparents, who played a central part in their lives. Talk about déjà vu! I loved that show. I even loved the theme song. When they took it off the air, I was really dejected. There were so many similarities to my own experiences. New York...Chicago.... It didn't matter.

The apartment on St. Louis is the one where I most vividly recall Grandma *benching licht* (blessing the *Shabbos* candles.) This is also the place where I remember her stretching the lace curtains (the place behind the store didn't have windows) or rolling out the dough for her baked goods. And this is the place where she rubbed the circulation back into my hands and feet when I came shuffling in after school on freezing cold days. Her hands were gentle, but with a surprising strength that reflected a lifetime of physical labor.

It was at these times that the events of my day spilled out in a torrent. She listened sympathetically to my complaints and laughed good naturedly at my attempts at humor. It was during these afternoons, sitting in the warmth of their kitchen with a *glasele tey* (a glass of tea) with preserves, that she gave me the benefit of her wisdom and experience.

Looking back at that period of my life, I know that I was very fortunate to have so much of this special time with my grandparents. As the oldest of my cousins, I am the only one who was lucky enough to have had this privilege. I learned a lot about their values and about their lives during those years. I still remember the advice I heard there.

Their apartment had a living room, dining room, kitchen, two bedrooms and an enclosed sun porch. Compared to the place behind the store, it was a palace! The sun porch, on the corner of the building, was where we spent a lot of time. They would sit and peel their apples with a knife, leaving the peel in one long, unbroken curl. The old sewing machine was out there, along with a settee, a chair and lots of vibrant plants vying for their place in the sun along the windowsills. It was sunny and cheery most of the time. In the spring, the lilac tree outside had glorious blooms whose sweet fragrance wafted in through the open windows. This smell can still trigger images of this room. Here they sat and talked, or read the *Forward* (a Yiddish-language newspaper), or just listened to the radio. I heard stories about life in Russia or other remembered events. This became the talking place. It was pleasant and comfortable.

Their experiences flowed through them and burst out unexpectedly in unguarded moments. They would tell their tales, spilling out life stories and dreams. They drew me in. For a while I was transported....

Even as they traversed the vast ocean on the voyage taking them to freedom, they could not shake the vision of tearful farewells and the life

they left behind. They didn't speak of that life often, but the tales lay dormant, waiting for their memory to be rekindled by some comment or event.

"Did I ever tell you, Rosele, how I had to hide for a week behind the cold cemetery tombstones with only a single crust of bread?" Grandpa asked. "The Cossacks never found me."

"They tied my little brother, Barele, to the back of a train—those devils. Why? Why did they do such a terrible thing?" my grandmother lamented.

"Such things are better forgotten," she was advised. But they couldn't forget them, and they never did. They told tales of a past that was engraved as in stone. Images flashed before Grandma's eyes. "There was a trap door covered by a rug under the table. This is where we hid when the Cossacks came. One day they found us and dragged us from our place. They beat my elder sister. She was never the same."

"Tanta Brana had her scars, too," she remembered. "Making her escape she burrowed under the hay in the corner of the wagon. The soldiers thrust their pitchforks into the dusty pile, searching...probing. She never made a sound, even when the heavy fork plunged into her jaw. That's how she got that scar on her face.

"Tanta Pasee didn't want to leave Papa. He was old and not in good health. 'Who will take care of him if I leave?' she cried. So she and her daughter, Cousin Sally, stayed behind. Until Papa made up his mind that it was time for them to go. One day, he just laid down and died. And that was that!"

Grandma would sit quietly staring ahead, seeing nothing...seeing everything. Then, just as quickly, the memory would recede, and she would continue on with a comment about the news in the world or of somebody's upcoming *simcha*.

They also had a canary called Pinza, named after the famous opera singer Ezio Pinza, and his happy tune serenaded us periodically all day long. In our old place, we too had had a canary. That was the extent of my childhood experience with pets. My Uncle Sam, however, had a beautiful tri-color collie named "Lady." Grandma spoke to Lady in Yiddish, and Lady understood. When Grandma said, "Lady, *gey aveck!*" Lady went away. Even the dog was bilingual.

Our apartment still only had one bedroom, but it did have a dining room, which was adjacent to the living room with no wall between. During the day it was our dining room, but at night it became "my room." There was a sofa bed against one wall, and every night I had to

push aside the table and chairs to make up my bed. It wasn't so *ay-ay-ay,* and there wasn't any privacy, but at least it was separate from my parents' room. It also had a built-in unit with a mirror in the center over a shelf and some drawers. On either side were cabinets with glass doors and shelves, where someone else might have kept dishes, but where I put my *tchotchkees* (little trinkets) and belongings.

This early lack of privacy and place to call my own made me extremely conscious of the importance of providing this "space" for my own children. Except for the first year or so, they always had their own rooms. And, other than checking on them while they were sleeping, I always made an effort to knock on the door, waiting for the response that it was okay to come in.

When I said my living quarters weren't so "ay-ay-ay" it reminded me of an old joke that distinguishes between "ay-ay-ay!" and "oy-oy-oy!" It can be described like this: If you have money, it's "ay-ay-ay!" but if you don't have money, it's "oy-oy-oy!"

"Ay-ay-ay" means hotsy-totsy. But "oy!" all by itself is a very expressive word. Alone, repeated or combined with other words, (*Oy gevalt! Oy Gott! Oy vey iz mir!)*, it can express all human frustrations and agonies. It can also mean "Oh boy!" What other language can express so much with so little?

There was one more thing in "my room" that I cherished—my piano. My mother bought it just after we moved in. It was a Baldwin Acrosonic spinet, made of cherry wood with delicate Queen Anne legs. It became my entertainment and my therapy. I could sit for hours playing and singing along.

I had started taking piano lessons in third grade, using a cardboard keyboard, of all things. On Wednesday afternoons at two o'clock, when the Catholic kids went to their catechism classes, we could take group lessons. There was one piano in the room with a mirror on top, perched at an angle over the keys so that we could see the teacher's hands. All of us sat at tables with our makebelieve pianos, pressing our fingers on the unyielding keys as we pretended to play the music. One by one, we took turns going up to the real piano to try out what we had learned.

Later, I had private lessons with a real piano to work with. Grandma and Grandpa had purchased an old second-hand upright for their living room, and this was where I practiced. I can't say that I enjoyed sitting there for an hour every afternoon, but I will be forever grateful that they made me do it, because the pleasure I have derived from this instrument over my lifetime cannot be calculated.

When we moved to Twentynine Palms, knowing how much I missed it, my mother had my piano shipped out to our quarters on the base. My lovely Acrosonic is still one of my favorite pieces of furniture, and occupies a place of honor in our living room today.

This tradition continues on. My children grew up with music and play not only the piano but other instruments as well. They grew up with it, and they still get a lot of satisfaction through this outlet. When our daughter and son-in-law bought their first home, we bought them a piano as a house gift so that their children could follow the tradition and have the pleasure of growing up with music, too.

Our new neighborhood also had pretty much everything we needed within walking distance. There was a drugstore on the corner, and a movie theater (the Grand) half a block down from that. Next door to the theater was the neighborhood ice cream parlor—the "Slop Shop." (That really was the name!) Upstairs, over one of the other stores, we could visit our dentist or the family doctor.

All the important stores were on North Avenue, and the synagogue, Atereth Zion, an Orthodox *shul* on Spaulding Avenue near Division Street, was a short walk away. The dry cleaners on the corner belonged to Sid's Uncle Seymour. The neighborhood delicatessen was a place where you could see everyone and catch up on current happenings. It was a community. People actually knew each other.

Sid lived on Crystal Street, just a block from Division. He remembers helping to deliver his first "babies" when he was about twelve years old. He had a dog, a pregnant stray named Topsy, that they had picked up on the street. Her first litter of puppies gave him an early experience with the wonder of bringing new life into the world. I guess that thrill carried over. He became an obstetrician and is still getting a thrill from it today. Topsy was a character, and the only dog I ever saw that actually liked being vacuumed. She would sit right in the way, until Sid's mother gave in and gave her a good going over. This dog didn't understand Yiddish, but my mother-in-law used to make fun of Topsy's lack of intelligence by pointing to the door and yelling, "Topsy, go get Lightning out of the corral!" It was a family joke.

When our children were growing up, Sid convinced me that every child needed a dog. Fluffy the guinea pig, the nameless turtle and the tropical fish weren't enough. A dog could help teach our children important lessons about responsibility and taking care of someone besides themselves. They were wonderful companions, and so on. The result was

a Jewish springer spaniel named "Shana Maidel." (Yiddish for "pretty girl.") She was very sweet, but very dumb. She didn't know she was a dog. I'm sure she thought she was a person. We never could teach her even the simplest tricks. But Shana earned her place in our family in a way we could never have anticipated.

When our son Larry was battling his illness, he was at a stage in his life when he was no longer a child, but not yet an adult. As a mother, I longed to take him in my arms, comfort him, taking his pain into myself if I only could. But teenage boys can't allow themselves such a luxury. He was past the age for his mother's cuddling. His father and I could be there for him, and we were. But the warmth and reassurance of a living being could be supplied by only one member of our family: Shana. Her warm brown eyes gazed lovingly and sympathetically into his. She never left his side and was his companion and his warm body of support. He could wrap his arms around her without a thought, and draw her close as the long days and nights crept by. She gave him the one thing that we could not, and we loved her for it. Shana didn't live quite long enough to have her *Bat Mitzvah*, but almost.

Now Larry has a beautiful border collie named Kohai (the Japanese word for "student." Larry is obviously the *sempai*—or teacher). This dog is very smart. He loves to play ball or frisbee, and would gladly chase and bring back his prize all day long if he could. Whenever our "grand-dog" looks at us with his very intelligent-looking expression, I'm always tempted to call out, "Kohai, go get Lightning out of the corral!" If he knew what a corral was, he would probably do it. Not to be left out of the tradition of providing pets for their children, Wendi also has a dog, named Ranger. (After the Power Rangers, of course.) Ranger is also sweet. Don't ask him to bring anything back, however. It's not in his job description. He's a companion. That's good enough. And why not? Kindness to animals (and all living things) is a Jewish tradition, too.

Sid's family also went to Atereth Zion, which was across the street from the Deborah Boys Club. We both belonged to a Young Judea group which met at this *shul*, and afterwards we often stopped at the corner delicatessen, Itzkovits', for a phosphate or soda. That was kind of a tra-dition, too. All the kids hung out there.

We never went to restaurants in those days. It would have been too extravagant. But the deli was something else. A good, lean corned beef sandwich with a kosher pickle and a chocolate phosphate was such a treat. The container with pickels was always on the table so you could help yourself, but you could, of course, buy more—"a nickel a pickle"—

to take home, too. It was a happening place. In years to come, both of us would have gladly given up quite a lot to have one of these meals we remembered—never mind the cholesterol!

I had switched grammar schools when we moved. Instead of walking a mile or riding the el (the elevated train) for five cents in really bad weather to Harriet Beecher Stowe school (which wasn't in a Jewish neighborhood), I now went to Lowell (which was). Sid also went to Lowell, but was a year ahead of me and a big high school freshman by the time we met.

Life's Lessons

Traffic on our neighborhood streets was light, and you could usually see kids playing stick ball or riding their bikes without fear. On the sidewalks, we played hop-scotch, kick-the-can or jacks. In seventh and eighth grades, hanging out on the street corners in the evening was a favorite past time. We mainly just talked, rode our bikes around or played "mumbletypeg" with penknives.

On one occasion, Uncle Sol walked into the sun porch and saw me holding a knife which I had just bought in the army surplus store. He didn't lose his temper. No lectures. He just said, "Why do you have that?" "For protection," I answered, not daring to mention that we actually *played* with such things. "How much did you pay for it?" was his next question. "Three dollars," I told him. He pulled out his wallet, took out three one-dollar bills, put them in my hand and took the knife. "You can get badly hurt with one of these. Don't ever carry one again." And I never did.

Years later, when I was teaching third grade at Koscieuczko School, near Division and Ashland, I encountered a similar situation that made me think of Uncle Sol and my knife.

This was a very poor neighborhood. When I asked one little girl what she had had for lunch that day, she told me, "A slice of bread." "And what else?" I asked her. "Gravy," she said. From that day on, there was always a box of graham crackers on my desk or some other snack for them to have with their milk. And it broke my heart to see some of these youngsters come to school during sub-freezing weather without gloves on their hands or socks on their feet. My mother and I would collect all the warm clothing we could from relatives and friends, and I periodically brought in boxes of sweaters, jackets, stockings, scarves, gloves and boots. I just kept the carton in the cloak room, and let the children go through and take whatever they needed.

The concept of *tzedakah* was one I had grown up with. Grandma's

pushke was only one example of their concern with the welfare of those less fortunate than ourselves. We still practice that principle. It never occurred to me not to do what I could to help, and they knew that I cared about them.

One day, during recess, I saw two boys playing in the schoolyard with something that caught my eye. When the playtime was over and the class came back in, I questioned them about it. What I discovered didn't shock me, but it did catch me off guard. That one afternoon, I confiscated nineteen churchkeys, metal can openers with sharp pointy ends, from the students in my class. They told me that they had to have one if they wanted to be included in their "gang." Third grade!

We talked about it for a while, and I tried to help them understand what friendship really meant, and how you didn't need a weapon to prove that you were a friend. I remembered my grandmother stressing how important it was to *be* a friend in order to *have* a friend. And how important it was to look out for one another. It was a good dialogue. They didn't have to be Jewish to understand the concept of the negative golden rule.

Believe me they weren't bad kids, any more than we were. In fact, if anything they were pretty well behaved and obedient, certainly not trouble-makers. They, like me, were just trying to be like everyone else. And that hasn't changed, even this many years later. Kids still want to be like everyone else. Uncle Sol knew it, and I knew it, too.

Crinolines and Penny Loafers

When it came time to go to high school, our "neighborhood" extended to encompass another area several miles away—Albany Park. We were in Tuley High School district. My mother and uncles had all gone to Tuley. During their school years, it was considered a good school, where most of the Jewish teens went. But by the time we finished grammar school, the neighborhood had changed drastically.

It was still possible then to obtain a permit to go to a school outside your own district. Roosevelt High School, on Kimball and Wilson, was reputed to be one of the best in the city. It had a high scholastic rating; and not only that, but it was ninety-nine and forty-four one hundredths percent Jewish. Five students from my class later became rabbis. On the Jewish holidays, they might as well have closed the place down. It was deserted...only a few teachers and students showed up.

Going to Roosevelt meant taking two buses, with a transfer at Logan Square, and about a forty-five minute ride, depending on the weather and traffic. But there was no question—it was worth it.

Marilyn Schechter Phillips, in our fortieth high school reunion book, considered the changes that our class had witnessed: "We were born before television, before penicillin, before polio shots, frozen foods, Xerox, plastic, contact lenses, Frisbees and the pill. In our time, closets were for clothes, not for coming out of. Bunnies were small rabbits, and rabbits were not Volkswagens.... We were before radar, credit cards and ball point pens; before pantyhose, dishwashers, clothes dryers, electric blankets, air conditioners, drip-dry clothes and before man walked on the moon. We got married first and *then* lived together. How quaint can you be?

"In our day, grass was mowed, coke was a cold drink, and pot was something you cooked in. Rock music was a grandmother's lullaby; aids were helpers in the principal's office, and gay meant happy.... No wonder we are so confused, and there is such a generation gap today!" (I can feel heads shaking up and down here!)

Since we girls didn't have the honor of celebrating the traditional *Bar Mitzvah* ceremony that the boys reveled in, we made the most of one of our own...the sweet sixteen luncheon. These were usually held in nice restaurants or hotels and were our coming-of-age symbol. We dressed up like young ladies, and there were always flowers and (I'm sorry to say) cigarettes on the tables. Nobody knew about the hazards; it was just a grown-up thing to do. Only girls, and sometimes their mothers, were included. This was strictly a female affair. But it, too, was only a really nice birthday party after all, with presents and songs and candles on the cake.

The friends we made in high school, and the things we did during that time, probably had as much to do with the way we turned out as anything else in our lives. For one thing, we learned about "style." While Levi's and blouses or sweaters were the usual costume during grammar school days (and our kids thought they invented 501s!), in high school clothes took on much more importance. In the 50s, casual was not in. Cashmere sweaters with Peter Pan collars, poodle skirts with crinolines and penny loafers or saddle shoes and bobby socks were. Pony tails, friendship rings and club jackets were part of the scene. The male students wore crewcuts or duck cuts, sweaters and shirts with collars—no tee shirts, at least not in school. Both guys and girls wore their silver *mezzuzahs* or gold stars around their necks.

I watched Sid go from five-foot-three to six-foot-two-and-a-half in a period of three years. I always felt so sorry for the boys; their arms and legs always seemed to be so far ahead of the rest of their bodies. Eventually, of course, everything caught up, and all was normal. At Roosevelt

everybody belonged to a club. We had two main girl "social" clubs in my year (every year had it's own), the ADOs and the Zeta Phis. Ours was the ADOs. Can't tell you what it means...it was a secret then and shall remain so. The guys had the Jovens and the Funny Fellows.

Not only were these the people that we had lunch with and spent all our free time with, but they were our family away from home. There were also inter-club competitions, like volleyball games after club meetings at the Max Straus Center (the "J" some people called it), or talent contests at school dances and, of course, pajama parties at regular intervals, where we acted crazy and generally had a ball.

Over the years, some of these old friends who still live in Chicago have managed to stay in touch with each other. My life has taken me far away, but when I do have the opportunity of corresponding or talking to any of these people, it's interesting how comfortable this can still feel. Of course, not having seen them in so long, they will forever look the same in my mind. I'm sure we wouldn't recognize each other on the street today. I know I don't look at all like I did then, but in my mind we're still sweet sixteen—and that's okay, too.

"On the Doorpost of Thy House"

I talked about the *mezzuzah*s we wore around our necks in high school. Those were sometimes considered "good luck charms" or merely nice pieces of jewelry that showed off our Jewish identity. The ones on our doorposts were more symbolic. When I said that I always thought they contained the Ten Commandments, I wasn't far from wrong. Actually, the *mezzuzah* is a piece of parchment, inscribed with a passage from Deuteronomy (6:4-9) which begins with the *Shema*, the holy prayer which is part of every Jewish religious service. It is rolled up and inserted in a case, which is usually decorative and attached to the doorpost. We do this because our religious doctrine states, "and thou shalt write them upon the doorposts of thy house and upon thy gates." Usually, it's hung on the right side of the doorway in a slanted position, so that you have to reach up to touch it upon entering or leaving the house. We would touch it with our fingertips, and then bring our fingers to our lips and kiss them.

There was always a *mezzuzah* on every door of every house we ever lived in. Kissing it on entering or leaving was a ritual. Even when we don't remember to do it, we know it's there and are aware of its symbolism.

When Rabbi Gitin speaks to non-Jewish groups, he says his listeners always seem to be intrigued by this custom. He tells them that

having this *mezzuzah* on their doorway means that the people who live in the house have to be good to one another. If parents and children and husbands and wives are nice to each other, God will bless them; but if they're not, He will go away from them. After telling this story to one PTA group, he says twenty-four Christian women immediately rushed up and asked him where they could buy one.

He also recalled that when he moved out of his old house, they forgot to take the *mezzuzah* off their door. When he went back to get it, the new occupant asked what it was. Once he explained, the man pleaded with him to please leave it and he would gladly buy him another one. "This isn't so surprising," he says. "The essence of Judaism is about loving each other. And this is what the *mezzuzah* represents. By loving each other, that's how you show your love of God."

Flashbacks

Some of my friends talked about their old neighborhoods and the things they remember from their pasts in New York, California, Massachusetts, England and Israel:

Vivian Herman: "I remember the ice man, too. We had a card that you put in the window, and whatever you wanted him to deliver, you'd tell on the card—twenty-five cents or a dime's worth or whatever. We had a shed at that time where we used to play. It was way in the back, and one day we were playing house there. We didn't think he would see it. I put the sign up, and the next thing we knew, he was there—knocking on the door with the ice."

Ruth Schwartz: "In London, the men would come to deliver coal or coke. They wore leather hoods, with long capes that reached all the way down to their rear ends. These capes were filled with these black chunks. That's how they carried them."

Vivian: "We had coal delivered, too. Only they brought it with a big truck. My friend's grandmother spoke very little English. The man would come with the truck, and she would tell him "*Shitt-arein* here, *shitt-arein* here!" We always thought that was hilarious."

"*Shitt-arein*" is probably best associated with cooking and food. It roughly translates to "throw in" and means so much of this or a little bit of that. Cooking "by the eye." That's how our grandmothers cooked. They didn't have recipes. They "*shitt-arein.*"

Evelyn Turkus could hardly stop laughing as she recalled her own embarrassing incident regarding this Yiddish expression:

"This goes back about twenty-five years. It was here in California. My friend's mother, who was a caterer in Freeport, New York, a very

nice area of Long Island, came out for a visit. My friend was giving a big party, and her mother made all these wonderful pastries for the party.

"I was talking to her and raving about how absolutely delicious they were. I innocently asked her, 'Are you one of those people who cooks with recipes, or do you *shitt-arein*?' She looked at me with the most shocked expression on her face and walked out of the room. A minute later, her daughter came over and said, 'My mother didn't understand what you said. She thought you seemed like such a nice person. Why would you say something like that?'

"I couldn't believe that a Jewish woman from New York wouldn't know what that meant!"

Growing up in Los Angeles was quite a different scene. Addie Kopp recalls: "It was easy to grow up Jewish in Los Angeles in the the 30s and 40s because it was a much smaller community then. People knew each other. It was nice—you had little groups from school and little groups from temple, and you played in the parks. You could always go down to the beach. We had no regular youth groups at our temple—nothing like that. Our school was fifty-fifty, Jewish and non-Jewish.

"My mother always started her day in a very formal way…getting up, getting dressed in the morning, getting ready for the day. I rarely saw either my mother or my grandmother go around the house in a robe. That meant that they were either sick or going to bed. I wouldn't have dreamed of doing it any differently. My grandmother, who lived with us, was born in Montreal. She didn't speak Yiddish, but she was still very traditional. She was the one who took my sister and me to services on Saturday mornings. I used to love to go with her.

"And Grandma was a very frugal woman. She would send us to the store with a dollar and a list of three things to buy. We had to tell her exactly what we spent and account for every penny. She used to say, 'There are times when a dollar has to be a nickel, and there are times when a nickel has to be a dollar, and you need to know the difference!' She would occasionally go and do something really extravagant, but she always validated herself. She knew when that was okay and when it wasn't."

Things were very different for Cantor Itzhak Emanuel. His childhood neighborhood wasn't one of buildings and stores and Saturday afternoons at the movies. He lived in a very different world. But even there, in that faraway place, we are reminded of how Jews in every age and in every country carried their traditions with them wherever they might be.

In fact, many of the traditions we celebrate in America began in this very place....

"I came from an interesting family," Cantor Emanuel recalled. "My father and my uncle married two sisters. My aunt and uncle had nine children, and my parents had three. Altogether, we were 'the twelve Emanuels.' My family had come to Israel from Spain in 1830. Seven generations have lived in Israel since then.

"When I was a child we left Jerusalem for the 'west.' We became pioneers. What was the west? It was the dunes south of Tel Aviv. It was called Holon. Today it is a city of half a million, but in those days it was just sand dunes. My father and my uncle were only the third family to build a house there. It was a very small house. One bedroom for our family, and another two bedrooms for my aunt and uncle and their nine children. I'm not talking about a bedroom like in America. Just a room—a little room, and a kitchen.

"The most beautiful holiday I remember was Passover and our *seders*. All of us in that little house. We read the entire *Haggadah*. We always waited for the end, and then we sang all the songs, and we never stopped singing. That small house was full of love and the beauty of the holiday. The Sabbath, too, was a joyous occasion. We were a close family in more ways than one.

"The house was surrounded by orange groves. It was next to an Arab village and near a lake. And this was my childhood atmosphere. We had a beautiful relationship with our Arab neighbors. My best friend was an Arab Bedouin shepherd. I saved his life, and he saved mine—many times.

"After the 1948 War of Independence, I don't know what happened. They had to leave their house. They had to leave their village. We had to leave our house. It became a frontier of the fighting. But what I really remember was the beautiful friendship that we had in our childhood. We played football together; we helped take care of the sheep together; when I came home from school, I taught him geography and calculus—everything I had learned.

"We lived a very simple life. But it was a very rich life, filled with values—love of our family and love of other people. That is why I love people so much today and have my whole life."

Cantor Emanuel's childhood environment wasn't a "neighborhood" in the conventional sense. But it was a community. A community of people who knew each other and cared about each other.

In the suburb of San Jose, where we live now, there really aren't

neighborhoods, in the sense of "community." Kids do play with other children who live near them, but our lifestyle is so different. In my grandparents' neighborhood, we always knew that no matter what happened, the family was there. The neighborhood itself was a kind of family, too. It was also a community where people knew each other and cared about each other. Today we barely know our neighbors at all. If we do know them, we only know them superficially. And our families are spread out all over the world.

In our modern world, we don't have to stay around our homes anymore. We work. We travel. We can go around the world in less time than it took Grandma to make her *challah*. In California, nobody walks anywhere, except for planned exercise. Our automobiles carry us wherever we want to go. I wouldn't dream of walking to the supermarket. How in the world would I carry all those bags, filled with exotic specialties from every country imaginable?

But some things never change wherever we live.... Our family is still the most important thing. We celebrate our holidays in traditional ways. We try to live our lives with the values we have been taught. And our *mezzuzah* is still on the front doorpost.

Bubbe Meises

Don't ask! Just chew!

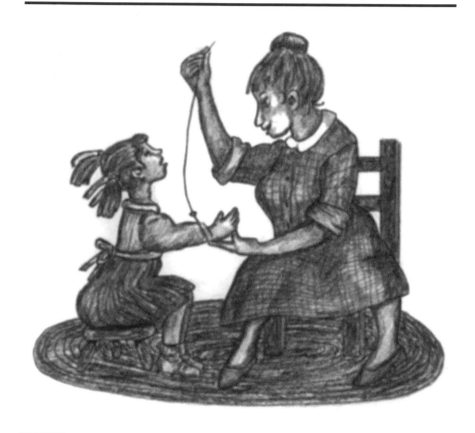

Bubbe meises and old habits
Are the keys to olden times,
So our children and their offspring
Understand their elders' minds.

How they worked and how they studied
All the things to say and do;
How they lived and loved and married,
As their children thrived and grew.

They taught important lessons
Like respect and taking care
To safeguard all life's blessings,
And of evil things—beware!

To believe in God, and never—
Whatever else you do—
Forget the old, wise stories,
And they'll take good care of you.

> *—Esfir Dynkina, 2/9/97*
> *(translated from Russian by Inna Eydus,*
> *with poetic assistance by Rosalie Sogolow)*

GRANDMA DIPPED THE COMB into a glass of water and painstakingly divided my hair into sections, which she twirled round and round into long, fat curls. I wasn't crazy about the process—or the result—but I supposed that if it was good enough for Shirley Temple, then it was good enough for me.

"What's this—a loose button? Here, darling, chew on this piece of thread while I sew it back on for you." "Chew on thread! Why?" "So your brains shouldn't get sewn together! Don't ask! Just chew!" What a thought. Could such a thing really happen? So silly, but how could you take a chance on something like that? To this day, I somewhat sheepishly stick a piece of thread between my teeth whenever I need to sew something on myself. Of course, I don't believe it—but, you know....

Bubbe is from the Russian word *babushka* (accent on the *bab*), and is an affectionate name for grandmother. A *meise* (pronounced *my-sah*) is a story. So *bubbe meise* has come to mean "old wives' tale" or some silly nonsense. *Bubbe meises* have been around for a long time, and my grandmother's house was no exception. If they weren't spoken with such seriousness, you could almost laugh. Here are a few other ones from the collective memories of my friends and myself:

> If you stand out in the rain, you'll grow.
> Don't step over anyone, or you'll stunt their growth.
> Salt in your pocket will protect like a charm.
> If you break a dish with your right arm, it means good luck.
> If you kiss across a threshold, it's good-bye and not good night.
> Wash your hands when you come home from a funeral, or you'll bring death into the house.
> Don't hand a knife to someone, or you're sure to have a fight. (If you do give someone something sharp, ask for a penny in return.)

Don't put shoes on a table, it'll bring bad luck.

If you sneeze while telling a story, that means you're speaking the truth.

If you sneeze exactly at the same time that someone is talking about death or illness, pull your ear lobe down to get rid of the evil spirit.

Place a red ribbon on an infant's crib or carriage to keep him safe from harm. (Some say to put a red ribbon on the baby's wrist.)

Wearing an article of clothing inside out means a surprise is in store.

If you spill salt, pour some over your left shoulder, or you'll have bad luck.

A piece of thread on your outer garment means you will receive a letter.

Dropping silverware means company is coming: a spoon is a child, a fork is a woman, and a knife is a man.

If you cut a cloth too short, your memory's going to go. (So that's the reason!)

If your nose itches, you're going to kiss a fool.

If your palm itches, you're going to get some money.

If your ears are burning, somebody's talking about you.

If you sing before breakfast—you'll cry before lunch.

And whatever you do, don't tempt the "evil eye"; just say "pooh, pooh, pooh!"

They had an explanation for just about everything. If they saw someone with a strange birthmark on his face (maybe in the shape of a paw), they would nod knowingly and pronounce: "The mama must've seen a *moyz* (a mouse) when she was pregnant, put her hand up to her cheek, and yelled *'oy moyz!'* and that's why the baby got such a mark." Of course. Why not? How else could such a thing have happened?

Bubbe meises and their cousins, superstitions, have been with man from his earliest days. Many old superstitions revolved around the fear of the "evil eye." Virtually all people and religions had uneasy fears about evil spirits. So mothers might drop a bit of salt into a child's pocket for protection, and architects design buildings without a thirteenth floor. Rationally, we say we don't believe in such things, but just in case....

Neil Simon, in his book *Rewrites*, says: "I was not overly religious at all, but your culture, by osmosis, or what you hear around the dinner table as a boy, brands fears and superstitions into your mind forever."

Sylvia Metz, president of the Addison-Penzac Jewish Community Center board, was born and raised in New York. She had a heart-wrenching example of how ingrained these beliefs can be. "Before my son was born, my mother made me put a red ribbon in my hospital bag so that I could immediately tie it around his wrist to keep him safe from harm. She was deadly serious about this. She wouldn't let me forget that with my previous pregnancy, I had ignored her advice and fixed up the baby's room before the birth. When I lost that child, she was convinced that breaking this taboo had something to do with it."

And there were lots of other precautions that mothers used to take to keep the evil eye away from their offspring as they were growing up. Cantor Emanuel smiled as he remembered one of his mother's habits:

"When I was a child, I always used to find in my pockets little blue stones. My mother put them in there to protect me from harm."

Not all superstitions have sinister connotations. Alan Engel told me about a ritual his grandmother asked of their family, which I think is actually kind of nice:

"We think my grandmother, Chana, is somewhere in her late eighties, though no one knows for sure her exact age. She was born in Belorussia, sometime during the first decade of the 1900s. During World War II, the family went east to the Urals, and after the war, they settled in Vilnius with their three daughters. In 1957, they were able to leave Lithuania for Warsaw, where they lived for one year before emigrating to Israel, where my parents met and were married. In 1960, they came to America, first to Brooklyn and later to California, where my grandmother has been living with my parents since Grandpa died.

"My grandmother is one of the sweetest, most cheerful and energetic ladies I know. She loves nothing more than to be with people. She loves to be included and will go anywhere at the drop of a hat. But Grandmother has always had one requirement upon which she has staunchly insisted. Anytime there was to be an important trip, and on all holidays and special occasions, she asks the family to gather and sit together for at least two minutes before leaving the house. This is her special way of asking God to bless her family and keep them safe from harm. This, she thoroughly believes, is a good luck tradition.

"And on *Shabbos*, she has one other ritual she observes to help keep the family safe. When she *benches licht*, she always adds (in Yiddish) 'Good angels to the light; bad angels go away from the light!' This is her custom, and I always remember her doing it."

There is an old Jewish belief that before the Sabbath angels would

come down to earth to make sure everything was ready for this holy day. When Alan's grandmother said her special prayer as she lit her candles, this was probably what she had in mind.

There are many Jewish superstitions involving numbers. One is that it is unlucky to actually count the number of people in a room. You had to pretend that you weren't doing it, even while you were doing just that. "Not one, not two, not three…etc." It's also considered bad luck to tell one's age. Instead of saying you were, for instance, sixty-two, you were supposed to add, "*biz hundert tsvanzig* [till one hundred twenty]." When wishing someone long life or talking about long life, the number one hundred twenty years is used because, according to the Bible, this was the age that Moses attained.

My father-in-law had a habit which we always kidded him about. As soon as he passed a birthday, instead of saying how old he was at the time, he would always say, "On my next birthday, I'll be ___" (one year older!) as if willing himself to live to see one more year. My grandmother would have added, "*Alevei!*" (God willing!) Actually, this expression was used all the time. "God willing, we'll see you at the wedding." Or "God willing, he'll pass the test." We should live and be well…God willing. I still use this expression often. It just pops out.

Ruth Schwartz remembered a variation of this. "If you ever pick up a letter from my family, you would see several PG or TG's scattered throughout. We were so accustomed to saying, 'Please God' or 'Thank God' that we just took to abbreviating these to PG and TG."

Ruth told us some other *meises* from her youth in London: "If you drop a glove, never pick it up yourself; ask someone else to pick it up for you. When they do, *do not* say 'thank you' or you'll have bad luck. Also, when you leave a house, you're supposed to turn a glass upside down to keep away the evil eye. And another thing you're not supposed to do is stand behind a baby, or they might become crosseyed."

The number thirteen has always had bad connotations with all cultures. Perfectly rational people, who seem normal in every other way, will avoid doing anything important on Friday the thirteenth.

I was told that in Russia, Monday the thirteenth—not Friday—is considered to be their unlucky day. Manya Reyzis, from Odessa, had this to say about that:

"The number thirteen is supposed to be a *bad* number. In Russia, this number is called 'devil's dozen.' For me the number thirteen is the *best* number, because I gave birth to my son on that day." It's all the way you look at it.

As irrational or illogical as they might seem, there is usually some reason or explanation for these practices. No matter how enlightened we are, the fact is, at some time or other, everybody—no matter what his education or place in life—has been affected by these habits or customs, even if they don't realize it.

For example, have you ever wondered why people say, "God bless you," when someone sneezes? This habit is so ingrained in me that I will automatically stop whatever I am doing or saying to utter this benediction, if even a perfect stranger lets out a sneeze. It was thought in olden times that whenever someone coughed or sneezed, part of his soul could escape through that person's open lips along with the rush of air. At the same time, evil spirits might slip in and fill up the space. So to ward off these bad forces, it was customary to say, "God bless you" at once. Some people say, "*Gezundheit!* [Be healthy!]" instead. Needless to say, that is not the reason I hasten to form these words. I'm just a creature of habit, I'm afraid. I do it without blinking an eye.

Have you ever seen someone spill salt and immediately throw a few grains over his shoulder? From the beginning of civilization, salt was important in the daily diet. It was considered a holy substance and a necessity at every table. It is still traditional to bring bread and salt to a new home in many places around the world.

There are many references to salt in our everyday speech. We speak of people not being "worth their salt," and the word "salary" comes from the Roman soldiers being paid either with lumps of salt or an allowance to buy salt. Because salt purifies, it became a symbol of incorruptability.

The Greek philospher Pythagorus saw in it an emblem of justice that belonged on every table. To upset salt was seen as a forewarning of an injustice. Spilling salt has long been considered a sign of bad luck, which could be remedied by tossing a pinch of it over the left shoulder with the right hand. Salt is also a preservative, which made it a symbol of immortality, as well as lasting friendship. In many countries salt was put into coffins as a reminder of the soul's survival.

Man has always felt fear of losing something precious, that spirits might be jealous and try to rob us of our good fortune. Speaking of good luck almost seems too much of a challenge—tempting fate, so to speak. This fear gave rise to precautionary measures. One of these is the custom of touching wood. "He's doing well. Knock on wood!"

Interestingly, this expression appears to have originated in reference to the cross of Christ. Churches all over the world treasure pieces of wood, which they believe were once part of the true cross. To touch them would assure inner peace and happiness. Touching any kind of

wood in memory of the cross was an obvious further development of this custom. The church was also a place of sanctuary. If a pursued person was able to reach and touch the wooden door, he was protected from harm.

Another explanation goes back even further, to a time when people lived in wooden huts. Those who were prosperous were afraid to talk about their good fortune, in case evil spirits should envy their luck and try to take it away. So when discussing these things, they knocked loudly on the wooden walls, in the hope that the noise would prevent their words from being overheard.

That this custom has become such a commonly used gesture in the lexicon of Jewish conversation is an ironic twist. If no wood is around, I just knock on my head.

And God forbid you should break a mirror! This superstition is so old that it actually goes back to a time before mirrors *could* be broken, because they were made of metal—or, before that, water. The first mirrors were reflections people saw in lakes and pools. People looked into them to see not only their images, but their fate. This reflection was interpreted to show what the future had in store. If the image appeared distorted or broken, it was taken as a bad sign of coming disaster. Unfortunately, all it took was a pebble to disturb the calm image.

Later, other beliefs made breaking a mirror even more ominous. Centuries ago man imagined that what he saw was actually his soul. If the image shattered, so did the very substance of his being. He was afraid that by losing his soul in the broken glass, he was bound to die. There were other unfortunate associations, also. There was a belief that injury to the reflection would actually affect the person whose image was shown, or that the wounded spirit, living in the mirror, would seek vengeance on the offender or his family.

Chinese people used to attach mirrors over idols kept in their houses. They were believed to be a potent power against evil spirits, who would be frightened away after seeing themselves reflected. If the mirror should be broken, the powers were lost, and the home vulnerable to their malevolence.

Even though we use all sorts of mirrors to decorate our homes, we somehow can't help but cringe should a crack appear. Breaking of any glass usually brings a *"mazel tov"* from anyone around. Another habit, I guess.

Many rituals and superstitions revolve around mirrors because they are regarded as the border between our world and the unknown universe. One of the most widely held superstitions is that coming back

into a home to retrieve a forgotten object would bring danger in the resumed journey, unless the forgetful one glances into a mirror before going out again. Some even say that you should stick out your tongue or make a face to scare off evil spirits who might be lurking behind the glass.

This has its origin in an ancient belief that a guardian angel follows us as we leave the house, and that if we return, the angel would be left outside waiting and unable to protect us from harm.

And, like mirrors, thresholds, too, were considered dwelling places for spirits. The practice of carrying the bride over the threshold has already been mentioned. Shaking hands or kissing over a threshold is also considered bad luck for this reason.

Superstitions abide in every walk of life and all levels of society—even in space. When the Russian space station *Mir* and the U.S. space shuttle *Atlantis* linked up while in orbit in June of 1995, *Mir* commander Vladimir Dezhurov hesitated for several seconds after *Atlantis* comander Robert I. Gibson extended his hand in greeting through the portal linking the two spacecrafts. Dezhurev eventually threw caution to the winds and shook the hand of his counterpart, even though he was obviously troubled momentarily by the ancient taboo.

There are many other superstitions that affect us every day. They pertain to weddings, funerals, babies, health and anything else you can think of. Every culture has it's own *mishegoss* (foolishess). One of my students from Odessa, Minna Vaistikh, told me about a *bubbe meise* pertaining to pregnancy in her country.

"When I was a student, I had a very close friend named Gala. She married at a young age and soon became pregnant. Once, her grandmother told us that there was a belief that if anyone failed to satisfy the wish of a pregnant woman, all of that person's things would be eaten by mice.

"Of course, we thought it was foolish, but Gala and I decided to take advantage of this little superstition anyway. When we entered a lecture hall and saw that all the good seats were taken, we went up to a classmate in the first row and told her that she should give Gala her seat or a mouse would eat her dress. Of course, she got up. This always got Gala the best seat—and I sat next to her!"

Minna's story, though silly, is just one example of the many omens and superstitions which fill Russian folklore. Another one involves the way you get out of bed in the morning. Touching the floor with the right foot first is supposed to ward off a day filled with troubles. And if

you have a bad dream, you have to get rid of it first thing by retelling it to running water from the faucet so that it goes down the drain.

Even Naina Yeltsin let her hair grow out during her husband's, Russian President Boris Yeltsin's, heart surgery and recovery period, apparently abiding by the old fear that contact with a scissors is bad luck when a loved one's health is in jeopardy. Believers pointed out that after she went to have her hair cut, her husband became ill with pneumonia and had to be hospitalized once again.

And one more mysterious custom that Carol Gopin, Executive Director of Jewish Family Service of Santa Clara County, laughingly recalled is the old tradition of a mother slapping her daughter's face when she begins menstruating for the first time. Office manager Marsha Geeser shook her head as she remembered this one. "My mother never did that to me," Marsha said, "but my good friend's mother did it to her. She was so surprised when her mother quickly slapped her on both cheeks. Something about making the blood return to the head, I think."

Teaching assistant Diane Calmis thought this was done so that the maturing girl should have rosy cheeks. Faigie Rosen, Director of Senior Services at the Addison-Penzac Jewish Community Center, was born in Canada, and said that this custom was performed there, too. She remembered it as being done for good luck.... A preventative against the evil eye, so that this event wouldn't be a bad omen for the emerging woman.

Whatever the reason, this too was just another one of those inexplicable bubbe meises that our mothers carried over from their own pasts.

The Magic Phrase: *Kayn Aynhoreh*

In order to ward off all of these evil spirts, Jews began to utter a magic phrase: *"kayn aynhoreh."* (Keep away the evil eye.) When my grandmother pronounced it, as she often did, it came out sounding like "ken-ahora." "He's such a beautiful child, *kayn aynhoreh* [Thank God]...." "We should only live that long, *kayn aynhoreh!*" This was often accompanied by the imaginary act of spitting three times, "pooh, pooh, pooh!"

Did it work? Who knows? Don't ask!

The Holidays

When asked if he could explain Judaism while standing on one foot, Hillel replied:

"That which is hurtful to you, do not do unto your neighbor. All the rest is commentary."

•

"The Torah is the tree of life to those who hold fast to it, and all who cling to it find happiness."

—Proverbs 3:18

I T HAS ALWAYS BEEN A CHALLENGE to keep the ancient faith, practice and traditions of our people alive and yet in line with contemporary life. An old Hassidic tale captures the feeling about the loss of these traditions as customs give way to change.

When the Ba'al Shem Tov, a revered rabbi who founded the Hassidic movement, had a difficult task before him, he would go to a certain place in the woods, light a fire and meditate in prayer, and what he had set out to perform was done. A generation later, another rabbi was faced with the same task. He would go to the same place in the woods and say: "We can no longer light the fire, but we can still speak the prayer." And what he wanted done became reality. Again, a generation later still another rabbi had to perform this task. He too went into the woods and said: "We can no longer light the fire, nor can we recite the prayer; but we do know the place in the woods to which it all belongs—and this must suffice." And it did. But when another generation had passed and one more rabbi was called upon to perform the task, he sat down in his chair in his house of worship and said: "We cannot light the fire, we cannot speak the prayers, and we do not know the place in the woods, but we can still tell the story of how it was done—and this must suffice." And his result was the same as all the others who went before him.

As our generations pass, we may no longer know the exact rites or the place in the woods, but we can still tell the story.

The High Holy Days

As the sun's rays slid under the windowshade on Rosh Hashana morning, I was awakened by a tinkling of dishes and the smell of freshly baked honey cake coming out of the oven. I realized with a start that I wasn't in my own bed at home. Mama let me sleep at Grandma and Grandpa's house so that I could go to services with them early this morning. We put on our good clothes and hurriedly ate breakfast so we wouldn't be late.

I liked walking to *shul* with my grandparents and felt very grown up in the new dress that Grandma had just finished embroidering with pretty blue flowers. It was exciting to walk alone with them on this special day—without my mother and father, who wouldn't come for a while yet. Grandpa carried his zippered velvet bag with the gold Star of David on the front, which held his *yarmulke* and *tallis* (prayer shawl). He let me carry his prayer book as I hurried to keep up.

As we passed through the tall, richly polished and carved wooden doors of the synagogue, Grandpa took his book, gave me a hug and whispered, "You have to go upstairs now, *mamele*. Go with Bubbe and be a good girl." He turned and walked into the sanctuary where he made his way to his usual seat near the front. Uncle Sam and Uncle Sol took their places next to him a few minutes later. Their long, fringed prayer shawls enveloped them as they turned to greet familiar faces around them. Some of the men were wearing hats instead of *yarmulkes*, but all heads were covered. The *chazzen* (cantor) was already chanting. The service had begun.

How disappointing to have to go up with the ladies and the girls! All the action was taking place down below. Men and women had to sit separately in our Orthodox *shul*. It didn't seem fair. But I followed Grandma up the stairs and took my seat on the hard wooden bench. She smiled and moved closer to share her book with me, though she knew I couldn't read the strange symbols on the page. Not having had the privilege of going to *cheder* (Hebrew School), which only boys could do, I didn't understand a word of Hebrew, but the melodies and prayers were familiar, nonetheless. I recited by rote and hummed along when the songs were sung.

Because the chanting made no sense to me, I spent my time looking around a lot. Above the congregation, suspended from the high-domed ceiling, dangled an enormous chandelier, its multitude of flame-shaped bulbs sparkling on the golden curlicues of its outstretched arms, sending shimmers of light to the far corners of the sanctuary, where they met fingers of shadow and formed mysterious shapes. Intriguing, too, was the *ner talmid*, the eternal light that is always lit and hangs over the *bimah* (platform) on the eastern wall, where the rabbi and cantor stand and where the Torah scrolls are kept in the majestic-looking ark. The scrolls themselves had beautiful white satin coverings with gold designs and were topped by silver handles with little bells hanging from them.

The most interesting thing was watching the people. I noticed that the rabbi and the cantor were wearing white robes instead of the usual black ones they wore on other days, and they also had big white hats,

rather than *yarmulkes* like the other men. The Torah covers were changed to white too, instead of the usual dark-colored ones. Sitting on top of the ladies' heads were fancy hats to compliment their new outfits, home-made or newly purchased to welcome the new year. Looking over the railing to the floor below, I saw the men and boys swaying on the balls of their feet as they *davened* (prayed). I was awed by the music and the almost hypnotic sound of so many voices chanting in unison.

As a child, attending *shul* and spending holidays with my grandparents and family gave me a special feeling of comfort and belonging that I have never forgotten.

Religion with Jews is an everyday matter. The Jewish faith is meant to be a way of life. But the holidays have always been special. And each family has its own unique way of celebrating these holy days and of honoring their age-old traditions.

When we were growing up, people weren't so mobile. Most families stayed in the same cities. Family members usually weren't dispersed to faraway places as many are today. Our families were close, and we saw them for all of our birthdays, as well as every other celebration.

During high holidays, the story was much the same. Maybe not everyone every time, but at least our entire immediate family was usually together. After leaving Chicago, that was probably the hardest adjustment for both of us. There had never been an occasion when our relatives weren't present, and we missed them very much. The worst times were the holidays. When our children were younger and still joining us at services, I would sometimes wonder if our grandchildren would someday sit by our side as we repeated the ancient prayers.

The Days of Awe
The High Holy Days begin with Rosh Hashana and end with Yom Kippur (the day of atonement) ten days later. All of our holidays emphasize morality. On Rosh Hashana, the biblical birthday of the world, we take inventory and promise to rectify our wrongs. Then we are given ten days to think about it, and on Yom Kippur we are told, "God will forgive you." Yom Kippur is the holiest day of the year. It is a day of fasting. Jews ask not only to be forgiven for their wrongdoings but also to be inscribed in the book of life for another year.

Reform temples observe Rosh Hashana for one day, while Orthodox and Conservative synagogues hold services for two days. On the second day of Rosh Hashana a ceremony called *Tashlikh* is held. It symbolizes the theme of the holidays. Participants empty the pockets of their cloth-

ing above a stream or other body of water to symbolically cast out the accumulated sins of the previous year. There is always something to atone for...a word or action we regret.

When the rabbi said the words, "On Rosh Hashana it is written.... On Yom Kippur, it is sealed.... Who will live, and who will die...." I believed him. I prayed very hard that my family would be allowed to live another happy, healthy year. I prayed very hard that all my "sins" would be forgiven, and I promised to be a better person during the coming year. Yom Kippur still makes me take stock of myself. That's what it's meant to do. When we recite the confessional prayers on this day of atonement, we do it in the plural, as a community. The life of each person is considered to be interwoven with the life of every other person. When it's time for silent meditation, I pray for my husband, my children and my grandchildren—that they will be happy and healthy through the coming year. But I also pray for peace in the world, and especially in Israel.

When the cantor chanted the *Kol Nidre* prayer during those long-ago evening services, its plaintive melody caused a tightening in my chest. It still moves me. But when they blew the *shofar*, the hollowed ram's horn, then—like now—everyone looked at each other and smiled. The *shofar* is a 3,000-year-old musical instrument. It was once used to herald great events or to summon armies to battle. It's high blasts are like a wake-up call: Be good. Do good. Even though many Jews don't attend services the rest of the year, this is the night when almost everyone goes to synagogue for this moving service. I think this is true wherever Jews might find themselves, anywhere in the world.

My daughter and son-in-law took their boys to children's services for the first time this year. They weren't sure if the youngsters had gotten anything out of the experience. But the next day, they chuckled as they told us about their five-year-old riding his bicycle down the block, singing, "Ta-kee-aw...too-too-too-toot! Ta-kee-aw...too-too-too—toot!" Obviously the ancient call of the ram's horn at the conclusion of the service had definitely made quite an impression.

During the afternoon *Yiskor* service (the memorial service), you could always hear lots of stomachs growling after the long day. People tried not to think about that and just prayed twice as hard. Once home, we always broke the fast with a piece of *challah* and a glass of juice. The meal was usually dairy. We still do it the same way.

This was not, however, the same with Rosh Hashana. After Rosh Hashana services were over, we hurried home. Everyone said, *"Gut yontif. Gut yor"* (wishing each other a good holiday and a good year) as

we passed them on the street. I usually went home early with my mother and aunts to help get everything ready. After a delicious meal, with *gefilte fish*, chicken soup with *kreplach*, roasted chicken, *kasha varnishkas* or *tsimmis*, *challah* dipped in honey, *strudel* and sponge cake or honey cake for dessert, the women cleaned up in the kitchen and talked, while the men usually sat down to their game of cards.

The custom of eating sweets on Rosh Hashana is more than fifteen hundred years old. It expresses the hope that life will be sweet during the coming year. A dish of honey can be found on almost every Rosh Hashana table. Most of the year, bread is dipped in salt; but on this holiday it is dipped in honey. We also dip slices of apple into the honey for a good, sweet year.

My parents loved to dance. In fact, that's how they met. They used to have neighborhood dances often then, and on Yom Kippur eve, it was usually a tradition to hold a Yom Kippur dance. I stayed home, of course, but my mother and father looked for any excuse to get out on a dance floor and never failed to go if they could. Unfortunately, by the time I was old enough, this custom seemed to have gone out of style. It's too bad really. If they were willing to go, I think it would be a good way for young people to meet each other even today.

Our *shul* was Orthodox and my grandparents kept *kosher*, though I don't remember them doing some of the things some other families we knew did. I had a good friend in high school whose family was much stricter in their observance. Not only didn't she eat or drink on Yom Kippur, but she would never dream of wearing lipstick for fear of licking her lips and accidently ingesting some. Her family also tore their toilet paper on Friday afternoon, so that they wouldn't have to do it on *Shabbos*. Of course, this applied to opening the mail, as well. That would have meant tearing paper.

One of Sid's friends in medical school held similar beliefs. When an important examination was scheduled on one of the Jewish holidays (these things weren't usually taken into consideration at that time), he knew he had to take it or he would fail the course—which even his family agreed would be unacceptable. But he insisted on walking the ten miles there and ten miles back, because he refused to drive on this day. There was no way he would compromise his beliefs, even for such a significant reason.

The High Holy Days have always seemed to me to be the "beginning" of the year. Never mind that we celebrate on December 31, too. My husband laughs when I say something about doing something "this year"

when it's already November or December. By "this year" I mean between now and next September. It makes more sense to me. It's how I mentally mark my time.

The Jewish calendar is very different from the one we use in everyday life anyway. To begin with, it goes by the moon. The beginning of the month always coincides with a new moon. It's also quite a bit older than the one we use. I never gave it much thought, until my daughter pointed out to me that she always remembered what year it was on the Jewish calendar because the last two digits were always the same as my age. Oh, my! Not that it was a secret before, but now everyone knows! Let's just say that in 5710, I was 10 years old. Anyway, that's why the various holidays aren't on the same date as on our standard calendar, and the reason that they change from year to year. The date is constant on the Jewish calendar, but the two calendars don't match.

Pat Markman was telling me about her father and *Yontif*: "We lived in Brooklyn. My parents were immigrants from Bessarabia. We didn't belong to a synagogue. My best friend was the daughter of a cantor, and I became the only one in my family to go to high holiday services because I always went with my friend. But on Rosh Hashana and Yom Kippur, my father would put on his *tallis* and *yarmulke*, take out his prayer book and pray in the living room. We didn't bother him. We knew he wanted to be left alone. He believed that God was all around you. You didn't have to go to synagogue to pray because he could hear you wherever you were."

Pat's story reminded me of something I had heard way back in the 1960s that has stuck with me all these years. It was a television play about Cardinal Mindzenti. Toward the end of the play, the cardinal was talking about God. I never wrote it down, but the words made such an impression on me that I actually still remember what they were.... "There is, at the core of every man, a slender thread—called God. And it is by this thread, in time of need, we pull ourselves toward heaven." What a thought, that each of us could be so "connected" to God. There's something very reassuring about that.

On a more humorous note, I remember somebody saying that for years, as a child, they thought that God lived behind the lighting fixture in their kitchen, because every time their mother got upset, she would throw up her hands, look up at the ceiling and cry, "Why me, God?"

Driving on *Yontif* was definitely not allowed. Walking to synagogue was expected. Vivian Herman recalled that: "We always walked to services. The first time we ever had to ride to shul was after I was married.

We lived quite far away, and there wasn't any way we could go on foot. It was such a traumatic thing for me that first time. Now we're accustomed to going by car." Which brings back that image of the people I remembered who left their cars in Humboldt Park and walked out from there on the high holidays. Everybody knew, of course, that they had driven, but nobody mentioned it.

Getting ready for the new year also meant getting new clothes. According to the Talmud, Jews aren't supposed to appear serious and dowdy at this time. We're supposed to dress festively, to symbolize our confidence in our spiritual regeneration.

Itzhak Emanuel remembered: "Every Rosh Hashana my father used to buy me something new for the New Year—new pants or a new shirt. It was a nice tradition, and a nice memory. I always knew that on Rosh Hashana there would be something new waiting for me on the table."

My grandmother was so handy with her hands, that I always had something handmade for *Yontif*. I had some really lovely knitted dresses, and a beautiful multicolored coat with all the colors of the rainbow. Joseph didn't have anything on me. Since I was the oldest grandchild, these handmade things were always passed on to my younger cousins. I wish I could have had some of them for my daughter, but I have no idea where they ended up. My mother knitted quite a few things for her, though, so she did have some of her own.

A Fish in the Bathtub

Betty and Leo Rinsler shared some of their holiday memories with me: "When my mother made *gefilte fish* for the holidays, she went and bought a live carp," Leo smiled. (Another fish story!) "We kids used to play with the live fish in the bathtub for a day or two until she was ready for it. And then she would put it on the sink and give it a *klop* over the head with her rolling pin. I can still see it. When she cut it in half, each individual piece would continue to jiggle around a little. Now it sounds awful, but this is what everybody did. I used to look forward to the holidays because I knew that my brothers and I would be able to play with the fish in the tub. That was the highlight of Rosh Hashana. That's the only way we had *gefilte fish*. It didn't come in glass jars then. It also meant we didn't have to take a bath as long as the fish was in there."

Betty remembered going to the fish market and seeing the fish in the big tank. "You would point to the one you wanted. They wrapped it in wet paper to keep the gills damp, the tub would be filled and ready, and you ran home and plopped it in. It would revive itself there."

Barbara Cohen wrote a children's story about her remembrances of

bringing home the fish. She called her story "The Carp in the Bathtub" (from *The Family Treasury of Jewish Holidays*, by Malka Drucker). In her story she recalled how hard it was to get fresh carp just before *Yontif*, since all the other women in the neighborhood wanted to make their own *gefilte fish* too. So her mother used to buy her carp a whole week ahead of time. She carried the flopping creature home in a bucket, where she also kept it in the bathtub until she was ready to cook it. The problem was that after a few days of feeding and playing with the carp, it was so much like a pet that Barbara and her brother couldn't bear the thought of ever eating it.

I do remember watching my grandmother prepare her *gefilte fish* for the holidays. It was an all-day affair. But we never had a live fish that wasn't specifically bought as a pet, that I can ever recall. Grandma got all of her fish at the fish market. She skinned it, ground it by hand with onion and *matzah* meal and whatever other ingredients she used, and then shaped it into balls and dropped them into boiling water to cook.

My Russian friends tell me that this is not the way they prepare this dish. *Gefilte* means "stuffed" and that is exactly what they did with it. They stuffed the ground fish meat, after it was mixed with spices and other things, back into the skin. They baked it in the oven, until all the liquid they had added was absorbed.

The recipe really isn't that important. The main thing is that it was always handmade. And no can or bottle from the supermarket can recreate that particular flavor. In later years, my mother made her own accommodation. She didn't have all day to prepare as my grandmother had done. She simply took the fish from its jar and then proceeded to boil it, adding onion, spices and vegetables to enhance the flavor, thereby producing a half-and-half result—her version of "homemade." Unfortunately, this is something I have neither the time nor inclination to do. There never seem to be enough hours in the day as it is. But I do continue to serve *gefilte fish* as the first course for our holiday dinner. How could it be *Yontif* without this staple? Homemade or store-bought, this always remains a traditional dish for the holidays.

Pesach

When I went away to school, some big changes took place. My grandparents sold their apartment building and bought a little house in Albany Park. My parents bought their first house, too, in Budlong Woods, about a ten-minute drive away from them. For the first time in my life, I had my own room. Only I wasn't home to use it. When I returned to Chicago to continue my studies, I got to sleep in a real bed of my own,

in my own room, with my own closet and a door and everything—for one year, until I got married.

My grandparents' house was quite small. My grandfather called it "the doll house." It did kind of look like that. It had a living room, a kitchen and two small bedrooms. I think my grandfather's favorite part of his "doll house" was the back yard—their first. He really loved puttering around in the garden, and they both enjoyed sitting on the little back porch and looking out over their very own flowers and grass...just like a miniature private park.

On St. Louis Avenue, our *seders* were held in the dining room. There was always plenty of room there for all of us. In this house, the small bedroom was turned into the "dining room." When all of the family crowded around the dining room table for the Passover *seder*, we looked like someone had wedged us in there with a shoehorn! But we all miraculously managed to fit, and I do remember some pretty lively *seders* in there.

Pesach was always such a beautiful holiday. But it took Grandma a long time to get ready for it. It was generally a time for a thorough spring cleaning. The whole house had to be scrubbed clean so that no crumb of *chometz* could be found. All food that was not *kosher* for Passover (anything with leavening) was taken off the shelves. Special dishes that we used only during this week were unpacked, and our regular everyday dishes put away until after the holiday was over. She bought boxes of *matzah* that we would eat instead of bread, and spent hours making *gefilte fish*, soup, *chremslach* (something like a *Pesadickeh knish*, but made with *matzah* meal instead of flour, and then dropped into boiling water), and usually chicken or brisket.

The finishing touch was the compote she made for dessert. Compote was stewed fruits, which came in handy after the heavy food that came before. It was a standing joke. After everyone stuffed themselves and could barely move, my uncles would say, "Okay, Ma, where's the compote." "I don't have any today," she would say. "Well, we'll just have to sit here until you make some," came the rejoinder. Of course, she would then disappear into the kitchen and come back with the mandatory dessert.

But there was quite a bit that went on between the main course and the dessert. The *seder* was a long, drawn-out affair. *Haggadahs* were passed out, and we all read the story of Passover. When I was little I didn't really understand the significance of the story. All I knew was that it meant sitting for a long time, drinking wine (I had grape juice), and eating lots more food than I wanted. I loved the songs we sang at the

end, reading the four *kashas* (questions) and looking for the *afikomen* (the hidden *matzah*) with my cousins, but it wasn't until I was much older that I understood the symbolism involved.

Retelling the story of the Jews' exodus out of Egypt year after year is a tradition that Jews all over the world observe. Passover is so important because it is a celebration of freedom. It reminds us of the importance of continuing the battle for freedom in every generation.

There was a struggle between Moses and the pharoah. A series of ten plagues were brought against the Egyptian ruler in order to convince him to let the Jews leave. The tenth was the most severe: the slaying of the firstborn sons. The Jews were instructed to mark their doorposts with lamb's blood, and when the angel of death struck, he saw the markings and "passed over" the Israelite's homes.

Pesach is the oldest Jewish holiday. In America, Passover is observed for eight days. Jews remember the power and importance of this event by eating special foods linked to the bitterness of slavery and the sweetness of freedom. We eat *matzah*, or unleavened bread, to remind us that the Jews left in such a rush that they didn't have time to let their bread rise. We never had trouble buying our *matzah* at the neighborhood grocery store, but Betty Rinsler remembers her father going all the way to the city to buy theirs at the *matzah* factory. "He would lug home a great big box for the week."

Rabbi Gitin's son David and his wife Eileen were surprised to discover, while traveling in the south of France, that all the synagogues had been built over bakeries. This made the baking of *matzahs* not only convenient, but easier to supervise.

During Pesach, I used to take *matzah* sandwiches to school and eat *matzah brei* (softened *matzah* dipped in egg and then fried) for breakfast. This is still a family favorite, which I even make at other times of the year. Grandma liked to rub the *matzah* with *shmaltz* (chicken fat), *tsibilleh* (onion) and a clove of garlic. For her that was a treat.

Another ritual for this special time was getting the house ready. Everything had to be completely free of *chometz*. The night before the *seder*, the head of the family traditionally holds a feather and brushes away the last vestiges of symbolic non-Passover crumbs, which are put into a bag and burned, indicating that the house is ready for Passover.

Abraham Heschel has been quoted as saying that "the important thing in life is to ask the right questions. For this we need an occasion, a structure, a set of symbols to prod us, all of which are provided by the sensory delights of the *seder* table." On my grandmother's *seder* table she always laid out her finest white cloth. Her candlesticks flanked the tra-

ditional *seder* plate, to add to the festive look. Several bottles of wine were ready to serve during the evening, when everyone was expected to drink the prescribed four glasses. One extra glass was always set aside for the prophet Elijah. It is believed that this prophet will usher in the messianic era. We also leave the door open, just a crack, in case he decides to show up during our meal.

Legend tells us that Elijah always comes in disguise. We will know that it is him when goes to the table and takes a sip from this special glass of wine. When Elijah reveals himself, then the Messiah is supposed to come to earth. Meanwhile he is believed to be traveling around making people happy. So we pour the extra glass, leave the door open, and we wait.

The *seder* plate in the center of the table always contained specific foods: a roasted egg, *maror* (bitter herbs like horseradish), a shank bone (for the sacrificial lamb) and *haroset* (a mixture of apples, nuts and wine). And then the *afikomen*. Grandpa would take a middle piece of *matzah* and wrap it in a napkin. Then, when he thought *"de kinder"* (the children) weren't looking, he would hide it. It was always a game to see who could find it first. The lucky finder would get a prize, usually a silver dollar.

Joe Gabriel only got ten cents for finding the *afikomen* at his family's *seder*: "I grew up in Brooklyn. I was the youngest of three kids. Every Pesach the *seder* was at our house. My father was a very gentle, timid man, but in our house he was king. At least my mother had him convinced that this was the case.

"Everyone dressed quite formally at our *seders*. My father and all my uncles wore jackets and ties. When it came time for the *afikomen*, I always watched carefully to see where my father would hide it. On one occasion, when I was about nine or ten years old, I saw him surreptitiously slide it into his inside jacket pocket. Well, I knew where it was. The question was—how could I get it? Then I got a bright idea....

"When my mother told me to help clear the dishes from the table, each time I passed the thermostat on the way to the kitchen, I 'accidently' bumped it up a notch or two. Pretty soon it started getting kind of warm in the dining room. My father, of course, wasn't about to shed his jacket. After a while, my Uncle Morris pulled out his handkerchief and started wiping his face. 'Sadie,' he pleaded, 'maybe we should take off our coats....' My mother nodded at my father, and he reluctantly agreed that maybe it would be better to shed the outer layer than to sit there and sweat.

"And who do you think they asked to collect all the jackets? Little

Yossele, of course! And that's how I was the one to get the prize that year. I was very proud of my ten-cent reward!"

The *afikomen* has a history, too. It was considered a good luck charm for Middle Eastern Jews. They thought that a piece carried in a pocket would ward off illness and shipwrecks. Kurdish Jews bound a piece to a grown son's arm and said, "May you be as close to your wife!"

One part of the service that was my favorite was the reading of the four *kashas* (questions). This is where the children at the table got to speak. The youngest child usually asks these, but often, I had the honor. This part always began, "Why is this night different from all other nights?" In the story, these questions are asked by four sons...one who is wise, one who is cruel, one who is simple and the fourth who is naive. The answers explained the meaning of the holiday.

Ruth Schwartz told me a funny story about her family's reading of the *Haggadah*: "Our *Haggadah* had a misprint. When they came to the part about the plagues, there was one line that always made us laugh. The word *dipsitinto* [really dips-it-into]. As each plague is recited you're supposed to dip your little finger into the wine and tap it onto the plate. We would always say, 'Is it *dipsitinto* time yet?' And then if somebody accidently started to put their finger to their lips, we would shout at them not to. That would be like bringing the plague into your own mouth."

Leo Rinsler shared his recollections: "Our families just lived too far from us. It was a good hour's ride away, and they wouldn't ride on *Yontif*. So we usually celebrated our holidays by ourselves. My mother had a barrel for all the Passover dishes. They were each individually wrapped in newspaper. My mother, brothers and I would unwrap them, and then rewrap them again at the end of the holiday."

Leo's wife, Betty, added: "My father made his own Passover wine with concord grapes. I used to love to play with those grapes. Under the skin was a little ball which encased the seeds, and I used to love to break them. They used a vat, or maybe a barrel. It gurgled and made strange noises as it was fermenting. It was excellent, and that's what we used for Passover. And the games we played were always nut games. I would take my mother's cutting board, lean it against the wall and roll nuts down, trying to hit other nuts lined up on the floor." We played nut games, too. It must have been a tradition.

Leo's story of the dishes reminded me of another story I heard long ago. Getting out the special dishes was a big deal. If you kept kosher, as most of the people did, this meant getting out *two* other sets (for milk and for meat).

There were two friends named Ida and Rivka. Neither family had much money, and these two ladies came up with a bright idea so that they wouldn't have to invest in two more sets which would only be used for one week. Each year, they would wash and pack up their dishes, and just before Pesach, Ida would take her carton over to Rivka's house. Rivka would come and bring her carton to Ida's house. Then they proceeded to unpack the other's dishes, and their husbands always thought that these were their second sets. Not exactly *kosher*, but I did remember thinking that they were pretty clever at the time.

Actually, according to my friend Betty, there is a way to make glass dishes that have been used for everyday use *kosher* for Passover. "If you soak them in the bathtub for three days," she said, "that makes them *kosher* for Passover. If you want to *kosher* metal things, however, like silverware or pots and pans, they had to be buried in the dirt. There was something else, too.

"We couldn't allow the Passover things to touch the counter or sink or they would be spoiled. So we would go to the green grocer and get the old wooden crates. The slats from these crates would be laid on the counter and in the sink, and that way the things wouldn't touch these surfaces. These crates were wonderful things. Not only did we use them for Pesach, but those and the wooden boxes from cheese became our toys. I remember using a box from Breakstone Cheese as a cradle for my doll. Leo used to use them as sailboats. It's amazing what a little imagination can do."

Well, Passover *seders* at my grandparents' house were happy family occasions. But once my grandfather died, that all stopped. With Grandpa gone, the days of all the aunts and uncles and cousins coming to their house went with him. After that everybody started to have their own family gatherings. Grandma sold the house, and after a brief attempt to live alone, finally moved in with my mother. Sid told me that the same thing happened in his family. When the grandparents are here, everybody gathers around. Once they're gone, they disperse.

We discovered after leaving the city of our birth and the security of our families that there was a huge hole in our lives. Holidays just didn't seem the same. We also discovered something else. When you no longer live near family, if you're lucky, your friends become your family. We were lucky. We made some very dear friends. Our families have shared holidays and life events for almost thirty years now. Our children grew up like cousins. I'm glad because that is such an important part of childhood. On Thanksgiving, we have everyone to our house. That has

become a much anticipated tradition. But on Passover, we happily join our friends for their traditional *seder*.

Once again, we crowd around the festive tables (one is no longer sufficient). The children all know each other and look forward to seeing one another and catching up on current details. There are new little ones, to bring us joy and amuse us as they stare with big eyes at all the goings on. The younger generation now outnumbers us. The table with our parents, their grandparents or great-grandparents, has been replaced. We miss them. Now it's our turn to be the "older" generation.

We eat all the traditional foods and drink our glasses of wine. We read the Haggadah and retell the story. There is a moment of levity, when another tradition occurs. One of our friends has a birthday which falls around this time of year. Years ago, we started to insert this into the ritual. When we recite the part about Moses wandering around the desert, instead of the usual forty years, we shout in unison the number of years she has been alive. Poor Moses keeps getting his sojourn extended. Everybody knows that this is coming, and gets ready to join in the chorus. We laugh and continue on. It's a tradition. The children look for the *afikomen*, we eat and drink and sing all the songs, beginning with "One kid." It feels like *Yontif.*

Hanukah

Hanukah, oh Hanukah, come light the menorah;
Let's have a party, we'll all dance the hora.
Gather round the table, I'll give you a treat,
Dreidels to play with, and latkes to eat.
And while we are playing, the candles are burning bright;
One for each night, they shed a sweet light
To remind us of days long ago.

This song is sung everywhere Jews gather to mark this occasion. *Latkes* (golden brown potato pancakes), *dreidels*, Hanukah *gelt*.... This is one of the happiest of holidays. Sholem Aleichem said, "What's the best holiday? Hanukah, of course.... You eat pancakes every day, spin your *dreidel* to your heart's content, and from all sides money comes pouring in. What holiday can be better than that?" He was right. We don't have to go to *shul*, and there is no long ritual like the Passover *seder*. We just sing, play, exchange gifts and eat. But first, we light the candles on the *menorah*.

The *menorah* is a nine-branched candelabra, one branch for each of the eight days and one, called the *shamash*, which is used to light all the

others. Unlike the Sabbath candles, which usher in the *Shabbos* and whose original function also served to illuminate the house, the candles in the *menorah* are intended exclusively to remind us of the miracle and to help celebrate the holiday. That is why the *menorah* is sometimes seen in a front window, where passersby can also see the flickering lights. A *menorah* can be made of anything that won't burn. A friend recently told me that she didn't remember having an actual *menorah* when she was a girl. Her family saved jar lids and stood their candles in those. It served the purpose.

Because Hanukah usually comes around Christmastime, non-Jews sometimes get confused and think it is the "Jewish Christmas." This couldn't be further from the truth. It's actually a celebration of an historic event that occurred in the second century before the birth of Christ. But Jewish children, seeing what joyous and elaborate festivities their Christian friends were experiencing, felt a bit left out. And so, this commemoration of Jewish victory over religious persecution in 165 B.C.E. took on added importance. To counteract the strong influence of the Christmas season, Jewish parents began giving gifts and trying to let their children know that they, too, had their own special holiday to celebrate. It's only in recent times that Hanukah has become so popularly observed.

I'll never forget how upset I was when my grandmother regretfully told me that there really wasn't any man in a red suit who came down the chimney and brought toys for all the good children. I didn't speak to her for the rest of the day, until my mother came to get me after work and reluctantly confirmed what Grandma had said. I was only about six or seven then. That was when they decided that it was necessary to play up Hanukah and make sure I realized that our holiday was important, too. I'm not sure we ever observed Hanukah before that time. But from then on, we did.

We checked out books at the library and read stories about the Maccabees and how they fought against the Syrians, who had defiled their temple and tried to destroy their religious beliefs. Judah Maccabee and his brothers were heroes who defeated those tyranical rulers and gave the Jews back their freedom of religion. We read about the miracle of the oil. When the Jews came back to their ruined house of worship, they found only enough oil to keep the holy light burning for one night, but it miraculously burned for eight nights. That was why we celebrate for eight nights and light eight candles in our *menorah*. It is also why we make *latkes*, not because of the potatoes, but because of the significance of their being fried in oil. In Israel, instead of *latkes*, they usually eat donuts, which are also deep fried in oil.

I know I didn't get anything like the kinds of gifts our children got. (I won't even mention the high tech stuff with computer chips that make our grandchildren's toys come alive!) No one spent a lot of money on toys then. Usually there was maybe one nice gift, like a doll or a book or a game. But one of the gifts was always the same. Every year, Grandpa gave us Hanukah *gelt*, and it wasn't chocolate. It was one silver dollar. I still have every silver dollar he ever gave me. Between Hanukah and the dollars I got for finding the *afikomen* at the Passover *seders*, I have a nice little collection. I don't know what their monetary value is, but I do know that there isn't enough money in the world to make me part with them. If he had given us paper money, I'm certain it would have been long gone. But silver dollars were something to keep. Some of them even have dates that go back to the 1800s. My very special treasure, though, is one that I got from him posthumously. While going through my mother's apartment after she died, I found a small leather pouch in her dresser drawer. In it was a silver dollar with my Grandfather's birthdate—1891. I remembered that he always carried it with him as a good luck charm. I don't carry it with me, but I still consider it good luck.

The winter holiday season was always a puzzling time of year for me. Before we moved to the building on St. Louis Avenue, I went to a school where most of the children celebrated Christmas—not Hanukah. Even in our apartment building, almost everyone had a Christmas tree, and even some of my mother's friends gave in and had a tree, which they facetiously called "a Hanukah bush." This caused something of a quandary for me…not because of the other kids, but because I was so torn about how to act. For one thing, I knew that these weren't our traditions. It didn't seem right. If they weren't Christmas people, then why did they have Christmas stuff?

In school, I was even more confused. For instance, I always loved music. I enjoyed singing and was always glad when music period came around. But before Christmas, the teachers started handing out booklets with Christmas carols. I liked the melodies and wanted to join in, but I felt really uncomfortable singing about the baby Jesus. Not only did every art time involve making ornaments and drawings of reindeer, Santa Claus and Christmas trees, but there was always a big assembly where the children put on plays or sang songs pertaining to Christmas. Naturally, I wanted to take part in all of that. And it was also customary for all of the classes to stand around the big decorated tree in the hall and sing carols. Never did we make anything pertaining to Hanukah, nor did we sing any Hanukah songs.

So, I had to make a decision. Should I excuse myself from art and

music for two months of the year, or should I simply go along and do everything that everyone else was doing? You can probably guess what I decided to do. No child wants to feel left out of things, especially fun things. So I cut, pasted, drew and sang. But when there was any reference to "the child," I simply mouthed the words. This was my accomodation.

As I got a little older, my love of music of all kinds won over, and I told myself it was all "just music." My daughter found herself in a situation similar to the one I had experienced while we were living in Twentynine Palms. She turned five the second year we were stationed there, and started going to kindergarten in town. When Christmas came around, there were the customary art and music activities. A big Chrismas play was planned. Guess who they selected to play Mary? Of course. Our Wendi—the little Jewish virgin! We sat in the audience like all the other proud parents, as our little girl sweetly sang her solo, "Away in a Manger"—all three verses. We told ourselves it was "just music" and smiled and *kvelled* like any good parents would. And then we went home, lit the candles in our *menorah*, played *dreidel* games and ate our *latkes*. We lived in two worlds.

The *dreidel* game is always the traditional pastime during these family occasions. My cousins and I always had a good time spinning these little tops. My children did, too. Now they have a computer chip inside that plays songs as the top spins. My grandchildren already love to watch them spin, and now they can also listen to the music.

Each of the four sides has a Hebrew letter on it. They are:

Nun—a miracle

Gimmel—great

Hay—occurred

Shin—there (In Israel "there" is changed to "here")

The top is spun, and whatever letter comes up on top tells what you do. It's usually played with nuts or small coins. *Nun*, you get nothing; *Gimmel*, you take all; *Hay*, you take half; *Shin*, you put in.

I can still remember my mother and grandmother sitting at the kitchen table, grating the potatoes with a metal *ribbeizen* (grater). They were fast, and never seemed to injure themselves in the process. I made my *latkes* like this for many years. It was a pain, but naturally, I wanted mine to taste exactly the same as Grandma's. Sid used to say that grated fingers added to the flavor. Then, somewhere down the line, I discovered how much easier it was to let my blender do the grating. When you do it this way, the texture is not the same. They turn out much lighter, but

the flavor is still delicious. It just wouldn't seem like Hanukah without *latkes*.

Once Sid came into my life, I was invited to join in his family celebration. This is where I heard my future husband sing these blessings for the first time. I have enjoyed hearing him repeat this ritual every year since. He and his relatives did the honors at his Aunt Blanche and Uncle Irv's annual party. They have been hosting this event for all of the family since their children were born. Two whole generations of children grew up looking forward to the Hanukah festivities there. This year was the fiftieth year this tradition has been going on.

When I was a girl, all of my relatives came to my grandparents' house for dinner on the first night of Hanukah. My cousins and I would watch with fascination as the candles were lit, and everybody sang the blessings. First the *shamash*, and then the first candle on the right received it's dancing flame. Grandpa gave us our *gelt*, we opened our gifts and then sat down at the table where we eagerly devoured our delicious *latkes*, with lots of apple sauce and sour cream.

Sometimes you can almost smell a memory. A turkey roasting in the oven conjures up images of Thanksgiving. The aroma of popcorn makes me think of the movies. And Hanukah smells like golden potato *latkes*, sizzling in the pan!

A Joyful Noise: Sukkot, Simchat Torah, Shavuot and Purim

It really wasn't until my children began to go to religious school that the celebrations of Sukkot, Shavuot and Simchat Torah came alive for our family.

In biblical times, Shavuot was celebrated as the harvest of the first fruits. But this holiday has come to have even more significance. It has become increasingly associated with the giving of the ten commandments on Mount Sinai, which occurred about the same time of the year. When the association was established between Shavuot and the Revelation on Mt. Sinai, the original agricultural holiday also became a time for celebrating the Torah. This is the traditional time for boys and girls, generally thirteen to sixteen years of age, to go through their confirmation ceremonies, confirming their allegiance to the Jewish way of life. Both of our children proudly went through this meaningful service.

And, usually in October, we helped the class build an outdoor arbor (*sukkah*) for the fall harvest celebration of Sukkot. The story of Sukkot tells of the Jews finally reaching the holy land after forty years of wandering in the desert. There they became farmers. When it came

time for the harvest, they needed to be near their crops in case a sudden storm necessitated gathering them quickly. They built little huts in the fields and lived in them until the harvest was over. In time, the *sukkah* became a symbol of both the wandering and the harvest. Very much like a Jewish Thanksgiving.

When the *sukkah* is built it is always placed on the ground because Judaism is earthy, concerned with man's relationship to man here on earth. In the Jewish ethic, we are not even allowed to reach for God until we first reach for man. But the top of the *sukkah* is always left open to the stars, so that we can also look up toward heaven.

Some families eat and even sleep in these *sukkahs* during the holiday to experience the feeling of nature. Some of the symbols of Sukkot are *etrog* (citron) and *lulav* (palm). These huts are decorated with all kinds of fruits, vegetables, branches and sometimes with drawings and paintings made by the children.

There was an old family tradition regarding Sukkot that Rabbi Schiftan remembers and continues to follow with his children to this day.

"After breaking the fast at the end of the long Yom Kippur service, we would immediately go out into the back yard and hammer in the first nail of the *sukkah*. One of the most beautiful measures of Jewish life is that it is always a cycle. Immediately after this great day of severity and renewal, you are replenished. You go out and celebrate life all over again with this holiday of rejoicing and thanksgiving.

"I still try to find the energy to go out and hammer in this first nail after the fast. I did it as a boy, and continue this tradition even now."

Simchat Torah comes right around this time, too. What I remember best about Simchat Torah is the children parading around the sanctuary carrying miniature Torahs in the air and singing songs. This was a time to celebrate the conclusion of the reading of the entire five books of Moses. When the last portion has been read, there is no pause. We start reading from the beginning all over again.

Speaking about Simchat Torah in his high holiday sermon, Rabbi Schiftan explained, "And on that sacred night, in every synagogue across the globe—whether traditional or liberal, Orthodox or Reform or somewhere in between—Jews will await the moment when the ancient scrolls are removed from the ark, the moment when the scrolls are carried through the congregation, embraced by all who wish to hold them close to their hearts, as their greatest treasure. It is the *same* scroll, the same *exact* treasure, letter for letter, found in every synagogue anywhere in the world. It has not changed for two thousand years.

"And as the scrolls are embraced by this ancient, holy people, there will be only one question left to be answered: Can this people, can our people, still find a way to embrace one another?

"That question, we know is not ours alone. It is asked, on this evening, in the heavens above. The answer lies within the scroll, but also within the hearts of those who cherish it. Can we not embrace the scroll with one hand, even as we reach out towards our neighbor with the other? For both are precious in God's eyes, as they should be, also, in ours."

As soon as we complete the reading of the ancient scrolls, we immediately begin again. As Rabbi Schiftan so eloquently reminded us, "Jewish life is a never-ending cycle."

And in the spring, for Purim, I painstakingly used my limited sewing ability to make costumes for the yearly Purim carnivals. Wendi always wanted to be Queen Esther, of course; and Larry was usually Mordecai. He even made a very clever puppet of Mordecai in his religious school class, out of a pop bottle, fabric and yarn on a papier-mache head, which he painted and even fashioned glasses for. I kept that creative little guy for years.

Like Hanukah, Purim is connected to an historic event. It is a celebration of right over wrong. The story comes from the Book of Esther and recounts the saga of a king named Ahasveros in Persia, who married the beautiful Esther. The villain of this story is a bad guy named Haman. He didn't like the Jews and wanted to do away with all of them. Of course, he's unaware that the queen is Jewish, and at her cousin Mordecai's urging, Esther pleads with the king to save her people. During the reading of the *Meggillah* (story) during the service in the synagogue, everyone typically boos, stamps their feet and twirls *groggers* (noise makers) whenever Haman's name is mentioned.

The traditional food for this holiday is *hamantashen*, a three-cornered pastry named after the shape of Haman's three-cornered hat. There were Purim carnivals at various synagogues when we were growing up, but my recollection of these is limited. I do, however, have definite memories about that pastry. My grandmother made them every year. They were usually made with prune, apricot or poppy seed filling. I liked the prune best.

Dvora Cogan talked about her memories of this holiday from her youth in Eastern Europe:

"When I lived in Rumania, we had this tradition: all the Jews in the neighborhood baked triangular-shaped cookies which we called *haman-*

tashen, cakes and *fluden*. Then people exchanged their goodies with each other. This custom is still alive in present times. I remember that during the holiday, people wore fancy costumes and went house to house, dancing and singing. We would give them cookies and try to guess who they were. Sometimes they would be complete strangers, sometimes friends. It was great fun. We celebrated at night with carnivals and parties in the streets.

"In Israel, where we lived before coming to America, people also send each other baked goods. Children celebrate at their schools and adults have carnivals in the streets. Even now, when the cantor pronounces the word 'Haman' everyone screams and stamps their feet to condemn this name. Unfortunately, there is a Haman in every generation of the history of the Jewish people."

Cantor Emanuel told me that in Israel, they don't give *gelt* (money) or gifts for Hanukah. They give them for Purim instead. Purim is a happy holiday.... And when you get *gelt* it makes you happy! Why not?

Active community worker Ruth Ross recalled how extremely important all the holidays were on the street where she grew up in Dallas, Texas:

"During Sukkot, people actually built *sukkahs* on the street where we lived in South Dallas. And during Hanukah, the women would all stand there and grate potatoes together for their potato *latkes*. The street was about six blocks long, filled with lovely homes. And everybody belonged to the community. It was like a big family.

"My father came from Bialy, Poland," Ruth recalled. "He saw his mother beheaded in a pogrom when he was twelve years old. He ran as fast as he could. He boarded a ship for America, and landed in New York all by himself when he was thirteen.

"He had always dreamed of being a cowboy in Texas, with real cowboy boots. He worked his way out west, and made a life for himself in Dallas. Through the years he had four wives, and he lived to be one hundred and five years old. He never learned to speak English, though. He only spoke Yiddish. But he read the Yiddish newspaper every day of his life. He was active until the end.

"Dallas had a wonderful Jewish community. We belonged to a very large Orthodox *shul*. It even had a *mikvah* [ritual bath]. And there was also a huge Temple Emanuel, which was Reform, an Eastern Orthodox *shul* and a Conservative *shul*. All in South Dallas. On the holidays, the kids would walk from *shul* to *shul* to *shul*, visiting all their friends. People were observant.

"People don't realize how many Jews settled in Texas. Many Jews got off the ship in Galveston, which is only about three hundred miles from Dallas. And the high school I went to was about 60 percent Jewish. All the officers and most active students at Forrest High School were Jewish.

"A lot of very talented Jewish writers, businessmen and Hollywood people came out of that school: Aaron Spelling, Stanley Marcus [of Neiman Marcus fame], just to name a few. Our family name was shortened by a customs official from Benyanson to Benson. It may sound familiar. My brother is also a writer, and his son became an actor of some repute—Robbie Benson....

"It was a beautiful environment. I grew up proud of my heritage and still continue the practices of my youth. And I especially remember the holidays. The holidays were always very special times."

Thanksgiving and the Fourth of July

The Jewish holidays and birthdays were always big events in our lives. Our schedules and foods all revolved around these days. And, of course, we always make sure to attend our grandchildren's birthday celebrations, just as our families were always present at ours. They are milestones we wouldn't miss for anything in the world. But looking back over the years, there were two other times when the entire *mishpochah* would gather without fail: Thanksgiving and the Fourth of July.

While the other holidays concerned religious observance of some kind, and birthday parties to mark the passing of years, these two days were purely American traditions. Aunts, uncles, cousins (Lady included) would spend these holidays not at Grandma and Grandpa's house, but at our house for a change. This was my mother's chance to entertain. I still love these two holidays. They have become my favorite times of the year.

July Fourth is always fun. It's a day to relax and to play. No fancy dishes or good silver. This day is simply paper plates and a cooler full of cold drinks. The barbeque is often fired up, and the conversation lively. Just a good old American celebration of the birthday of our country. Our friends and their children and any parents who are still around have come to our house for more than twenty-five years to help us enjoy the afternoon and evening. It also happens to be our friend Joe's birthday. The whole country helps him celebrate his day, so it has become our birthday party for him, too.

Thanksgiving is especially meaningful for me. It may not be a religious

holiday, but to me it has always been a spiritual one. It's a time to count our blessings, and I do...*every* one. I give thanks for the well-being of my family and the gift of friendship. Material things are nice, but these are the most precious. We have lived long enough to experience the pain of terrible illnesses, natural disasters and the loss of our loved ones. This day makes you put things in perspective. Thanksgiving gives us all a chance to take stock and appreciate what we have. For nearly thirty years now, we have had the good fortune to spend this holiday with our family (immediate and extended) and good friends. Our circle has grown as our children began to bring friends, spouses and children of their own. I look around the table and feel the joy of our togetherness. I also feel the loss of some of our parents and friends who once sat at our table and are with us no more. Nothing stays exactly the same, I suppose. I know that's the way it's supposed to be.

Well, I shouldn't say "nothing." One of the best parts of this particular day is knowing exactly what the menu will be. That never changes: turkey, stuffing, sweet potatoes, green bean casserole, cranberry sauce, *kugel*, birthday cake for Larry and pumpkin pie for dessert to round out the meal. Nothing else will do. It's a tradition.

Jewish Wisdom, Proverbs and Curses

"During the centuries of the diaspora, Rabbinic Judaism shifted our attention from the food that went into our mouths to the words that came out of our mouths."

—Rabbi Arthur Waskow

•

"The beginning of wisdom is to desire it."

—Solomon Ibn Gabirol

MY GRANDMOTHER WAS BUSY in the kitchen putting the finishing touches on a fresh batch of strudel. It was nearly time for Rosh Hashana, and she had already begun her preparations. The holidays were late that year, and it was almost the end of September.

"Everybody will be here soon," she said. "It will be nice to have the family all together for *Yontif*. Remember, Rosele, the family is the most important thing. Friends will come and go, but your family is always your family."

I was sitting at the table doing my arithmetic homework, getting more agitated by the minute. I had begun fifth grade just a few weeks before, and I already knew that it was not going to be a good year. "I hate arithmetic!" I cried, "and I hate Miss Gottchalk!" Grandma had been sprinkling one little pinch of sugar on each piece of the golden pastry as the tears started rolling down my cheeks. She stopped what she was doing and wiped her hands on her apron. She sat down next to me and put her arm around me.

"I don't like to hear you talk like that," she said. "You have to have respect for your elders, and you have to have respect for your teachers." "But, Grandma, how can I have respect for someone like her? She is so mean to everyone, and she picks on me all the time." "If you can't respect the person, you have to respect the position," she answered. "She's your teacher, and you have to do what you can." "But, I can't even think when I'm in her class. I know my tables, and I know what seven times six is. But when she points at me, I start to shake and everything goes right out of my head. I hate her!"

Grandma didn't say anything. She got up and started putting pieces of *strudel* on a plate. She covered it with aluminum foil and put the package down in front of me. "Will you do me a favor?" she asked. I looked up at her wondering what she was up to now. "When you go to school tomorrow, give this *strudel* to Miss Gottchalk."

"What! Why should I give her anything? She doesn't care about me. She doesn't even know who I am." "I know," she went on, "but do it for me. What can you lose? It's only a plate of *strudel*." I loved my grandmother with all my heart. I wasn't so sure about this, but if she wanted me to do something, how could I refuse?

The next morning, I put the package into my school bag along with my books and my lunch. I was a little embarrassed that the others would see me, but I had to do what I had to do. Miss Gottchalk had her back to the class, writing the problems for the day on the blackboard. She was rail-thin, skeletal even, with white, white skin that reminded me of chalk. Her raven-black hair was pulled back into a tight bun. If I thought that Mashinka was intimidating, that was nothing compared to Miss Gottchalk. I could hardly breathe in her presence.

I quietly slipped the foil-covered plate onto her desk and tried to slink away. But she had spotted me out of the corner of her eye. "What's this?" she asked. "My grandmother made this *strudel* yesterday, and she thought you might enjoy some." It came out barely more than a whisper. And then, something happened. For the first time since school began, she actually smiled. I couldn't believe it. Her whole face looked different, and I wondered why she didn't smile more often. When she did that, she was actually not bad looking. "Thank you, Rosalie," she said kindly. (She did know my name!) "Please tell your grandmother thank you for me."

As I sat down, I remember thinking that maybe that was the first time anybody had ever given her anything. I started to look at Miss Gottchalk a little differently. Maybe there was a real person underneath that gruff exterior. She actually spoke to me like I was more than just a body sitting at a school desk.

From that day on, Miss Gottchalk always smiled when she greeted me. I still hated arithmetic. It has never been my favorite subject, and I think this is largely because of Miss Gottchalk. But I learned an important lesson that day. I learned that everybody has feelings and needs to be treated with respect and like a human being—children, too. We all respond to kindness. I still think she was a bad teacher—not because she didn't know her subject, but because she didn't understand how fragile her young charges were, and how her withering looks could damage their self-esteem. And when those looks and harsh words come from a teacher, the student can be turned off to that subject forever. I also learned, once again, to trust my grandmother.

A Question of Values

When we talk about Jewish wisdom, we are really talking about values. Love of family. What is right and what is wrong. Respect. And good old common sense. God gave us the freedom to choose which actions we take. If we were not free to choose evil, then we would not be free to choose good, either. All the stories, the proverbs, the sage advice revolved around moral responsibilities and obligations that we have to God and to each other. In Judaism actions are much more important than words.

Rabbi Hillel said, "If I am not for myself, who will be for me? And if I am only for myself, what am I? And if not now, when?" If I learned anything from my grandparents, it was to have respect and consideration for others. But not to forget to respect myself first. "Be a *mentsh*!" Be a good human being. That, to them, was of paramount importance. I don't mean to give the impression that they were continually lecturing to me. On the contrary. They didn't preach it. They *lived* it. They taught by example.

Itzhak Emanuel talked about the values with which he was raised "They were: respect of my elders, love of family, love for the people of Israel. These are the values that will always stay with me wherever I go.

"My mother's father was one hundred and six when he died. He was a tailor, like my father. Before he died, he told me, 'Life is what you do with it. You have to know yourself.' And he also told me, 'Remember, every hour of the day—every day—every month—whatever you do, it will never come back. It's gone. So what you do with it, that's what you have.'

"In order to remind me of this, he said 'I don't have much to leave you when I'm gone. I'm going to leave you one special thing that will always remind you...the clock that is on my wall. Every time you hear the sound of this clock, remember that the time will never come back again. So, do whatever you can with your time.' And I still have this clock on my wall.

"After he died, when I opened the clock, I had a surprise. I found a scroll of the Book of Esther that he and I used to read together for years and years whenever I was with him. These were two very valuable memories that represent values he taught me."

Cantor Emanuel went on to say, "Both of my grandfathers gave me precious gifts. My father's father gave me a love of singing songs and prayers. My mother's father talked to me a lot about Jewish wisdom and philosophy. Between both of them, I learned a lot. I cherish them very much.

"My mother's father was called *Cha-Cham Dovid* (wise man)—another title for a rabbi in the Sephardic tradition. Before the high holidays, at the time of Selihot, (a special service for penitential prayers), the *shamash* (caretaker of the synagogue) used to come and knock on the door and call 'It's time to get up!' It was about four or five o'clock in the morning. In the Sephardic tradition, these prayers have to be said before sunrise. I used to go with him, and it was a precious experience. I loved to listen to the melodies. He was regarded as the leader of the synagogue, and *Cha-Cham Dovid* for the neighborhood. Even today they continue to light a candle in his memory in the synagogue.

"I learned from him the most important things. 'What is hateful to you, don't do to others' and 'Before you do things—think!' I was for him like a sponge. I learned and I learned. It was a rich, rich childhood with values and with love...love of our family and love of other people. And the best part is that for my whole life, I continued to teach my own children the same things."

(In America, the Selihot service is usually held at midnight on the Saturday preceeding Rosh Hashana. These prayers are also recited on many occasions during and before the holidays.)

In his book *Down to Earth Judaism* (William Morrow and Company), Arthur Waskow wrote: "There is wisdom in community and history; wisdom in joining a 3,000-year-old conversation. Not everything in Jewish tradition is wise—not by a long shot. But the conversation is wise: the talking, the questioning, advising, debating."

Sacred writings, such as the Torah or the Midrash, are almost inexhaustable repositories of the legends, myths and parables of the Jewish people. Jews of every age and every country absorbed these elements of folklore and entered them into the cultural experiences of their lives. There was always a proverb or a story which answered the question or illustrated a point.

And they used common sense. "Always respect other people, but don't forget to also respect yourself." "Do the right thing." "Be a *mentsh!*" "Think before you speak. Once something is out of your mouth, you can never take it back." "Count your blessings. Appreciate what you have. You never know what tomorrow will bring."

I have often marveled at how wise my grandparents were. For uneducated people from the pale of settlement, they always seemed to know an awful lot about life. When I think about the many times I have hoped and prayed for the "right" thing to say to my children when they needed my guidance, I am even more awed.

Where did they learn all these things? They may have been unedu-
cated, but no one ever said they weren't smart. My grandfather was a
pretty astute businessman, and Grandma was no slouch either. The De-
pression played havoc with their lives, like everybody else's. They, too,
lost everything and had to start over. But they landed on their feet, en-
tirely due to their own efforts.

Most of the sayings and stories they told, they had heard in their
own homes or synagogue or in the marketplace. And they had the knack
of being able to relate what they knew to whatever situation happened
to be occuring at the moment. Common sense has always been the most
valuable commodity in the struggle for survival.

My grandparents learned this lesson well. They had always had to
manage for themselves. They had always had to figure out what course
of action to take or what decision was needed. They made the biggest
gamble of their lives when they decided to leave their families, their
homes and their country for a chance to escape the repressive atmo-
sphere of Russia with its poverty and pogroms to start a completely new
life. What courage that must have taken. And all the time knowing that
they would probably never see their parents or country again. They fled
for their lives in the wake of pogroms, inquisitions and massacres to seek
a place of refuge and of peace.

The thing is, they managed to take much of what they valued with
them, all the way across the ocean to the New World. What was in their
hearts and minds didn't take up any room in their small packs. It wasn't
heavy. But it was their most valuable possession. They brought along
their memories and traditions, and they also brought the collective wis-
dom of their people in the old stories and expressions. The wisdom of
these old tales provide insights into the very essence of our faith.

A Variety of Views

Judaism focuses on relationships: the relationship between God and
man, between God and the Jewish nation, between the Jewish nation
and the land of Israel, and between human beings. Talmudic scholars
have spent lifetimes trying to interpret the infinite intricacies of these
relationships. Our Scriptures tell the story of the development of these
relationships from the time of creation. They also specify the mutal obli-
gations created by these relationships. The various movements of Juda-
ism disagree, however, about the nature of these obligations.

The Orthodox say that they are absolute, unchanging laws from
God that must be followed without exception.

Conservative followers say they are laws from God that change and

evolve over time but must be followed religiously as they are interpreted by current dictates.

Reform believers say they are laws from God that change and evolve over time, and which serve as guidelines that emphasize the moral way of life that is mandated by God. (Not so much *rite* as *right*. "The essence of God is morality.")

And the Reconstructionist branch defines itself as religious humanism with traditional rituals, and says that one should study the laws and then search within to find what is relevant.

The logic of the old tales usually embodied the basic premise that love of God and consideration of others took precedence over everything else. To call someone a *mentsh* was to give him or her the greatest compliment. A *mentsh* is someone who is a decent, considerate, honorable human being, someone with character. "Be a *mentsh!*" is a common expression of advice. Much more than "Be a man"; more like "Be a good human being!" It has nothing to do with success or status. If someone isn't a *mentsh*…that is one of the worst things that you can say about that person.

Some of our wisest sages gave advice that is as timely today as it was so long ago. Hillel said:

"Those who cease to learn, cease to live."

"Do not say, When I find time I will study; time is never found, only made."

"More Torah, more life. More learning, more wisdom. More counsel, more insight. More charity, more peace."

"Acquire a good name and you acquire fame; but acquire wisdom, and you acquire eternity."

Rabbi Judah ha Nassi said:

"Remember three things, and you will not err: If your deeds shouldn't be known, perhaps they shouldn't be done. If your words shouldn't be shared, pehaps they shouldn't be spoken. Act with attention, for all your deeds have consequence."

In Judaism, actions are far more important than words. Everyone has heard the story about the two women who went to King Solomon, each claiming to be the child's mother. The king's instruction to "cut the child in half" quickly showed which woman truly cared for the child.

In one classic folktale, a rabbi's wisdom saved the entire community

of Seville, Spain, from death. He had been arrested, along with other leading Jews, and accused of murdering a Christian child and using his blood in a religious ritual. (This accusation became known as "blood libel.") The priest declared that their future would be in God's hands. He would simply fold two pieces of paper and put them into a hat; one would read "Innocent" and the other "Guilty." The rabbi was to choose one of the pieces of paper. If he chose "Innocent" he and the other Jews would be released. But if he chose the one that said "Guilty" all of Seville's Jews would be killed.

The hat was placed in front of the rabbi. "At least there's a fifty-fifty chance," someone said. The rabbi, however, was smart enough to realize that there was no chance at all. The priest couldn't run the risk that either chance or God would save the Jews. He was sure that both pieces of paper had to read "Guilty."

The rabbi quickly pulled out a piece of paper, put it in his mouth and swallowed it. "What have you done?" the priest cried. "How will we know which one you swallowed?"

"Look at the one that is left in the hat," the rabbi said. "Whatever it reads, I swallowed the opposite!"

This is what we call using your head!

Another old story also illustrates the logic of our wise judges. One day a poor man saw a little bag lying on the ground. He picked it up and found, to his amazement, that there were a hundred coins inside. That very day, it was announced that the richest man in town had lost a large sum of money and had promised a reward to the finder.

When the poor man heard this, he began to struggle with his conscience. No one had seen him find it, and his children were crying for food. Besides, if the loser of the money was so rich, would he ever miss it? But then he became ashamed of his impulse, and hurried to return the money.

The rich man took it without even a "thank you," and began to count the coins. Meanwhile he thought, "This man is a fool. Maybe I won't have to give him anything."

"Where is my reward?" the poor man asked timidly.

"Reward!" cried the rich man. "For what? I lost two hundred coins, and there are only one hundred coins in this bag. Since you've already stolen one hundred coins, I don't have to give you anything."

"Then let's go to the rabbi," suggested the poor man. "Very well," the rich man replied. The rabbi listened attentively to both men. Then he turned to the rich man and asked, "How much money was in the bag

you lost?" "Two hundred coins." "And how much money was in the bag you found?" he asked the poor man. "One hundred coins." "In that case," said the rabbi to the rich man, "the bag of money he found is not yours. You'll have to give it back to him!"

Sometimes a person can be too clever for his own good!

Well, obviously, not everybody is as wise as these old sages, but Grandma and Grandpa didn't do too badly in the advice department anyway. If I was frustrated because things weren't going the way I wanted them to, it was "If you can't go over, you go under," or "If you can't do what you want, you do what you can." If I got off on a tangent and tried to do too much at once, I heard, "You can't sit on two horses with one *tuchiss* [behind]." Or when someone complained about something that seemed too good to be true, "What's the matter? *De kalleh iss tzu shayn?* The bride's too pretty?" When I was confused about something, Grandma told me, "Listen to what everybody has to say. Then do what *you* want." A smart lady.

Here are some other sayings or expressions that my friends and I remember:

> From your mouth to God's ears! (This one still pops out of my mouth on a regular basis.)
> One always thinks that others are happy.
> No answer is also an answer.
> You can't ride in all directions at the same time.
> Better the devil you know than the devil you don't.
> A wise man knows what he says; a fool says what he knows.
> God takes with one hand and gives with the other. (Or, some say, when God closes the door, he opens a window.)
> Money can't buy happiness or good sense.
> If the rich could hire others to die for them, the poor could make a living.
> When one must, one can.
> If you sleep with dogs, you get up with fleas.
> Life is a bargain. We get it for nothing!
> Men think (plan), and God laughs.
> It's just as easy to fall in love with a rich man as a poor one.
> If you haven't tasted the bitter, you can't understand the sweet.
> A boil is fine, as long as it's under somebody else's arm.
> Better one old friend than two new ones.

Scratching and borrowing are only good for a while.
When a girl can't dance, she says the band can't play.
If you can't bite, don't show your teeth!
He who is no good to himself, is no good to another.
A half truth is a whole lie.
Nothing is ever lost. It's just where you haven't looked.

And I'm sure I wasn't the only one who heard: "Always wear clean underwear; you never know if you'll be in an accident." God forbid your underwear wasn't clean and some stranger saw it—it would be a *shandeh* (a shame). Leave it to Grandma.

Sometimes Old World people had trouble understanding New World ways.

I heard this story from the fifties about a boy named Benny and his old grandfather from Poland, who was very much puzzled about all the newspaper publicity about a scientist named Einstein and his theory of relativity. "Tell me, Benny," he finally asked with curiosity when his grandson returned from college for the summer. "Who is this Einstein, and what's this relativity business?"

"Einstein is the greatest living scientist," Benny answered enthusiastically. "Relativity is—well, it's hard to explain. Let me put it this way: if a man's sweetheart sits on his knee, an hour feels like a minute. On the other hand, if the same man sits on a hot stove for a minute, it feels like an hour. That's the theory of relativity!" Benny concluded triumphantly.

Grandpa looked shocked. For a minute he sat in silence, and then he finally asked, "And from that, this Einstein fellow makes a living?"

Everything Is Relative

Daisy Gelb remembers this story which demonstrates one way of solving one person's problem: A *rebbe* went down the street and met a poor Jewish man. "How are you?" asked the *rebbe*. "Oh, Rebbe, I am very poor, and my house is very little. I have many children and lots of troubles. Can you give me some advice?"

The *rebbe* said, "Do you have a dog?" "Yes, Rebbe." "Bring the dog inside, and keep it in your house."

The next week, the man came and cried, "Now I have more trouble. Help me, Rebbe." The *rebbe* said, "Be patient. Do you have a rooster?" "Yes, Rebbe." "Bring the rooster inside and keep it in your house."

The next week, the man came and cried again, "Now I have much more trouble. I can't live this way anymore!" The *rebbe* said, "Be patient!

Do you have a goat?" "Yes, Rebbe." "Bring the goat inside with the other animals."

The next week, the poor man came and cried, "Help me, Rebbe. My wife is very angry. The dog fights with the cat all the time, the rooster flies about the room and yells like a crow, the goat bleats constantly, and the children are always crying."

The *rebbe* said, "Now you have to take out all the animals." The next day, the man came back and said, "Rebbe, now I am happy. My wife and children are very happy, too. We have much more room, I have no more trouble and we are all content."

Everything is relative. Learn to appreciate what you have! For every situation there's always a story, and for every story, there's always a moral.

Esfir Dynkina, from St. Petersburg, Russia, told me about an incident which showed how her mother expressed her feelings in a way that made her really understand:

"The best day for me was the day when I was born. I was the second girl. My parents wished for a son, but they got me. My brother was born soon after. So my mother was happy to have her three children.

"One time I asked her, 'Do you love me as much as your other children?' And she answered, 'Whatever finger I cut, the pain is the same.' Her explanation made me realize that we were each important to her and that she loved us all."

My grandson Joey told me how you couldn't tell things that weren't true, or else nobody would believe you when you told the truth. His mommy had told him about the boy who cried "wolf" all the time to make people come running. When a real wolf came, nobody believed him, and they wouldn't come.

Aesop's fables aren't a Jewish thing, but Aesop wasn't the only one making this point. The Talmud also states, "A liar's punishment is that even when he tells the truth, he is not believed." People have always told stories to teach a lesson or make a point. My daughter might not have realized that by doing just that, she was following a tradition that goes back hundreds of years.

Music teacher Rosa Zaks Feldman talked about her father and his *saychel* (common sense): "Tatele was always busy at the tailor shop. As he worked, several of his pals would come in to chat. While hovering over the sewing machine, they would discuss the latest politics, philosophy, local business and the economy. He was well informed about the daily

news. He was also full of wise advice. He often told me, 'Rosele, think before you speak, and when you speak do not talk foolishness. The mind should work and the tongue should slow down.'

"I have learned many lessons from my parents," Rosa added. "From Mamele I learned that we should always live life to the fullest, because tomorrow we may not have a life to live. And from my *tatele* I learned that laughter will give you a desire to live and the enthusiasm to celebrate that life."

Judaism puts great stress on reverence for parents, respect for our elders and charity for the less fortunate and infirm. Stealing, flattery, falsehood and oppression are forbidden. Justice, truthfulness, care for the less fortunate, regard for the rights of others, love for our fellow man and mercy for the beast are virtues which are taught.

There is also great emphasis on the sanctity of life. We can't forget that life is precious. We must preserve it and enjoy it. In fact, according to the Talmud we should not deprive ourselves of pleasure *that does not hurt anyone else*. To do so might mean that we are ungrateful for the blessings we have been given.

Curses!

My grandparents were pretty even-tempered. They didn't often get angry; but when they did, some of the curses that were uttered were hilarious. Not that very many harsh words were spoken in their house, but on the rare occasion when one of these expressions passed their lips, I could hardly believe my ears.

The worst one that I ever heard my grandfather come out with when he was *really* upset with someone was "*Er zol vahksen vi a tsibele, mit de kop en drerd!*" (He should grow like an onion, with his head in the ground!) Not quite "Go to hell!" but a much more interesting way of expressing the same sentiment. He may have been angry when he said these words, but the image always made me laugh. Leo Rinsler says he remembers his father using this same curse. Even in their anger, they managed to vent their emotions in the most colorful ways.

When Grandma reached the end of her rope, she cried *"Hock mir nisht kein chainek!"* (Don't bang on my teapot!) Leave me alone already! Or *"Klop mir nit in kop arayn!"* (Don't bang into my head!) Stop talking so much! Believe me, this was pretty strong stuff.

Not everyone was as subtle. Some curses were really mean:
"He should lose all his teeth except one; and that one should ache!"

Ouch! Fortunately, these were not often heard in my vicinity.

Other Proverbs

There were other rather picturesque expressions that I recall hearing fairly frequently, such as:

> *Vey iz mir!* (Woe is me!)
> *Azoy geyt iss.* (That's how it goes....)
> *Es gornisht helfn.* (Nothing will help.)
> *Far dem zelbn gelt.* (For the same money; while you're at it....)
> *Geb zikh a shokl!* (Give yourself a shake! Hurry up!)
> *Host es gedarft?* (Do you really need it?)
> *Loyf nit.* (Don't run. Take your time.)
> *Loz im geyn.* (Let him go.)
> *Tuchiss afn tish.* (Rear end on the table. Let's be serious.)
> *A gantsa Megillah.* (A big, long story.)
> *A gantsa tsimmis.* (A big deal.)
> *A kleyner gornisht.* (A little nothing.)
> *A lek und a shmek.* (A taste and a smell—only a little bit.)
> *A kop dreyanish.* (Makes you feel all turned around—drives you crazy.)

And of course—

> You can't dance at two weddings at the same time!
> It shouldn't happen to you!

No wonder I'm so fond of the *mama-loshen*. How else could you say so much in such a few words? Because it wasn't just what they said, but the whole feeling that their words conveyed. With a nod of the head and a wink of an eye, the wisdom of the ages spilled out with their wonderful expressions.

And they were also wise enough to know that a lesson taught with humor was a lesson retained.

That's Entertainment!

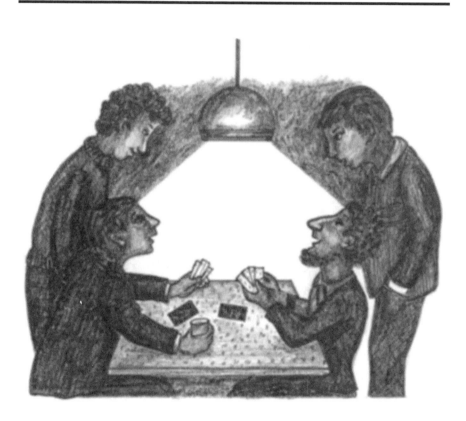

Life is a banquet—sometimes bitter, often sweet.

•

"Measure life's worth according to its blessings."
—*Rabbi Akiva*

THE WAY WE ENTERTAINED OURSELVES had a lot to do with our environment and the values our parents instilled in us. I never had many toys. In fact, we had a small smoking cabinet in our living room, and just about everything I owned fit inside. With the exception of my Princess Elizabeth Doll, that is. I got her for my sixth or seventh birthday, and she became a favorite companion. I also had a Captain Marvel ring, complete with secret compartment. Nothing walked or talked on its own, of course, or came with batteries. Everything was completely child-driven.

But despite the fact that we didn't have television, there was plenty to do to keep us busy. Humbolt Park alone, with its 250 acres and picturesque lagoon, was an endless source of amusement. My father often rented a rowboat and took my mother and me for leisurely rides on lazy Sunday afternoons. There were always young people riding bicycles, rollerskating or playing ball. All four of my grandparents loved to sit on a park bench and watch the world go by. Tall trees with billowing branches cast shadows as they swayed in the breeze, sunlight dappling through their leaves and throwing shimmering reflections on the pathways and fields. With intense concentration I collected my flowery treasures, making chains of the wildflowers whose little pink and white faces popped through the blades of green looking for the sun's warm glow. The Good Humor man was a common sight, pedaling his bike with the insulated box attached. "I scream, you scream, we all scream for ice cream!" The tinkling bells and his melodic cry could be heard at frequent intervals. You might even occasionally see the organ-grinder with his little monkey begging for pennies with his outstretched cap.

In the middle of the park was a field house. All sorts of recreational activities were held here. This is where I learned to paint Easter eggs; we would never have done such a thing at home. Besides arts and crafts, they had a day camp every summer. I attended several times, and one year when we were fourteen, Sid and I both worked as junior counselors

there. They also had square dancing every weekend, and before we "graduated" to movie dates, this was a regular event for the two of us.

When my grandparents came to America, they immediately set out to learn English, but at home they usually spoke the familiar *mama-loshen* (Yiddish). I remember how surprised I was when, at a very young age, I suddenly realized during an animated conversation between my mother and grandmother, that I actually understood what they were saying. One of the things that Grandma and Grandpa really loved to do was go to the Yiddish theater on Kedzie and Ogden avenues. When I

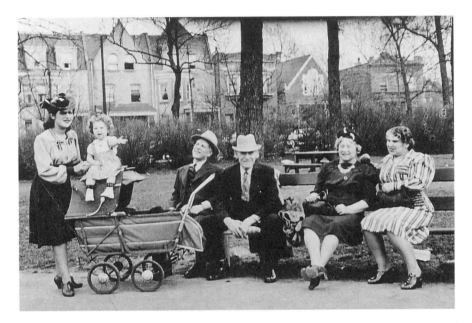

Sitting on a bench in Humboldt Park, 1941

was older, I looked forward to the times when they let me come with them. You had to take the streetcar to get there. It was such a spectacle, with its music and costumes and colorful language. Grandma sat next to me and whispered into my ear, translating, like a living dictionary, as best she could what I didn't understand. We saw famous actors like Manasha Skulnik, Molly Picon and a young performer named Bernard Schwartz, who later went to Hollywood and became Tony Curtis.

Hearing me talk about the Yiddish theater one day made Leo Rinsler, a retired engineer from New York, think of his own experiences: "When I would go to the Yiddish theater with my mother, we would go by subway to either the Second Avenue Theater or the National Theater.

My mother always liked to go to the dramas, not necessarily the musicals. Between my parents they had their own rating system as to how good the drama was. So when my mother would come home, my father would ask her, 'All right, Rushka [her name was Rose], how many *shmattes*? How many handkerchiefs did you have to use?' One was poor; two or three was a really good drama; and four *shmattes* was the ultimate.

Sometimes my mother and I went to the Goodman Theater on Michigan Boulevard, where they put on children's plays, fairytales with professional actors and elaborate sets. If we had lived in New York City, I'm sure we would have been regular visitors to the Broadway shows. As it was, we didn't have Broadway, but we did have the Shubert Theater downtown. The stage plays we saw there had me enthralled. In fact, I enjoyed the theater so much that my mother decided to sign me up for a children's drama group.

My mother was a firm believer in "lessons." I took tap dancing lessons, ballet lessons (I was much too much of a klutz for these), piano lessons, voice lessons and dramatic lessons. I never had the talent to become a star, but I've always been a "closet ham" (you should excuse the expression!) We even went by train to other small towns to put on our plays. Once I actually had a part on a weekly radio show called "The Websters," though my character was only on for a few episodes. People who have known me over the past thirty years or so won't be surprised by all this. Beginning with little plays which I later wrote for my young pupils to perform for school assemblies, I periodically had a lot of fun on stage, singing and dancing in musical comedy shows which I helped to write for numerous organizational fundraisers. My mother was so happy that all the lessons didn't go completely to waste.

In 1949 my grandparents got their first television set. Uncle Sam was an engineer with Admiral, and he made sure that they had one of the first ones on the market. It was black and white (color didn't come along for a while yet) with a "big" seven-inch screen in a mahogany cabinet. (No portable sets were being made in the beginning.) There was even a piece of plastic with colored stripes which you could attach to the front of the screen to give the idea of a color picture.

The very first program I ever watched was "Kukla, Fran and Ollie." I was a little old for a puppet show but, like everyone else, I was completely mesmerized by this little magic box. Tuesday night meant Milton Berle, and Sunday was reserved for Ed Sullivan. Even the test pattern, which was on most of the time, had an hypnotic attraction. The earliest shows were few and far between, but we were hooked. When my parents

got their own set shortly afterwards, I would sit in front of it and knead the package of margarine. The white doughy-looking stuff, accompanied by a little egg filled with yellow-orange food coloring, was encased in a clear plastic pouch. When you squeezed the egg, it broke, releasing its tinted contents. By kneading the mixture until it was smooth and yellow, you ended up with something that almost resembled the whipped margarine we use today, except it wasn't in tubs. Anyway, this was my mindless "job" as I sat there staring at the moving picture on the screen.

Fortunately, programming improved greatly as time went on, and we actually experienced some pretty good entertainment as the 1950s progressed.

One of the people responsible for this improved entertainment was Erna Lazarus, the mother of business owner and commercial radio voice Addie Kopp. "Humor has always been so important to the Jewish people, and my mother became a comedy writer," Addie said. "She did other things besides comedy, but comedy and dialogue were what she did best. So her take on everything was always a little on the Jewish side. Not obviously so, but even when she was writing for Martin and Lewis, it was really funny stuff that she would've said automatically. Her philosophy was so influenced by her Jewish background. It was what gave her the courage to strike out as an author on her own, which was definitely breaking a barrier into what was then definitely a very male-dominated field.

"Mother's brother, Milton Lazarus, was also a well-known writer in the entertainment field, having written such things as 'Song of Norway.' And her cousin, Emma Lazarus, won her place in the the world when her famous lines 'Give me your tired, your poor, your huddled masses yearning to breathe free...' were inscribed on our reknown Statue of Liberty. So writing was definitely in her blood. She was no Dorothy Parker, nor even an Adela Rogers St. John, who was a journalist and a very good friend of hers. But she was a very talented radio and, later, television writer.

"She told me about an interview she went on back in the early forties. She was a free-lance writer, and she would get a studio assignment—which was wonderful. If they liked the outline, she'd do a treatment; and if they liked that, she'd go on and do a full script. If she was on a series, especially television, which she did a lot in later years, those were always done in thirteen-week segments, and maybe she'd get two or three of those segments back to back. So many of the shows she wrote radio scripts for, like 'Ozzie and Harriet,' 'Father Knows Best' and 'Dragnet,' among others, went on to become weekly television programs,

and she continued writing for those. But she was always going on interviews. Her agent would send her out when he had practically finalized the deal.

"She was working on the Sunday night Maxwell House Coffee Show, doing all kinds of comedy stuff, when she got a call from her good friend Abe Burrows, who sent her to be interviewed by Ed Garner, who was doing 'Duffy's Tavern.' (Garner also played Archie.) Her agent had sent some of her material, which they obviously were very interested in, but nobody had paid any attention to the author's name. When she came in, Garner took one look at her, saw she was a woman, and said 'How do I know you can write comedy?' She answered, 'Mr. Garner, how do I know you can read it?'

"When she came home and told us about this exchange, we couldn't believe she had talked to him like that. But she was livid. She didn't get the job, but she had to speak her piece! She was a young woman of thirty-one when she began breaking into this male world, but she was also very much a feminist, way ahead of her time. She gets upset with the practices of feminists today because she feels that by identifying themselves as strongly as they do they are actually creating a barrier where there should be a bridge. Her attitude is that 'we're all in this together—writers, actors, whatever...together. Not one group entitled to special preferences.'"

Addie went on to talk about her grandmother and her philosophy. "My grandmother had the attitude that if you make up your mind, and God thinks it's right for it to happen—it's gonna happen. But first you have to make up your mind. And then, if it looks like God doesn't think it should happen, you'll find out soon enough. Well, mother made up her mind. She struck out on her own, and she made it happen. When she was working at home, we knew not to bother her. She would try out the stuff on us at the dinner table, and she was just so funny.

"My mother wrote for just about all the biggies at one time or another. She knew a lot of celebrities, but she only associated socially with people she liked. She was a real rarity in that way. She never used her private life to enhance her career. She wrote for Groucho Marx and Milton Berle. In fact, I heard her talk about the Berle brothers millions of times. They had all gone to Sunday school together—the Mt. Nevo Sunday school on 72nd Street in New York City. Morrie Amsterdam was another very good friend.

"There were so many of these talented people that were such good buddies, because it was the kind of humor that made them gravitate to each other. It was Jewish humor; not a cruel humor, but one that pokes

fun at itself, not others. They went through life looking for the absurd, and they found it everywhere they looked. If it wasn't in the genes, it was in the milk."

Addie's background fascinated me, so I was delighted when she shared some more: "I was a painfully shy child, though you'd never know it to hear me now. But it was so bad that whenever we went anywhere and somebody would ask me a question, my mother or grandmother usually ended up answering for me.

"During the Depression, the Hollywood Professional School decided to have some evening classes in radio writing, which is what my mother was doing at the time. They asked her if she would teach a class. She agreed, but only if they would allow me to enroll in the radio performing classes. So that's how I got my early experience in reading for the radio. She reasoned that if all I had was a piece of paper and a microphone, I would learn how to talk…. I guess she was right, because I haven't stopped since! I always felt that that was such a wonderful thing for her to have done. She was such a Jewish mother in her own way. She always made sure that her kids were going in the right direction."

Addie still uses her wonderful speaking voice reading books for the blind. When Addie said that humor was important to the Jewish people, I think she was stating a very important point. Jews have always used humor to cope with their problems. The ability to laugh at adversity may be one of the greatest contributions that Jews have made to our modern world. Without it, I wonder if we, as a people, could have survived.

Comedian Alan King, in one of his astute observations, commented that "The ability to laugh at ourselves, at all the sorrow, the grief, the aggravation, is good. Grief and aggravation are not Jewish monopolies, but the ability to laugh at them is one of the greatest contributions of our people."

One interesting example comes from a recent emigre, Frieda Gorlina. Frieda, who is from Moscow, told me about her husband's unique form of humor, which became a tradition in their marriage. She called it *bad-i-nage*.

"When we got married, life in Russia was very hard. My husband and I were young and poor. He usually got up earlier and left for the office while I was still asleep. On awakening I would come across a little piece of paper with some request or message…written in Russian, of course, and always in verses of four lines. It was *bad-i-nage*, or friendly joking. He wrote on the slightest provocation, pointing out that his pants needed mending or his shirt needed washing; or maybe it was an

apology for taking some money from my purse—but always in rhyme.

"Each time I opened my eyes, I began to search for a little piece of paper written in a careless manner. I can't translate them well because I am not a poet. How foolish of me not to have written down all that he had said. Here is one example:

> I briefly say for you to know,
> I badly need my pants to sew;
> In place that is on back...below.
> Penelope, I have to go!"

Maybe it's no coincidence that so many of our most talented writers and comedians were Jewish. As Addie said, "It's in the genes!"

When we weren't going to Riverview Park or socializing at North Avenue or Montrose Beach, another popular form of entertainment was sports. The one that was actually almost a bad word in our house was tennis. My father was a tennis fanatic. He loved the game, and living in Chicago, this presented something of a challenge. It meant an outdoor club for the summer, and an indoor club during the winter. He was a ranked player back in the days when this game wasn't yet fashionable. Unfortunately, I didn't inherit his playing ability, but I did inherit his love for the game and still play as often as I can.

In Chicago, sports meant the Cubs, the Bears and the Bulls. My husband, Sid, has always been an avid fan and is still loyal to his home teams to this day. I don't know what he would do without satellite T.V. Neither he nor our son, Larry, will willingly miss a Bull's basketball game if they can possibly help it.

One of our friends, Mel Gordon, who grew up in Brooklyn, also had a strong love of sports—specifically baseball. He told me a story about his efforts to make his dream of becoming a professional baseball player come true:

"I had a dream. I always wanted to be a professional ball player. At twenty-one, I was still going to college and majoring in meteorology when I decided to do something so nervy that even I can't believe I actually did it. It was my burning desire to play that gave me the courage to make a phone call to Mr. Ralph Houk, who was then the manager of the New York Yankees. Getting through to him at Yankee Stadium was impossible. So, knowing what city he lived in, I got the idea of calling information and trying to reach him at home. I had no way of knowing if his number was even listed; but, sure enough, they actually gave it to me.

"'Mr. Houk,' I said, 'I know you don't know me. I'm eighteen years old (I knew they'd never even consider anyone as old as twenty-one), and I'd love to try out for your team because I think I have great potential and I'd like to show you what I can do.' All this came out in one fast rush. To my astonishment, he told me to be at the stadium on such and such a day at such and such a time, and I could try out then.

"I couldn't believe it. I was ecstatic. People wait months, or even years, for a chance like that, if they ever get one at all. As I hung up the phone, my heart was thumping and it took me a while to realize that I really had an appointment to try out for the New York Yankees. And then I realized something else.... I didn't even own a pair of cleats. I called one of my cousins and arranged to borrow his. When the big day arrived, I strode into the locker room, got dressed, and started to put on my cousin's shoes. They were two sizes too small! I jammed my feet into them anyway, and stormed out onto the field.

"It was awesome! It was the first time in my life that I had ever been on such a field. And knowing that it was the same field where players like Lou Gehrig, Joe DiMaggio and Babe Ruth had played absolutely took my breath away.

"I didn't even know what position to apply for. I knew I was a pretty good player, but I didn't really have one position to claim as my own. Thinking that they needed pitchers more than the other positions, I foolishly said, 'I'm a pitcher.' Unfortunately, I only knew how to throw one ball—a fast ball. I threw a few of those, and then they asked me to show them a curve ball. Well, I threw the way I thought a curve ball should be thrown, but the ball stubbornly stayed on a straight course. 'Is that the only ball you can throw?' 'Yes, I'm afraid so.' 'Can you play any other position?' 'Yessir,' I answered, 'shortstop and left field.'

"Thank God that guy was nice enough to give me another chance. I hit three out of the first five balls they pitched to me way out into left field, and felt pretty good about my performance. 'What are your future plans?' was the next question. 'I'm still in college,' I told him. Well, those days, being in college didn't go with being a professional athlete. If you wanted to pursue that career, school was out. He offered me a position playing Triple-A ball, which was considered the first step to the big leagues, and told me to let him know my decision.

"I went home to talk it over with my family. Our family was close, and I was brought up to respect my elders' advice. But being a professional baseball player was not exactly high on their list of things for a nice Jewish boy to do. They discouraged me in no uncertain terms. Give up school...to play a game...you can't be serious! I respected them dear-

ly, and felt I would've let them down by choosing this path. Reluctantly, I called and said no.

"It was a tremendous chance. I'll never know if I would've really made it, and regret to this day that I didn't follow my heart and do what I wanted rather than what they wanted. But I still look back on that experience as one of the most exciting days of my life. At least I had a chance to try it. And I always felt that if it was meant to be...."

Mel is a very determined fellow. Talk about making up your mind to do something.... When it came right down to it, his parents' values significantly affected the direction his life took; but how many people would have gotten even that far on sheer *chutzpah*? And playing baseball wasn't the only dream Mel had. His determination drove him to fulfill still another fantasy:

"I also always had a desire to make people laugh—but to laugh at themselves. During the Vietnam War, I was in the Signal Corps, which made good use of my expertise in meteorology. While in the Army, I started jotting down some comedy situations in a book which I always carried with me. I had no idea what I would do with it, but the writing amused me, and so I wrote whatever popped into my head.

"I got out of the service just about the time that President Kennedy was assassinated, and found, to my dismay, that jobs in my field were nowhere to be found. Because of government budget cuts and the subsequent shuffling around, most of the available spots had already been filled. The job I had been looking forward to with WNBC was gone. I went through a period of depression, not knowing what direction to follow. I had been offered a job at the south pole working with a geological survey team, and another in Barbados doing research which involved shooting silver-tipped arrows into clouds. Another offer in Amarillo, Texas, sounded appealing, until I actually saw the place. I'm sure it's beautiful now, but thirty years ago, there was nothing there but cactus.

"So I drove back to New York, and contemplated my options. By then I had about twelve hundred comedy situations collected in my book. I decided to go down to the Ed Sullivan Theater, where the show 'Candid Camera' was being taped. My mother went with me, and I stationed her outside the side door while I covered the front. 'If you see Durwood Kirby [Alan Funt's sidekick], give a yell,' I told her. When he came out, she was so excited to see an actual celebrity, she almost couldn't get a word out. I came running over, and asked him if Alan Funt was still in the building. He told me that he was and would probably be leaving shortly.

"By the time he appeared ten minutes later, it had started to pour. I

was soaking wet, but I wouldn't budge. I just stood there in the pouring rain until I spotted him come through the door. Of course, he wasn't in the mood to stand out in the rain and talk to a complete stranger. But, again, I was determined, and wouldn't let him go until I explained who I was and that I wanted a chance to write for his show. I had written several letters to his office before this encounter, so he recognized my name. He finally gave me the name and number of the executive producer of the show and told me to call him for an interview.

"Well, the man was impressed with me and said, 'Boy, kid, you sure have guts!' I got the job! While it lasted, until Mr. Funt decided to get his ideas from his viewers for twenty-five dollars each instead of paying us such a good salary, it was absolutely great.

There were three of us writers working there then, and when it was time to leave, one of them, Saul Turtletaub, and I went to work together again on a show called 'That Was the Week That Was'—another great experience.

"Our office was directly opposite Alan King's. We watched him walking back and forth with a cigar in his mouth as he worked on his material. All the comedy writers worked in this area on 55th Street near 5th Avenue. It was an exciting place to be.

"The entertainment business didn't exactly offer job security. Ruthie and I wanted to get married, and for the sake of my future family, I decided to find more stable employment, which I then quickly did. But, looking back, I have to say that I was a pretty lucky guy. How many people have a chance to follow their dreams—twice—in their lifetimes? And who knows...the quiz show I'm working on now might just take off...."

My grandparents were sports fans, too, believe it or not. But they weren't into ball games. Their passions were boxing and wrestling. Talk about incongruous. Here were these two little gray-haired people cheering and clapping for their favorite contenders. Especially the wrestling. One would root for the guy in the *vaiyseh pantselech* (white pants), and the other would cheer for the fellow in the *shvartzeh pantselech* (black pants). And when "Gorgeous George" would step into the ring in his wild get-up and spray perfume all over the place, they thought that was hilarious. Well, that too was entertainment.

And when they weren't watching sports or television comedies, Grandpa would take out the jar filled with pennies that he always kept handy for their regular card cames. Casino was my favorite, but my grandfather, father and uncles looked for any excuse to sit down for a game of pinochle. Any time the family got together provided an oppor-

tunity. There was always a nutcracker on the table, and everybody kept busy cracking nuts and playing cards.

But, unquestionably, our most popular form of entertainment was going to the movies.

An amazing fact—with the exception of Walt Disney and Darryl Zanuck, all the early major studio heads—the ones who created the American motion picture industry—were Jewish: Mayer, Zukor, Thalberg, Fox, Goldwyn and the Warner Brothers, to name a few. They provided a mass entertainment that was unknown to previous generations of human beings.

This was a powerful medium. It was more than a form of escapism. It also had the ability to change the way people thought and perceived the world. This popular form of entertainment molded the cultural tastes of an entire population. And the mores and ethical standards of those who controlled these early moving visualizations had been influenced by their own upbringing. They were in business to make money, to be sure; but they exerted a profound influence nonetheless.

Even going to the movies involved a great deal more than handing over a few hard-earned coins. Ask anyone you know over the age of fifty—regardless of where they grew up—where they went on Saturday afternoon, and you'll no doubt discover, as I did, that 90 percent of them spent it in a movie theater.

But Saturday is also *Shabbos,* and so for Jews this also involved a slightly added dimension....

The Movies

There was nothing so special as going to the movies. It was our window to the world, our entertainment, our ticket out of the dull humdrum of everyday life and into a completely different realm. If it was Saturday afternoon, that's where you'd find me—without fail.

Story hour at the public library ended at noon. Afterwards, I checked out my stack of books, which would fill my time until the following week, run back to the tailor shop, gobble down a quick lunch and head off for the Crystal Theater down the street just in time for the one o'clock matinee.

For fifteen cents, we could enjoy a whole afternoon of pleasure. There was a newsreel that showed us up-to-the-minute news of what was happening in the world, then came a serial—"Superman," "Tarzan," or "The Adventures of Flash Gordon," starring Buster Crabbe with villains like Merciless Ming—a new installment every time. The serials went on for years. We lived in suspense from week to week. Then there

were five cartoons and, finally, the feature attraction.

This wasn't just a movie...this was an event! The theater was always jam packed, and the neighborhood merchants recognized a good thing when they saw it. They didn't flash advertisements on the screen like they do today. They had a better idea. All week long, when people came into their shops to buy food or merchandise, with every purchase they gave out tickets. The more you bought, the more tickets you got. The kids showed up at the theater on Saturday afternoons clutching handfuls of long strips of these precious pieces of paper with their rows of sequential numbers printed across the top. Each ticket was, of course, attached to a stub, which was deposited in a bin inside the lobby.

Since the program was long, there was usually an intermission somewhere in there. This not only gave us a chance to buy candy or popcorn, but was also a time of great anticipation. All the ticket stubs were mixed up in this bin, and every child held his or her breath as, with great fanfare, the winning numbers were called. The merchants supplied prizes every week, and these weren't just little nothings, either. I had my eye on a beautiful, shiny blue Schwinn two-wheeler—what I wouldn't have given to ride that baby home! Even though my numbers always seemed to miss by only a scant few digits, alas, hope springs eternal...I kept coming back thinking, "Maybe this time. Please...please...." It never did happen, but the anticipation was thrilling anyway.

And it wasn't just the kids who got prizes. There was no T.V. in the forties, so adults, too, looked forward to this escape. Wednesday was "Dish Night." With the price of a movie ticket, you also got a dish. Pretty soon, a whole new set could grace your kitchen table. After that maybe they'd have glassware or other household items. (In the fifties and sixties, gas stations used this ploy, too. I still have a few little sauce dishes I got years ago by buying gas. Glasses were probably the most common "gift with purchase" though—and gas was only about twenty-nine cents a gallon to boot!) Vivian Herman, who grew up in Manchester, Massachusetts, told me: "I still have a hairbrush, comb and mirror set that we got at the movies all that time ago. My mother also packed us a lunch. You would've thought we were going to be there for a week!"

My husband, Sid, recalls his Saturday afternoon forays to the movies with...well, not quite with...his grandfather:

"We lived off of Roosevelt Road in the Lawndale district of Chicago's west side in what was possibly one of the greatest concentrations of Jewish life in the United States at that time. There were three theaters within walking distance of our house: the Gold, the Central Park and the 20th Century. The Central Park and the 20th each showed current

movies. But Saturday morning and afternoon was the time for the Gold Theater.... Two cowboy pictures, coming attractions and a serial—all for ten cents!

"My grandfather, who was a very religious man, had one poorly kept secret. He had an addiction to cowboy movies. Such a dilemma! It was forbidden to carry money on the Sabbath, but the cowboy movies were *only* shown on Saturdays. So each Saturday morning grandfather went to Shabbos services, made his peace with God and accepted his little violation. Following the services, he would "go for a walk"—and sneak off to the Gold Theater! And if I happened to see him there, we would pretend not to see each other. It was a secret that really wasn't a secret. But if we didn't acknowlege it, that made it okay."

Even in London, England, where teacher Ruth Schwartz grew up, Saturday afternoons were spent at the movies. "In the morning we went to *shul*, and in the afternoon, the cinema. My sister and I would sometimes go with our grandfather, too," she said. "But when he took us, he always picked a romantic movie so he could take a little nap. The westerns were too noisy."

Ruth also remembers a big organ that came up from down below somewhere, playing music before the show and during intermission. Some theaters in Chicago had that, too. But in the London theaters, they flashed words on the screen so that everybody could sing along. I don't recall that particular routine.

Of course, the movies of the forties were not only exciting westerns with cowboys and Indians starring heroes like Tom Mix, Hopalong Cassidy and Roy Rogers. We also had Margaret O'Brien and a young and already beautiful Elizabeth Taylor, the antics of Abbott and Costello and scary films like *The Thing* and *Frankenstein*. I never could bring myself to look at the really gory stuff. I'd put my hands over my eyes. I still do that, actually. I couldn't watch the gory stuff then, and I still can't.

And then there were my favorites. This was the heyday of the "musical." When one of these was playing, I was in heaven. Judy Garland, Mickey Rooney, Ann Miller, to name a few, sent me from the theater humming every time. No wonder that the songs of that era are still my favorites to this day. In my imagination, it was *me* up there singing and dancing my heart out!

For a special treat, my mother would take me to the Chicago Theater downtown in the Loop, where we could see a real, live stage show, with a full orchestra and top entertainers performing during the intermission.

In New York City, people went to Radio City Music Hall to see the

famous Rockettes. And in Los Angeles, people like Addie Kopp went to the Orpheum....

"There were some neighborhood theaters, but it was always so much fun to go downtown," remembered Addie. "After temple, we'd go and have lunch and then we'd get on a bus and go to the movies. They had great stage shows, too. There was one group called the Meglin Kiddies and also Rita Hayworth's family—the Consicos—were in that dancing, vaudeville circle. They had a dancing school, and did all kinds of performances. But the Meglin Kiddies were about my age, or my sister's. So many of them had two left feet, and I learned about empathy watching them. My mother didn't feel too sorry for them, though. When I asked her if she didn't think they were embarrassed when they made mistakes, she shot back, 'Heavens, no! They're in the spotlight!' But, of course, many of them went on to do very well."

Meanwhile, back in Chicago, every year on New Year's Eve, until I got too grown up to want to go, Grandma and Grandpa took me with them to spend this special evening—where else?—at the movies. It was always timed so that we were still in the theater when the magic hour arrived so that we could join the crowd in yelling, "Happy New Year!" and singing "Aulde Lang Syne." We still spend New Year's Eve having dinner and going to the movies with a few good friends.

In high school, the movies served a different function. If you went to Roosevelt or Von Steuben on Chicago's north side, the Terminal Theater on Lawrence Avenue was the place to see and be seen on a Friday night. What better place to take a date, or just meet your pals? Some things don't change all that much. Going to the movies is still a popular pastime for this purpose, but nowadays there are so many movies and so many theaters that they don't serve as common meetinggrounds like they did in those days. I suppose if you live in a small town, this atmosphere might still exist.

And, as I mentioned earlier, when our children were small, we started another movie tradition. Along with most of our Jewish friends, we began going to the movies, followed by dinner in a Chinese restaurant, every Christmas. This is where we usually end up seeing just about every other Jewish family we know.

But I can't go on without mentioning that quite a few of these families have one more important tradition which they cheerfully observe before heading off for the theater on Christmas—volunteering their time to help serve dinner at a homeless shelter or other facility, so that their Christian neighbors can spend this day with their families. Grandma and Grandpa would have been proud.

A Breath of Fresh Air
Vacation Traditions

"We are here to do.
And through doing to learn;
And through learning to know;
And through knowing to experience wonder;
And through wonder to attain wisdom;
And through wisdom to find simplicity;
And through simplicity to give attention;
And through attention to see what needs to be done."

—*Ben Hei Hei*

YOU CERTAINLY DIDN'T HAVE TO BE JEWISH to go on a vacation. But if you did happen to be a Jewish child living in a big city like New York or Chicago, a Jewish summer camp or a Jewish resort would very likely have been part of your growing up years.

Parents wanted their children to breathe fresh air and enjoy a little bit of "country." And if we happened to absorb a litle *Yiddishkite* along the way, so much the better. Not all Jewish camps included religious activities, of course. That was not necessarily the point. My first experience was at Camp CHI (pronounced like the word shy).

Camp CHI.... My mother wanted to get me out of the city for at least part of the summer. I was almost eleven the first time she decided I should go. This was a Jewish girls' camp started by the Chicago Hebrew Institute. Don't ask me exactly where it was. I only know we got there on a bus, singing "one hundred zillion bottles of beer on the wall" all the way. They sent me to a cabin—more like a shack—with bunk beds, which I would share with seven other girls for three weeks. I didn't know any of the girls; they all seemed to be bosom buddies. The bathroom was half a block a way, and at night that meant mosquitos and using a flashlight. I hated it on sight. They insisted that we bring a stack of self-addressed, stamped postcards so that we could write home every day. My first postcard went something like this:

Dear Mom and Dad,
I hate it here. I want to go home.
 Love,
 Your daughter, Rosalie
 P.S. I got my (.). When are you coming to get me?

Of course, they didn't come. They were wise enough to know that in a few days I would be caught up in all the activities and stop being homesick. They were right about that, but unfortunately, that was a summer

when they broke the records with a pollen count of a zillion and something. I ended up in the infirmary. But it did serve one good purpose: they finally found out that I had hay fever, and didn't really have a cold every year around my birthday. The magic of antihistamines came into my life. And that was a blessing.

I wasn't the only one who went to summer camp. Sid's mother told me about the first time she sent him. He was only seven years old. I couldn't believe she would send such a young child away for the summer, but she said she really wanted to get him away from the streets and out into the country for a change. Sid's cousin Jordan was a counselor at Camp Glen Eden in Wisconsin, and so she thought this would be a good place for him. He had to get there on the train. She said it almost broke her heart. Here was this little guy, looking out the train window, with tears streaming down his face, crying "I don't wanna go to camp. I don't wanna go away. Please...don't make me!" But, she didn't change her mind either, and Sid became an avid camper once he got the hang of it. Later, while he was in high school, he and his buddy Paul Miller became counselors at Camp Henry Horner, which was just across the lake from old Camp CHI.

By that time I had also moved on and was working as a counselor for the summer at a USY camp (United Synagogue Youth). There were nine pre-teen girls under my charge, and I was very sympathetic when they complained about missing home. This time we lived in a big tent over a wooden platform. It was actually rather pleasant when the breeze blew through the netting, and the bathroom was much closer, too. This camp was really steeped in Judaism. We said prayers when we got up, before we ate, after we ate, and before we went to bed. Naturally, there were all the usual camp activities to keep our charges busy, but Jewish stories, songs and rituals were an integral part of the daily program and were painlessly absorbed into the carefree atmosphere of our little world in the woods.

Funny that what I should remember most from that particular camp was the way we started our day. They woke us up every morning playing "Pictures at an Exhibition" by Mussorgsky over the loud speaker. Talk about association—I can't ever listen to that particular piece of music without thinking about USY camp. However, one of the side benefits of being a camp counselor that summer was that it prompted me to go on to become a youth group advisor for USY and later to consider teaching as a career.

Both of my children carried on the tradition and went to a Jewish camp—Camp Swig. It was in the beautiful Saratoga Hills and was

sponsored by the UAHC—Union of American Hebrew Congregations. Neither of them begged to be taken home. Of course, part of that might have been the fact that this camp was only a twenty-five-minute drive from their home. They knew they could get there, if they really wanted to. We had been virtual captives. But we all agree that camp was a great experience. Larry actually created the most beautiful *mezzuzah* in the metal workshop there as a gift for us. It looked so professional that I immediately hung it on the wall in our entry hall, and still consider it one of my most valuable possessions.

And we also agree that our camp experiences taught us a lot about a lot of things, not all of them Jewish, though what we learned varied quite a bit. Besides being exposed to all the outdoorsy stuff, like boating and sports, and the crafts and the ritual camp songs, we also were in intimate contact with lots of other kids and enthusiastic teenage counselors who were eager to talk about everything under the sun.

In fact, in my mother's day one thing she and her mother could *never* talk about was sex. Whatever she knew, she had learned from her friends or by trial and error. When I got home from that first summer at Camp CHI and told her about our buzz sessions where we talked about the birds and the bees, my mother immediately said, "Well, tell me what you learned."

I think she really thought I knew some things that perhaps she didn't. She may have been right. I thought it was kind of funny then, and I remember thinking how much funnier it was when she sat down on my bed the night before my wedding and asked me if there was anything I wanted to know. After studying reproductive biology in college, I'm sure that, technically at least, I had a little edge. Experience, however, was a different matter. When my daughter came home after her first summer at camp, and I asked her, "Well, what did you learn?" she answered, "How to shave my legs!" We had already been all through the sex thing a long time before.

Like a Kick in the Stomach

Before the days of summer camp, my mother, grandmother and I used to go the Indiana Dunes State Park for at least part of the season. We spent most of our time at the beach, baking in the sun or splashing in Lake Michigan. My father sometimes joined us for the weekend, but Grandpa never wanted to leave the store. It was here that I had my first taste of prejudice, and I never forgot it.

A lot of Jewish families frequented the resort where we stayed, but the local residents weren't as tolerant as the resort owners. My mother

and I liked to take walks along the shore, collecting shells and interesting stones. One day we decided to go in a different direction.

All of a sudden, we came to a private stretch of beach. There was a big sign posted: NO PEDDLERS, DOGS OR JEWS ALLOWED. I felt like I had been kicked in the stomach. This had to be a mistake. Wasn't this still America? I was eight or nine years old that year, but that was old enough to realize that some people didn't like us just because we were Jewish. This was definitely a new experience for me. Even though I attended a public school where the kids represented many different nationalities, I had never encountered it before. I asked my mother what that sign meant, but she didn't answer. She just took my hand and led me off in another direction. "We didn't want to go there anyway," was all she would say.

To their credit, I never heard either my parents or my grandparents speak ill of any other religious or ethnic group. Their philosphy was "live and let live." Maybe all the discrimination the family had experienced in Russia, with pogroms and being forced to live in the *shtetl* environment and only mingle with others like themselves, taught them something about this abomination. They knew what it was like being on the receiving end of intolerance, and they themselves never treated anyone else like that in word or deed. They taught us by their actions.

These were people who definitely lived by the negative golden rule that the great sage Hillel taught two thousand years before. When someone asked Hillel if he could explain Judaism while standing on one foot, he answered: "That which is hurtful to you, do not do unto your neighbor. All the rest is commentary." The negative golden rule. Later, Rabbi Akiva cited a reference from the book of Leviticus, "Love thy neighbor as thyself." They were talking about the same thing. If we learn by example, I had some very good teachers. It's been said that you don't have to be religious to be a good Jew; you just have to be a good person.

Other years we went to South Haven, Union Pier or Lake Geneva, resorts where there were large groups of people like us. We ate, we laughed, we were entertained by some pretty good performers, we played "Simple Simon" on the lawn and we ate some more. That was a vacation.

The Jewish Alps

Sondra Goldberger remembered her vacations as a girl: "I grew up in Brighton Beach in New York. It was also considered a resort area, so we really didn't need to go anywhere else. It was great living right there at the beach. But when we did go somewhere on vacation, it was usually to

the Catskill Mountains. This was commonly known as 'the borscht circuit.' There were wonderful hotels like the Concord, Grossinger's and the Pines. They had golf courses, swimming pools, solaria, sun decks, food, bars, playrooms, counselors for the little kids, more food, card rooms and great entertainment. They also had talent shows that all the children could participate in. And did I mention more food? By the time you were finished with breakfast, it was time for lunch.

"Most of the waiters were medical students, or other students working their way through college. They did everything they could to get people to give them big tips. They encouraged everyone to order lots of food, and kept bringing extra rolls, drinks and desserts. The better they treated their charges, the bigger the tips, so they went all out. Flirting with the daughters was not out of the question, either. All the girls had crushes on the lifeguards and other help.

"I heard Robert Klein, the actor, talking about his experience as a lifeguard at one of these resorts," Sondra said. "One summer, he happened to be on duty when a little boy got into trouble. He saw him go under the water, and when he saw that the boy wasn't coming up, he dived in and saved the child's life. The father gave him a five-dollar tip! He couldn't get over it. 'How much is a life worth?' he asked with amazement."

Michelle Schneiderman has memories of the Catskills too. "I was a counselor at an Orthodox camp in the Catskills in the 1960s. Some of my fellow counselors came from rather well-known families, like the Manischewitzes or the Horwitzes of *matzah* and *kosher* food fame. These friends always had keys to Grossinger's, the biggest of the resort hotels. We used to sit at the pool and order room service and charge it to one of their parents' rooms. I remember those summers as some of my happiest times. There are still some hotels left, but most of the ones that were hot when we were kids are gone now."

The Catskills—the "Jewish Alps." This was the summer resort of choice for countless American Jews from the 1920s to the 1960s. From small bungalows to grand hotels like those of Miami Beach, the Catskills provided a luxurious respite from the harsh realities of city life. It was a place where people could feel comfortable, safe and able to relax, all the while surrounded by fellow Jews and fed in Brobdingnagian proportions. An entire entertainment industry was founded out of the games played on the lawn or around the pool. Three generations of comedians honed their skills at these popular places.

We were talking about this, and my friend Betty said her experience

was a little different. They couldn't afford to stay at the resorts. "Living in New York, it was very customary for people to go to the Catskills for the summer. But it was too expensive to stay a whole summer in a hotel, so what was very common in those days were what they called *kachalayn*. [Literally, cook by yourself.] They weren't even cottages. Sometimes it was one big room with a kitchen, or several individual rooms with one community kitchen. The husbands would only come up on the weekends. They called them the 'weekend warriors.' These were for the 'poor people.' They were near the big resorts, but we didn't go there. We made our own entertainment. There was usually some kind of swimming hole around."

"We always picked blueberries," Leo added. "We were stung by bees, but we had to have our berries. And people didn't have cars, so they usually were picked up by hack drivers—like a taxi service. It had a big rack on top for suitcases. The driver would pile about eight people into the car, sometimes more than one family, and you had to make arrangements in advance for him to come back and get you."

"If we didn't go to the Catskills, we would go to the beach and have the same kind of arrangement," Betty remembered. "A lot of people went to Coney Island or Rockaway. There were a lot of kids that had asthma, and the ocean air was always considered good medicine for them. I think it still is. In school, children who were kind of sickly would be put in 'open-air' classes. They had more recesses."

Leo said, "When we were in the city, we always had our own ways of making ourselves comfortable in the hot weather. There were fire escapes. We would bring out our mattresses and pillows and sleep out on the fire escape. Or we went up on the roof. We called it 'Tar Beach.' That was a favorite place to be. We'd sunbathe up there during the day, and sit and talk there in the evening. You'd meet all the neighbors up there."

Playing in the Snow
After we moved to San Jose, we started a new vacation tradition with our children. We started taking them to Lake Tahoe to play in the snow. Considering that the winter weather was one of the reasons we had decided not to go back to Chicago, this was almost humorous. But now we could drive there in a few hours, play in the snow as long as we liked and drive home. This made it fun instead of drudgery. Our very good friends Michelle and Joe and their children had become part of our extended family.

The first year, we packed up our stationwagons, cooked a lot of food

(I told you Jews always eat well!) and took off for the mountains. We had such a good time that we did the same thing for one week every winter until the kids started going away to school.

Two years ago, we decided to revive this tradition. Only now we take not only our children, but our children's children. We love it! Our sons and daughters get to go off and ski or whatever they wish, and we grandparents get to spend some quality time with our grandchildren, which gives us great pleasure. A win-win all around. And not only that, we still eat very well, but now each of the "kids" takes a turn making dinner. They plan their menu, give us a shopping list, and then we get to sit back and enjoy. Now, this is what you call progress. Our children grew up like cousins, and hopefully, their children will have this feeling of *"mishpochah,"* too.

Let's Plant a Tree
The Israel Connection

According to the Mishna:

"He who saves one life on earth will be credited in heaven as having saved a whole world."

I N 1979 WE DECIDED TO TAKE a different kind of family vacation—a trip to Israel. Wendi was sixteen and Larry thirteen, good ages, we thought, for a journey of this nature. We had never been to the Middle East and looked forward to our first experience—three weeks of exploration and discovery.

It was a very long flight. We had to stop over first in New York and then in London, where there was a delay of several hours before we could begin the next leg to our final destination. We had been anticipating tight security, but were nonetheless impressed by the intense scrutiny given to both our luggage and ourselves at Heathrow Airport. El Al is known for its strict precautions, and having our bags gone through with a fine-toothed comb wasn't surprising, though stuffing our once carefully folded belongings back into place after their thorough tossing was a challenge. Still, for safety's sake, we recognized the necessity of this scrutiny. However, though we remained fully clothed at all times, we were less prepared for a body search, never having been subjected to such personal attention by a complete stranger before. Finally the examination was over. We passed the test, and climbed the steps of our *Yiddishe* bird feeling confident and safe.

From the moment we entered the cabin and took our seats, we began to experience a new sensation. The realization hit…the pilot was Jewish; the co-pilot was Jewish; the flight attendants were Jewish, as were the majority of the people on the plane, judging by the mixture of Hebrew and Yiddish conversations going on all around us. An Hassidic family took up the entire row of seats immediately in front of us—a mama, a papa and five children ranging from toddler to teen. Our eyes took in the dark clothing and the hair—the woman with her *shaytal*, and the man and boys with their *payess* (side locks) curling from beneath their head coverings. The fringes of their prayer shawls stuck out from under their coats. We were already being swept up, and the plane hadn't even left the ground yet!

As we soared above the clouds our little moving room became a study in different cultures. The family in front of us had brought their own food, seemingly enough for a week. We watched in amazement as they managed to pass and consume every bit of it. (One or two of the children were usually draped over the backs of their seats surveying the crowd, giving us a good view of each bite.) A few rows down, we saw a gentleman wearing an Arab headdress sitting next to a petite woman whose face was covered with a veil. Businessmen in suits, clergymen, elderly grandparents and other families like ours were interspersed with turban-bound men, sari-clad women and young students in shorts and t-shirts. We began to feel quite international among this diverse group. The hours stretched out. After eating our *kosher* meal and taking a short nap, we finally began our descent.

Never in my life have I ever experienced such an emotional landing. The moment the wheels touched the ground, there was a round of ap-plause, and then something totally unexpected and overwhelming.... Someone began singing "Hatikvah"—the Israeli national anthem. Voice after voice joined in, until we too were among the emotion-filled chorus with tears in our eyes.

Yerushalayim! Jerusalem. With our first steps came a strange sensa-tion of coming home. How could that be? We had never been there be-fore. It is hard to explain, but this feeling stayed with us the entire three weeks we were there. Walking down the street was strangely exhilarat-ing. Skin tones ran the gamut from very light to very dark, clothing var-ied, but even without understanding a word of Hebrew, we knew that we were among people who shared a common heritage.

While planning our trip, we had decided to hire a guide and travel on our own rather than in an organized tour group. I think it was a good decision. We were met at the airport by Moishe, a grandfatherly type from Eastern Europe with an inexhaustible supply of stories to tell. His constant recital of history along with his *meises* and colorful opinions gave us an education for which we could have received a degree.

He picked us up at our hotel each morning and proceeded to lead us through this fascinating country, literally from top to bottom.

Along the way we passed a national forest. "These are the trees you Americans planted," Moishe said. Row after row of young trees stood proud vigil over the nearby desert. "Would you like to stop and plant one?" he asked. "Yes, let's," our children agreed. "Let's plant a tree." Let's plant a tree...how that took me back. That, too, was a tradition. As we were growing up, it was a common call. Whenever someone died, we "sent a tree"—that is we made a donation to the JNF (Jewish National

Fund) so that a tree could be planted in Israel in memory of the departed. A Tree Certificate would then be sent to the family. A new home, a new baby or other memorable occasion—"Let's send a tree." It was a way of showing respect or honoring the occasion and supporting and helping to build the new state of Israel at the same time. How many trees had my family alone been responsible for? I can't even imagine.

Trees are very symbolic in Jewish life. The Torah is referred to as an *etz hayyim*, a tree of life. King David wrote that a good person is like a "tree planted by the streams of water." Even in times of war, the Bible cautioned, fruit trees were not permitted to be cut down. There is even a holiday called Tu b'Shvat which is set aside as a festival celebrated by tree planting. It usually falls in January or February. The early buds of spring begin to appear in Israel at this time, and children go out into the forest areas, or areas where they hope to reclaim the neglected soil, and plant saplings, generally under the supervision of JNF.

There is an ancient custom, still observed in modern Israel, that calls for a cedar to be planted when a boy is born, and a cypress for a new infant girl. When the youngsters, who are expected to care for the trees planted in their honor, are grown, branches are cut down from their respective trees and are used to decorate the bridal canopy under which they stand during their wedding ceremony.

After planting our trees, we stopped for a tour of Hadassah Hospital with its beautiful Chagall windows. I was an active member of a Hadassah group back home and was particularly interested in finding out where my contributions had gone. Seeing the magnificent buildings and hearing about the wonderful work they did there made me feel genuinely proud. Hadassah was part of my family history, too.

My grandmother, though busy with her family and her sewing, also found time for her Hadassah meetings, which she loved to attend. Hadassah is a women's Zionist organization founded by Henrietta Szold, an American who traveled to Jerusalem in 1909 and found a purpose in her life that spread to the world. Henrietta Szold was appalled by the health conditions she had witnessed, and returned to raise enough money to send two nurses back to set up a medical clinic. The result of her early work laid the foundation for the development of Hadassah Hospital and medical center on Mt. Scopus (and later Ein Karem), with its medical and nursing schools, all supported by money raised by Hadassah chapters like Grandma's in America and around the world.

The rise of Hitler also threw Hadassah into the role of savior of

thousands of children throughout Europe under its Youth Aliyah program. Grandma baked, knitted and sewed layettes, contributing her talents with a willing heart. This was a cause she could sink her teeth into.

My mother also belonged to Hadassah, but when she wasn't working, her time and energy went to another organization supporting both Israel and community service. As president of her B'nai B'rith chapter, both in Chicago and San Jose, she was an active worker for this group, well known for its Anti-Defamation League, which battles discrimination wherever it is found, regardless of religious affiliation or race. My mother promoted the purchase of Israeli bonds, organized bake sales, luncheons and mah-jongg games, put out the monthly bulletin and coordinated meetings. During the annual rummage sale, she would disappear for days. She was a volunteer and fund-raiser par excellence. So I grew up with their spirit of community involvement and a dedication to helping the state of Israel.

When we moved to San Jose, I discovered to my pleasure that there was a very active Hadassah chapter there. Not only did I find lifetime friends and an enjoyable social outlet, I also found a way to make my own contribution to Israel and to the community. By becoming a life member in 1970, I felt like this was another tradition of my mother's and grandmother's that I could continue. So actually being there and seeing it with my own eyes was quite a thrill.

What Is It About Israel that Provokes Such Emotion?

Jews from other lands who decide to make Israel their home do not "emigrate" to this holy land. They are said to make *aliyah*—or "go up." If they should leave, they "descend." Departing is viewed as a step down. Whether or not Jews actually live in Israel, it is considered "home"—a place to which they are always welcome—the place where their faith originated. The compelling force of *aliyah* continues to draw Jews from all over the world.

Born in Haifa, Nurit Sabadosh, teacher and Judaica store owner, came to the United States with her husband and two children in 1981. She talked about her spiritual ties. "Being born in Israel, Judaism was as much a part of my life as the air I breathed, a natural and unquestionable act. I loved celebrating the holidays at home as well as at school. I enjoyed studying the Bible and the wisdom of our rabbis. The more I learned about the Holocaust and what happened to my family, the more Israel and being Jewish became important to me. All my life I was proud to be Jewish. It was a very hard decision for me to emigrate to the U.S.

"Coming to America," Nurit continued, "was the first time I really had to stop and think about what being Jewish in the *Galut* (Diaspora) means. How we would preserve our and our children's identity. Teaching in Jewish day school and at our synagogue helped me feel part of a community and continuously involved me in Jewish life. I found that my greatest joy was to share my knowledge of Judaism with my students and see them get excited and enthusiastic about being Jewish. I felt like an ambassador for Israel and our tradition, rather than the traitor that I felt like when we had left."

Because she was born in Israel, it is understandable why Nurit feels such a strong bond to the country of her birth. But it is often confusing to non-Jews that people who are staunchly American or Brazilian or French or Italian or Russian can feel such a bond to another country as well as their own. Members of other nationalities may also love their ancestral country and identify strongly with its culture and its people; but do they feel the need—indeed the obligation—to send money or get emotionally involved with its politics? Yet American Jews, who would never consider living anywhere else, also consider Israel the "homeland" of their people, making generous contributions and feeling fiercely protective and emotionally tied to this ancient land. Almost as though their familial umbilical cords have magically remained intact regardless of time or space or place of birth.

And the city of Jerusalem is much more than just the capital of Israel. It is the geographic heart of the Jewish people. It was chosen by David as the center of his kingdom. It was the site of the first Temple built by King Solomon to house the Holy Covenant. Three great religions were born within its gates. Outside its boundaries the Diaspora begins. Jerusalem is considered by many to be the spiritual center of the world and a symbol of religious faith. No wonder so many have fought to lay claim to it.

Israel is mentioned in every prayer. Every Passover *seder* ends with the intonation, "Next year in Jerusalem!" But there is more than religious, historical or even biblical precedent for this fierce dedication. Hitler's merciless attempt to completely annihilate the entire Jewish people showed the importance of establishing a Jewish homeland—providing a safe haven so that NEVER AGAIN would our people be at the mercy of such an evil force without assistance or refuge. The cry NEVER AGAIN became the driving force behind the establishment of the new Israel and the fervent devotion of Jews around the world. Israel's "Law of Return" guarantees that no Jew shall ever be turned away. Israel is still a haven for people who experience persecution wherever they may be. In recent

years Israel has opened its doors to Ethiopian, Bosnian and Russian Jews, swelling its population and taxing its resources. But it welcomes these emigrés with open arms.

The 1967 war and Israel's quick and significant victory also instilled a fierce pride in Jews in every land. This tiny country had finally won the respect of the world. Jews everywhere held their heads just a little higher.

In its holy books, theology and liturgy, Judaism calls its community "Israel" and asks for God's blessing upon "Israel," meaning the community of the faithful. Obviously not all practitioners of Judaism—the religion—are citizens of the state of Israel.

There is a great debate going on these days about "who is a Jew?" This is largely because of a recent pronouncement by the Union of Orthodox Rabbis declaring that in their eyes the bulk of American Jewry is not really "Jewish"—at least not their kind of "Jewish."

This only serves to dramatize the confusion betwen religion, ethnicity and nationality. Are Jews a religious group? An ethnic group? A nation-state with overseas dependents? Or are they an overlapping of all three?

Not all Jews practice Judaism, or even any religion at all. This is further complicated by the definition, according to the Jewish law, that the child of a Jewish mother is deemed part of holy Israel—a member of the community of Judaism. Because of its intimate tie to Jews as individuals as well as the Jewish people as an ethnic group, Israel—the state—helps define the secular culture of Jews wherever they live, whether they practice the religion of Judaism, no religion or some other religion altogether.

Neither of my grandparents ever set foot on Israeli soil, and yet they bought Israeli bonds and put money in their *pushkes* every week to support Israel and Jewish causes. My grandmother's work for Hadassah helped support this Israeli hospital and medical center; and the tree certificates they purchased ensured the reclaiming of this faraway land.

So the bond we feel is very personal and very emotional regardless of the degree, or even in the absence of, religious affiliation.

Cantor Emanuel spoke fervently about his native land. "I was a *shaleeach* all my life—an emissary for the State of Israel. I was sent by the Jewish agency to Spain, to Venezuela and to the United States to deliver the message of the state of Israel. And I still do it today. Now I do it through the synagogue. I always say, 'Let the rabbi talk, and let me sing; and I'll give the message through my music.'"

•

After three weeks of traveling in Israel on that first long-ago journey across time, our children came home like walking encyclopedia. They not only learned a lot of history and geography, but they also experienced something they could not have obtained from books—the spirit of a people.

We only made one small mistake. When planning our itinerary, we decided to spend a few days in London on the way home rather than on the way there. After walking on ancient cobblestone streets and visiting places that had been in existence more than two thousand years, our children just couldn't get too excited over cathedrals and castles "only" five hundred years old!

Like Grains of
Sand in a Bottle
Aging and Death

"To everything there is a season, and a time for every purpose under heaven."

 —Ecclesiastes

•

"Aging is when your mind makes promises your body can't keep."

 —Dr. Lillian Carson

I T'S NOT EASY TO ACKNOWLEGE that we're getting older. It's something that happens when we're not paying attention. Then, one day, you look at your children and realize that they're all grown up. You start talking about "the old days," and wondering how it all went so fast. One evening, my husband and I were sitting and quietly reading when we were struck with the same thought. (This happens sometimes when you've been together for a long time.) We suddenly realized that we were now the "older generation."

When did we get that old? When my mother-in-law died, she had been our last living parent. While even one parent is alive, you're still "somebody's child." But when the last one goes, you're an orphan—it doesn't matter how old you are at the time. Suddenly, there's no one to check in with when you come back from a trip, or ask for advice that only parents can give. Yes, your children worry about you (the tables have turned!), but it's not really the same.

Sid often jokes, usually when somebody teases him on his birthday, that getting older is better than the alternative. We both feel that being grandparents is our reward for getting to this stage of our lives, though we also realize that it is a great responsibility. Now we are supposed to have "all the answers." Now we are the ones who are supposed to be the voices of experience. But we are also in a position to pass on something of ourselves and the beliefs we have come to value.

I've heard people say that they think it would nice to go back and "do it all again." I really don't feel that way. As far as I'm concerned, some of the old days were great, but so are the present ones. And there are some advantages to maturity. After all the years spent trying to figure out what we wanted to do and who we were going to "turn out to be," we can finally "be ourselves" for the first time in our lives.

There may be a few regrets, however. The mother of one of my friends once told me, "One of the things that really bothers me about getting older is that there's no one left who remembers me when I was young."

Some time ago, I heard Rabbi Harold Kushner give a lecture in which he spoke about his thoughts on aging and life. He likened it to grains of sand in a bottle. He felt that rather than imagining a full bottle at birth, which gradually becomes less and less until it's all gone, he prefers to think of life as an empty bottle at birth, our experiences filling it up more and more with individual grains as we go through the years, until it's filled to the top and can hold no more. I like the metaphor. I think it's apt. Of course, we have no way of knowing the size of the bottle we've been given, and that's part of the mystery.

Rabbi Kushner also said, "All living creatures are fated to die, but only human beings know it. This knowledge (that we are going to die someday) changes our lives in many ways. It moves us to try to cheat death by doing something that will outlive us—having children, writing books, having an impact on friends and neighbors so that they will remember us fondly. Knowing that our time is limited gives value to the things we do."

At a recent funeral service, I heard the traditional words, "Life is a journey—and death is a destination." It made me stop and think. We all know we have to reach that particular destination sometime, but that sometime is always going to be way off in the very distant future. At some point in time, we begin to feel our mortality.

My mother-in-law, may she rest in peace, loved watching old movies on T.V. She was an old-movie addict. Her days were practically turned upside down because she would sit up half the night watching all of her favorites. Then, one day, she stopped watching the old movies. When I asked her why she said, "I suddenly realized that everybody in them was dead!"

Death is so final. The realization that we'll never again see the people we love or hear their voices is a part of life that no one takes lightly. Elaine Kahn expressed in lyric form her intense feelings as a child at the death of her aunt:

Remembrance

Who is the black-bearded man coming slowly down the street? No stranger, yet strange to my child's eyes. "There's your father," my little friend cries. How strange the beard never seen before in my five short years. How stranger still the paleness in his eyes.

Did my child's mind understand too young a death and the ritual of mourning? Burial within twenty-four hours and then one week of *shiva*, mourning, in the home of my father's dead sister. I understand now the ritual, all concern with self blocked out, mirrors covered, men unshaven,

women without make-up, dressed in the black of death. But my child's mind understood the emotions of death, the never-to-be-compensated for loss of one too young to die.

Up the steps to lift me in his arms. No word spoken. Silently, he lifts me in his arms, his last-born. Holds me close to his heart, holds me close to his soft beard, my cheek against his velvet cheek.

I remember the strength of his arms, the silkiness of his beard, the strength of his silence. Rising up the stairs, I remember love unspoken. I remember the glow, the warmth, the security of my father's arms. Unspoken love I understood, my arms around his neck.

—Elaine Filene Kahn, 6/7/94

Losing someone we love is never easy. The first time I remember being hit really hard by this kind of loss was when my grandfather died. I was one month short of twenty and had come back to Chicago, after attending the University of Illinois at Urbana, to continue my education in teacher's college. I had just gone to sleep when the phone rang shortly after midnight on a Tuesday night in July. It was my grandmother. Why was she calling on my phone and not my parents'? I never found that out. My grandfather had fallen out of bed, and she couldn't wake him up.

I called the operator to ask for help, giving the particulars and my grandparents' address (911 wasn't in use yet), and went to wake my mother. We hurriedly threw on some clothes and drove to their house. The firetruck and paramedics were already there when we pulled up. One look told us all we had to know. Grandpa was gone. He'd had a heart attack. He was only sixty-eight years old, and hadn't even been ill. Grandma had called their family doctor, who, believe it or not, actually came to the house—at one o'clock in the morning. He prescribed a sleeping pill and some tranquilizers for all three of us. We were in shock. My uncles, Sam and Sol, came rushing in, and we all sat around the kitchen table for a long time, each lost in his own thoughts. Eventually, we went home to try and pass what was left of the night. Grandma came home with us. We gave her a sleeping pill, and she went to sleep with me in my double bed.

As I lay next to her that night, listening to the sounds of her troubled dreams, my heart was breaking, right along with hers. Just four days earlier, the whole family had been at their house for the Fourth of July. I remembered, with a start, that this was probably the first time in my life that I hadn't kissed him good-bye. Why not? Thinking back to that day, I recall starting to do just that. Sid was there with me, and we were

rushing off to another party. I turned to go kiss him, and something made me stop…a premonition? Maybe. I just knew that I didn't want to go and kiss him good-bye this time. I waved and blew him a kiss as we headed off. I felt a little pang of guilt, but soon forgot all about it.

Premonitions…. I had a similar feeling the last time I saw my grandmother many years later. We were already living in San Jose and had come back for a visit. Grandma was living with my mother by that time. When it was time to leave, we hugged and kissed, and then Grandma said, "I don't think I'll ever see you again." The words, "Of course you will…" came out of my mouth, but inside I thought the very same thing. She passed away a short time later.

I've never been a big believer in the occult or psychic phenonemon. But I must admit that I've reached the stage where I think just about anything is possible. I ready Shirley MacLaine's book, *Out on a Limb*, about her paranormal experiences. It intrigued me, but I wasn't convinced. After reading it, I even tried meditating and attempting to bring on some mystical event such as she described. Nothing ever happened. I never had an out-of-body experience; but when I kiddingly mentioned this to a few friends, I was astonished to hear that two of them—people I wouldn't have imagined in a thousand years—had also had such experiences.

One woman was a very old, dear friend of my mother, and had developed a clot in her leg following a routine hysterectomy. She lost her leg because of it. I hadn't seen her for years, but she happened to be in California on vacation and had come for a visit. I'd known her all my life, but I listened with amazement as she told me that after her surgery she had "seen" herself lying in bed, with doctors and nurses around her, and had the sensation of being up near the ceiling, looking down. She said that it was a pleasant sensation, and that she really didn't feel like "going back" but that she thought about her children and reluctantly did. I was flabbergasted, but she was serious. She added that it could've been a dream, but that it seemed very real. Another friend related a similar event, when she almost died of pneumonia as a child. Well, I believed that they had experienced something, but it wasn't until my father died that I had a change of attitude.

My father was diagnosed with lung cancer in January of 1975. It was only June when we had to put him in the hospital. I had visited him during the evening, but had gone home for the night. I was sleeping fitfully, when I suddenly heard—or maybe felt—a loud *whoosh!* as a glaringly bright light streaked through the bedroom, jolting me wide awake. I sat up shaking. Sid asked what was wrong, and I told him it was just a dream. My heart was pounding as I tried to go back to sleep. The clock

said 2:45. Twenty minutes later, the telephone rang. It was the hospital, telling me that my father had died at 2:45. I have always felt that my father had come to say good-bye.

My mother-in-law told me she never believed in such things because her mother, with whom she had been extremely close, told her as she was dying that if there was any way she could possibly contact her from "the other side," she most certainly would, and that if she didn't hear from her, then she would know it wasn't possible. Well, she never heard from her.

Mourning is a universal reaction to death, but the way we express our grief varies from one culture to another. In the Jewish tradition, there are many different customs that are practiced after the loss of a loved one. We observed them all when my grandfather died.

The morning after the frantic call from my grandmother and our sleepless night, my mother went around the house, covering all the mirrors with sheets. We all walked around like zombies, but there were certain things that just had to be done.

When Jewish people die, it is required that they be buried as soon as possible. This is meant as a gesture of respect. Arrangements were made to hold the funeral two days later. The day of the funeral, the rabbi made a cut in the pieces of black ribbon which we had pinned on our clothes. He recited the *Kaddish* (the prayer for the dead), and people came up and hugged Grandma and my mother and uncles, giving them whatever comfort they could. I felt like the whole service was a bad dream. All I knew was that the weight in my chest felt like a ton of bricks, and I could hardly speak because of the lump in my throat. An era had come to an end. With Grandpa gone, our lives would change forever.

At the cemetery rows of weathered tombstones stood their lonely vigil. Little stones sat atop many of them as calling cards left by scores of mourners. Clods of earth fell with final thumps on the coffin down below.

It was decided to sit *shiva* (the mourning period) at our house. We drove home from the cemetery and found that someone had left a pitcher of water and a roll of paper towels outside our front door. Everyone used these to wash and dry their hands before coming in. My grandmother, mother and uncles took off their shoes and walked around in their stocking feet. Uncle Sol and Uncle Sam sat on the floor. The tall memorial candle in a red glass container, which we had been given at the funeral parlor, was lit and placed on the piano, its flame holding me in a trance.

Somehow, while we were gone, the table had miraculously filled up

with platters full of food. Some of my mother's friends had come while we were gone and made sure that everything was ready. Eating was the farthest thing from our minds, but people filled their plates and sat around talking. I wondered how they could do that when we had just lost our anchor. Every day for a week, relatives and friends came to our house to pay their respects in a steady stream. When the others weren't there, we sat quietly and reminisced about days long past. People had brought so much food for the family that we didn't have to think about such things for the time being.

After the week of sitting *shiva* had passed, both Uncle Sam and Uncle Sol began a ritual which would continue for the next year. Every morning, before going to work, they went to *shul* to say *Kaddish* for Grandpa. They did this faithfully.

These rituals were to be repeated many more times in the coming years. My grandmother, my Aunt Florence, my Uncle Sol, my father and my mother, not to mention other family and friends have left huge empty spaces in our lives. And each time, we did what Jewish families have always done...said good-bye the only way we knew how.

Sometimes trying to follow the old traditions presented problems. Lois Kalchman, a sportswriter in Toronto, Canada, recalled the time of her father's death:

"We were all grieving, and my sister felt a strong need to go to *shul* to say *Kaddish* for our father. She couldn't believe it when she was told that she couldn't participate with the others. Since she wasn't a male, she knew that she could not be counted for a *minyan*, but felt that she should have been allowed to pay this respect to her father's memory along with the others. My sister said her own prayers, but she was angry and frustrated to have been excluded merely because of her gender."

There's no question that in the Orthodox view males have always been dominant, at least where religion is concerned, with the exception of the blessing of the *Shabbos* candles. In the home, mothers held sway, but in synagogue females were relegated to the balcony or back of the *shul* (where they would not distract the men). And they were not permitted to come near the Torah. Something to do with a fear of defilement, since females menstruate, which makes them "unclean."

Today, most Conservative, Reform and Reconstructionist congregations do not adhere to this admonition. Females are generally allowed to participate in all areas of religious observance, including the celebration of *Bar* and *Bat Mitzvah*. And both males and females are included in the prayers of mourning.

For a period of eleven months after the date of death, *Kaddish* (the

mourner's prayer) is traditionally recited daily, but only for a parent. A son is required to do so, but daughters may also say this prayer if they wish. Another may recite the prayer in their place if they cannot, or if there are no surviving sons. Some Orthodox leaders, however, are still opposed to women reciting the mourner's *Kaddish* under any circumstances or to be called up for an *aliyah* (an honor to be called to recite a special blessing and stand near the Torah while the reader chants). In all other synagogues the decision to allow "egalitarian services" in which women participate fully depends on the individual rabbi and congregation.

In the Jewish tradition, the candle is symbolic of the body and soul. The flame is the soul, which is always reaching upward. By lighting a candle and keeping it lit throughout the *shiva* period, it is believed that the soul of the departed is aided in its journey toward heaven. We also burn a candle every year on the anniversary (*yartzeit*) of the person's death to honor their memory. The burning of candles or lights has been linked to death from very early times. They are used in many cultures as a special expression of grief. Catholics light votive candles on All Soul's Day, and the Japanese celebrate the Feast of Lanterns. In the Buddhist religion, incense is burned in the hopes that their prayers will be carried upward with the wisps of smoke.

One explanation about covering the mirrors in a house of mourning has to do with not paying attention to ourselves, but turning our attention inward. We should not be concerned with personal appearance during this time. And since we hold prayer services in a house where *shiva* is held, there is another reason for covering the mirrors. You are not supposed to pray in front of a mirror.

When the rabbi cut the black ribbons which were pinned on our clothes, this was called *keria*. It represents the custom of tearing the garment of a mourner, which is of biblical origin. But it wasn't practical to rip or tear a useful article of clothing, so people began substituting strips of black ribbon instead.

Washing the hands after attending the funeral comes from an ancient ritual of purification, so as not to bring death into the house, and sitting on low stools or on the floor brings us closer to the ground where the person has been buried.

The custom of wearing black for mourning is not really a Jewish one. It dates back to pagan days and originally had nothing to do with religion or a show of grief. Actually, it expressed fear. People put on a black disguise so the ghost of the deceased might not recognize and start haunting them. Wearing black, or even a veil, was also believed to

confuse any demons hovering around. Among some races, the painting of the face white or black was a trick to convince the ghosts that the mourners themselves were ghosts. Black is also symbolic of the night. The absence of color seemed to best express a person's grief.

The idea of trying to fool the spirits is a Jewish one. In fact, it was customary from olden times, when a person was dying, to begin calling that person by a different name. By doing this, it was hoped that the angel of death would be fooled into thinking that he was in the wrong place and coming after the wrong person. There are many such superstitions in the lore of our religion.

All the rituals we follow are meant to show respect for the one who has passed on. Jews believe that the soul lives on in the minds and hearts of those that are left behind, and in the acts of kindness that the departed has performed while on this earth. That's why, when we name our children after those who are gone, or keep them in our thoughts, we are, in some way, keeping a part of them forever alive.

There is one time when these mourning rituals are sometimes performed for someone who is not really dead. Marrying out of the faith was always considered a source of grief. In fact, in many families it was treated in the same way as an actual death. Mirrors would be covered and parents said *Kaddish* for their lost children. Some young men and women rebelled, but for many, this estrangement from their families was enough to cause the end of these relationships.

All life is sacred, and while I would never demean any death, it is often good to realize that there can be humor in any subject. Rabbi Gitin told me about an experience he had as a young rabbi:

"I traveled all over the country, setting up Jewish congregations. One time, I was in a hotel in Alabama, and the desk clerk handed me a message: 'Rabbi, would you please come up to Room 342 to say *Kaddish* for my son?' So I went up and knocked on the door. When I entered, four men were sitting around a table playing pinochle. I didn't want to disturb them; they were so engrossed in their game. So I began to look around the room for the dead body. I looked under the table, behind the furniture and in the closet. Finally, I said, 'I hate to interrupt you, but where is the person you wanted me to say *Kaddish* for?' 'Oh, it's for my son,' he said. 'He married a non-Jew. But you can start saying the prayer right now—over this terrible hand!'

"It was the custom to say the traditional prayer for the dead if the child married out of the faith, but never before (or since) have I been asked to say it for a bad hand of cards!"

Traditions from
Across the Ocean

"You have to survive—even if it kills you!"
—*Sholom Aleichem*

WHEN I BEGAN TEACHING ENGLISH to elderly Russian emigrés through Jewish Family Service in 1987, I found some new relatives. When my daughter was married in April of 1990, my students all came to the wedding to help me celebrate, many of them seeing an American Jewish wedding ceremony for the very first time. When my mother died the following year, they all came to the funeral, to support me with their caring. They had become my *mishpochah*, my extended family.

While we and our children were proudly wearing our *mezzuzahs* and Stars of David around our necks without a thought, they and their children could not. To do so would have been unthinkable in a country where the only acceptable religion was communism, and the only higher authority was "the state."

But that didn't mean that they had forgotten their traditions. Even if it meant having a *Bar Mitzvah* in the privacy of their own homes, with only ten men for a *minyan* and the windows tightly covered, they still remembered who they were. They still gathered for their Passover *seders* and observed their faith as best they could. In some places, this was easier than in others.

Ironically, though we blithely call all of them "Russians," whether they came from Estonia or Ukraine or Moldavia or Byelorussia, they think it's interesting that in Russia that was far from the case. There, if you were Jewish, you weren't thought of as "Russian." Only non-Jews were considered Russians. Wherever they lived in the fifteen republics of the former Soviet Union, they were categorized only as "Jews." Then they came to America, and we call them all "Russians." They think this is rather funny.

Growing up in such a different world, they were bound to have some different stories to tell regarding their own customs and rituals. During the course of our class discussions, they shared some of these stories with me.

Why include traditions so different from most of our own? Because I think it's important to realize that not all Jews growing up during the same era had the same opportunities or privileges. (I do not refer here to the Holocaust. That abomination is too horrific to be compared to anything else.) These people also fought bravely for their country and experienced at first hand the horrors of war fought on their soil. Many suffered gravely, but they managed to survive and to maintain a reasonably normal existence. If that existence did not include the religious aspects that Jews in other places observed, they were Jews nonetheless. And as Jews living in an environment which was largely hostile to their beliefs, they had to navigate obstacles which most of us cannot even imagine.

In encouraging my elderly students to remember their former lives and to use those experiences to facilitate their English language acquisition, I was forced to look back myself—to my own roots and my own development. Therefore, being with them became a further catalyst for this exploration of "self" which you are now reading.

Hearing their recollections brought me face to face with the realization that but for a quirk of fate, these pages might have been written in Cyrillic characters rather than in English. Their stories could just as easily have been about many of our lives had our parents or grandparents not taken their chances and left the Old World when they did. When they could observe old traditions, they did. And when they couldn't, they found other ways to instill in their children the values which were part of their heritage. They brought up their children with love. Family ties were still strong. Education was prized. And they did whatever it took to survive. In other words, life went on....

Mark Cogan, a recent emigre who had been a teacher and principal in his homeland, remembers his youth in a Jewish *shtetl* called Artiz, in the south of Bessarabia: "I spent my childhood in my grandfather's home. He was a tall and handsome man. He knew eight languages. For me it was a great happiness to go with him to synagogue every Saturday, to carry his *tallis* and to sit next to him during the prayers.

"In the dining room of our house, there were two money boxes hanging on the wall. One was the 'Existence Fund' and the other was the 'Basic Fund.' My grandfather would give me coins to throw into the boxes, explaining that this money was to buy land in Palestine for the new pioneers (*halutzim*) to restart Eretz Israel.

"With my first steps on Israeli soil, I remembered that. I burst into tears and thanked God that I was there. I have met many different people who changed something in my life, but the basis of my character and

my world outlook was shaped by my grandfather. His influence was a guide in my life.

"Customs don't last forever," Mark continued. "They disappear with the progress of society. I remember a custom from my childhood in Bessarabia. In Jewish families parents began to teach their children the Hebrew '*aleph bet*' when a child was three years old. They put a drop of honey on the first letter, '*aleph.*' The child touched the letter with his finger. The honey stuck to his finger, and when he put the finger to his mouth, he tasted the sweetness of the honey. This symbolized the sweetness of knowledge.

"I think that the Jewish holidays are common for Jews in all countries. Though it was not always easy to observe these holy days, the Passover *seder*, Rosh Hashana and Yom Kippur, Purim and Hanukah and other traditional holidays have been celebrated by Jewish families for thousands of years—one way or another—wherever they lived. That is the spiritual wealth of the Jewish people.

"But I would like to describe another tradition that I recall that also symbolized to me the sweetness of learning which I acquired from my grandfather. I had been a teacher for forty-one years including twenty-five years as principal of a high school. On September first, 700 to 800 students dressed up and lined up on the school square. The schoolyard was filled with parents, grandparents and teachers. The principal welcomed the first-graders. A boy from the tenth grade lifted a little first-grade girl in his arms. She held a small bell decorated with a red bow. Students ran in front of them and the girl kept ringing the small bell. All the tenth-grade students approached the first-graders and presented them with gifts: books, pencils, notebooks and flowers. The band started playing a march. The tenth-graders took the small boys and girls and showed them to their classrooms. The first lesson had started.

"On May 25, even more people showed up at the schoolyard. The best graduating student thanked the teachers and the parents. The students were beginning a new life. The first-grade students presented flowers to them. The band played a march and the graduates went out first. It was very exciting. Parents and teachers both had tears in their eyes."

Jews have always placed a high value on education, no matter where they lived. The first day of school always warranted special attention. Sonya Slutsker had fond memories of these times:

"When I lived in the city of Odessa, there was a tradition of celebrating the first day of the beginning of the school year. September first

was a special holiday for children, especially those who were beginning the first grade. Little boys and girls put on their new uniforms. The boys had blue suits and white shirts, and the girls wore brown dresses with white collars, aprons and white bows in their hair. Everyone was in a good mood, and parents and relatives took pictures of their children in front of the school in honor of this occasion. I always liked to go out on this day and watch these little ones in their new clothes, who, with an air of importance, proudly carried flowers in their hands and satchels on their backs."

Leonid Segal, a mechanical engineer, told the class about a hobby of his in St. Petersburg. It may not have been a religious experience, though some might think it spiritual. One thing was certain...it took determination. "Since the old times, there has been a tradition in Russia of swimming in ice holes in winter. It was especially common in Siberia, where the temperature in winter often reached −50 degrees centigrade. In our days in St. Petersburg, there were also some clubs for people who wanted to participate in this activity. They were called 'seahorses.' Among the members, you could see many prominent actors, scientists and artists.

"From 1987 until my leaving Russia, I was a member of one of these clubs. According to tradition, members celebrated the New Year in ice holes in the Neva River, with a New Year's tree and champagne. In 1988, I was persuaded to take part in such a New Year's celebration in the Neva. But after that experience, I was not eager to repeat this particular tradition."

After that experience it was more than his soul that needed warming! There are hardy souls in our country, too, who like to indulge in this tortuous fun. Here they are called "polar bears." Just hearing about it makes my teeth chatter!

Leonid mentioned a New Year's tree. Because religious observance of any kind was strongly discouraged in the Soviet Union, citizens of all groups began to collectively observe the New Year as their big holiday. Even Jews had yule trees, decorated with colorful ornaments. Since neither Christmas nor Hanukah was openly observed, everyone exchanged New Year's gifts and held festive parties and celebrations in their place.

The holiday of New Year was always special, said former lawyer Rachel Ushormirskaya. "It was connected with our secret wishes, hopes and dreams."

Sonya described her feelings about this holiday: "In Russia my fa-

vorite time was New Year. We didn't observe Hanukah, but New Year was a family holiday that everyone could enjoy. On December 31, we decorated our New Year tree with toys, candy and lights of different colors. It looked very beautiful. We cooked some very delicious and popular foods, and baked cakes with cream. At night on December 31, our children, grandchildren and friends came to our home to celebrate with us the end of the old year and the beginning of the new. We watched some very interesting films, concerts or circus shows on T.V. At twelve o'clock midnight, the president greeted us and wished us a good new year. All the guests wished each other good health and happiness, and expressed their hope for peace in the world. We drank champagne and continued the celebration until very late into the night."

Rosa Levit, from Leningrad, loved this holiday, too: "New Year's Eve and New Year's Day were my favorite times. Our parents would decorate the tree while we were sleeping as a surprise for us. We never thought of it as anything other than a New Year's tree. They filled it with beautiful decorations and ornaments. I couldn't wait until morning to open my eyes and see what 'Grandfather Frost' had brought us. There were usually new shoes and stockings, and a pretty apron and bows for my hair. It was very exciting.

"But, of course," Rosa added, "Passover was always a traditional holiday for us, with a traditional *seder*. My mother had six sisters, and my father had six brothers. The whole family was always together for holidays like this. And birthdays were very important, too."

Judith Gelb, a physician from Tallin, Estonia talked about her Passover recollections in *Memories from a Russian Kitchen:*

"When I was ten years old, we had a *seder* in my grandparents' house. Estonia was an independent country at that time, and religious observance was still allowed. It was always a happy occasion, and we eagerly looked forward to the holiday during the many days of preparation. There was so much to do to make the house ready and prepare the special dishes.

"When the day finally arrived, we dressed in our best clothes and went early to help grandmother get everything ready. During the *seder*, we ate eggs in salt water, *gefilte fish*, horseradish, *matzahs*, *charoset* and all the other traditional foods. My grandfather read the *Haggadah* and the children asked the four *kashas*. On a chair close to grandfather sat pillows, and under them was hidden the *afikomen*. The children crept under the table and the lucky finder excitedly picked up the hidden treasure. It was a big celebration for all the family.

"During the war, we spent four years in Siberia. From that time and for the next fifty years, from 1940 until 1992, we quietly celebrated our holidays, but only secretly. Our son and nephews celebrated their *Bar Mitzvahs*—but only behind the closed doors of our home, with ten men for a *minyan*. We couldn't go to the synagogue for these important rituals. It wasn't allowed. We could lose our jobs for such a 'crime.' We never forgot our traditions, but it would be a long time before we could do it without fear of someone seeing.

"Here in America, we have *seders* each year again. At these *seders*, we are now the grandparents, and we celebrate this holiday with our family and all our relatives. Here we don't have to be afraid, and we can celebrate once again as in the days of my childhood."

Edit Matov, a shipbuilding engineer from Moscow, recalls:

"When I was little, my favorite holiday was Passover. The main attraction that I felt towards this holiday was the secrecy that surrounded it. This came from the fact that religious practice was prohibited, and a lot of anti-Semitism was present in the former USSR at that time. Therefore, my parents asked me not to tell anyone that we celebrated Passover, and this personal secret made me feel special.

"Of course, there weren't any stores where we could buy *matzah*, and we had to make it ourselves, which was an enjoyable, although fairly long, process. The best part of Passover was the *seder*. The most thrilling moment for me was when we poured a glass of wine for Eliahu, the prophet, and opened the door waiting for him to come in and drink it. It was always scary and mysterious, and it always seemed like the amount of wine in the glass decreased.

"The funniest part of our *seders* happened at the moment when the children found the hidden *matzah* and received presents. My parents couldn't afford to buy anything grand, but all the presents that I got from them on Passover were very special to me anyway.

"The feeling of secrecy and fear carried through time, and I still have it every time Passover comes around."

Manya Rezis talked about the difficulties her family had in Odessa:

"Before the October Revolution in my country there were a few synagogues that Jewish people could go to every day or on holidays. After the revolution, it became difficult to visit the synagogue because the government had forbidden the observance of religious customs. They either tore down the buildings or converted them to other functions. In the city, only one synagogue was open, and only old people continued to

go there. Other people were afraid because of frequent KGB arrests and the fear of losing their jobs. It was very hard to celebrate Jewish holidays. We celebrated Rosh Hashana, Yom Kippur, Purim and Pesach in our homes.

"The biggest problem was getting *matzah* for Pesach. Usually *matzah* was baked under the seal of secrecy in a secret home. After the Second World War, the government permitted the baking of *matzah* in the synagogue, but anyone who wanted it had to bring his own flour and exchange it for the baked product, besides paying money. The last time we needed *matzah* before leaving our country, we brought the flour and paid our money to buy what we needed for the holiday."

People did what they could to continue the old traditions. And sometimes they invented new ways to pass on their values and to show their love and respect.

Rita Gorlin, a nuclear physicist from Moscow, recalled how her family began a tradition of its own: "I guess that each family has its own special customs. In our family we have a very nice one. On my son's third birthday, he presented me with flowers. It was my husband's idea. He gave my son Alex a bouquet of flowers and said, 'Please give these to your mom and remember that your birthday is a great holiday to her. Don't forget to present her with flowers every year.' I was very touched when I received this gift from my little boy. Since that day, my son always brings me flowers on his birthday, and this makes me happy each time. Now this tradition is taking place in my son's family, too. My grandson Mike also presents flowers to his mom on his birthday." What a nice idea!

Honor your father and your mother. I'm sure Rita's son wasn't thinking of that commandment when he presented his mother with flowers on her birthday, but by his tribute and the tradition he passed on to his own son, he was paying his respect and obeying this ancient admonition in his own unique way.

Rachel Ushomirskaya regretted her family's inability to observe Jewish traditions: "I was born in Moscow, and later lived in Leningrad. Both of these are major cities where Jewish culture, language and religion were forbidden. That is why it is difficult for me to tell about Jewish culture. Instead we took pleasure in those traditions established by the Russian intelligensia."

Literary editor Raisa Volkhover's favorite holiday in her home town of St. Petersburg was Women's Day:

"The eighth of March is International Women's Day. In Russia, that

day is a great holiday. Men present flowers and other gifts to women at home or at work. They cook foods, wash the dishes and even clean the house.

"Women only work half a day on March 8. And in the evening, they often go with their husbands, children and friends to a restaurant, where they dance and enjoy wonderful music. Others have a good time at the theater or a concert. This day is always fun."

It certainly sounds good to me. We usually reserve this treatment for Mothers Day or birthdays. Though I can't say I remember my husband cleaning the house, he does usually remember that the day is special. And I have to admit that my children often made an effort to rearrange the piles in their rooms and even fixed me "breakfast" on occasion (which I dutifully tried to eat!). Of course, we also have Valentines Day, and the men usually get in on that one, too.

Inna Eydus, an oncologist from St. Petersburg, remembered this:

"In the former Soviet Union, it was customary to celebrate the first of May and the seventh of November. These holidays began with military parades, which displayed the power of the Soviet state. Tank units, threatening *katushas* and air force planes began the spectacle. Members of the government in Moscow and important guests watched, standing on the tribune of the mausoleum. Television stations continually broadcast the activities and the accompanying cheerful music.

"After World War II ended, the ninth of May, celebrating the end of the hostilities in Europe, became the most important of these holidays. Everyone was happy to go then. No one had to insist on our attendance at demonstrations on this day. Very often veterans of this war gathered together for reunions. My father and stepmother served in the same flying unit, and I remember that even when they were old, they still enjoyed meeting with their old fighting comrades. It was hard for them, but they went. Very few people survived, and many of those who did were sick or suffered from injuries. But those who were left considered themselves lucky to have survived, and were glad be able to see each other. Such reunions became a tradition.

"But one celebration that would have been impossible to observe in the Soviet Union is one which I happily look forward to in my new country, the United States. A great event is expected in my family this year. My granddaughter, Alana, will be twelve. So she will be 'of age.' Alana attends a synagogue and is studying for her *Bat Mitzvah*. She and all the family are preparing to meet this event with great excitement. Never in my former country could such a day be marked! Here in

America Jewish traditions are very strong, and such an occasion is commonplace. But to us this is a very unusual and emotional event.

Alana will invite her friends to her *Bat Mitzvah*—Japanese, Chinese, Indian and others. Here there is a true friendship of people! My son and daughter-in-law are planning a great celebration in her honor. They want this day to stay in Alana's memory all of her life. Certainly, I want it, too. It will be a wonderful day for all the family—one that we could never have known before."

Judith and Aleksander Gelb spoke emotionally about their holiday remembrances:

"There are a lot of holidays we love, such as the New Year, Purim, Rosh Hashana etc. But for the generation who survived World War II there is no more important and happy holiday than Victory Day—May 9.

"A lot of Soviet Jews were forced to leave their homes and families to escape the terror of Hitler's army. They ran to Siberia, Central Asia, Ural and other locations. For four years they didn't know anything about relatives and friends, many of whom fought in this terrible war. It was a big struggle to preserve life in the world, especially for the Jewish people.

"For years, all of us felt hunger, freezing cold temperatures and other hardships. A lot of our relatives and friends were killed at the front or in concentration camps. That is the reason that when victory was achieved it was such an incredibly happy day, one that we hold in our minds and hearts forever."

"Victory Day is a sacred day for the Soviet people," said Leonid Segal. "It is joyful, but at the same time a day that brings tears to the eyes, because there was not a family that didn't lose someone—at the front or in the Holocaust. Even here in the United States, we still continue the tradition of coming together to celebrate this day and to remember those who didn't come home."

And from our resident poet, Esfir Dynkina, former technical designer from St. Petersburg (Raisa's younger sister!), comes her perception of what it was like being a parent in the USSR....

HOORAY! A BABY IS BORN IN THE USSR
 A baby is born. A new man
 Comes into this century.
 And starting from diapers
 He learns everything, together with his mom.

The best time for a mother, it's not a secret,
Vacation after delivery.
However, there were difficulties,
But they were later...later.

In the kitchen the mother heard: "You know, impudent woman,
We live in a communal flat; it's like a dorm.
You bathe him and launder when we're not here,
And don't disturb our cooking for dinner!"
And she had to get used to it,
And stay on a waiting list to get to a nursery,
And it's hard to get into a pre-school, too.
That's how all mothers brought up their kids.

But time cures all adversities,
Years passed by unwittingly,
And we are happy that our grandchildren
Don't leave us time to be bored.

They grow and fill hearts with happiness,
Those of grandmothers, moms and dads.

—Esfir Dynkina, 1/3/97
translated from Russian by Victor Eydus

Parents in the former Soviet Union could *shep nachas* too!

Not all traditions fall into a usual category. The one that follows is such. But because the subject was one that affected every Jewish person who lived under the Soviet regime, I wanted to include it. It came to me from the husband of one of my students with the following letter:

Dear Rosalie,
I'm not your student, but I wrote this story for my wife, Judith, because I think people have to know the truth about the communist country, and nobody except me can tell them about this particular incident. I know it's very long, but all the details are important for understanding the story. I hope you can understand what I had to tell, what I saw with my own eyes. It was a tradition, too: a Soviet anti-Semitic tradition!
 Yours truly,
 Aleksander Gelb

"It is known that in the former USSR foreign delegations were always accepted with great kindness, overly so, even in a patronizing way (although the KGB agents outwardly tried to appear respectable). This refers especially to the 'new builders of socialism'—the Vietnamese, the Yemenites, the Angolans, Ethiopians etc. (Really it was a strange socialism!) An exception to this were Israel's delegations. There were only a few of those. I would like to tell about one such visit by the Israelis to the USSR. I was an eyewitness to that occurrence.

"August 1973. Sportsmen–students from the whole world gathered in Moscow for the World Student Games. Also there was the very strong Israeli basketball team. I don't remember more about the other sports. After the Olympic Games in 1972 in Munich, Israeli sportsmen didn't participate in many big competitions.

"I was invited to be a referee for the tennis tournament of the games. The tennis tournament took place in the Luzhniky Stadium, and was very tense. But we also found a little time for visiting the other competitions, too. Once, my friend Avi Dobrysh called me to the basketball games. He told me that there was going to be a match between the Israeli and Cuban teams that day at the RACC (Red Army Central Club) sports complex. This was located about twenty miles away, but there were buses that cruised between the different stadiums and had special signs that permitted them to enter all the gates. Avi and I were able to change games where referees were needed, and had no difficulty taking one of these buses to RACC.

"When our bus arrived at the gate, we saw a crowd of Moscow Jews, about seventy to eighty men. They didn't have tickets, and couldn't get in. T.V. cameramen photographed this group of people. Through the open windows we could hear the words of a tall young fellow: 'Who are you taking pictures for? If it's for the KGB, you don't have to bother. They already have pictures of all of us!'

"The basketball tournament took place in a huge hall with seats for some thousands of spectators. But the Israeli team had to play in a small room, with only four rows of seats for spectators. All the referees of the games wore the same uniform: blue coats and light grey pants. Avi and I wore this, too. The basketball hall, besides the gate, was surrounded by two more chains—first the militia (police) and second, at the doors, the ticket collectors. Nobody, excluding delegates, could see the Israelis. But we were wearing referee uniforms and quietly passed through the referee entrance.

"The hall was almost empty. Absolutely free was the first row around the court. We took seats in this row. Immediately, a young man

in a sweatsuit came and asked us to move because those seats were 'taken.' We went to the last row—the fourth. Now we saw that the second, third and fourth rows on the opposite side were occupied by a group of Jews from Moscow who had been able to get tickets. Here I have to point out that spectators to these games were made up of 'worker' representatives and were given tickets by the Communist Party. Only Party members—reliable people—were given these tickets. This was also true for dissident court trials. So these Jewish guys were able to get tickets; the ones outside could not.

"One minute before the game began a lot of young guys, all of them shorn and wearing identical sweatsuits, entered the hall and occupied the whole first row around the court. It was clear that they were young KGB soldiers. The referees called the teams out. The match was tense and good. Both teams were high-level professionals, but Cuba's team was a little better. The Soviet people certainly supported their 'Cuban brothers,' but the group of Moscow Jews quite loudly and emotionally supported the Israelis.

"In the middle of the second halftime, the Jews in the third row suddenly unrolled an Israeli flag. It was painted on wallpaper. Immediately some of the KGB agents in the first row jumped up, ordered them to relinquish the flag and tried to snatch it away. But some of the strong, tall Jewish fellows in the second row got up to try to ward off this attempt. This went on for about five minutes. Meanwhile, the game continued, but it could be seen that the Israelis were watching carefully to see what would happen. Suddenly one of the KGB men made a really giant jump, like a soccer goalkeeper, and tore the Israeli paper flag. At that moment, the Israeli team held the ball, so they stopped the game: the state flag of their country had been profaned.

"Slowly, the Israelis began to move toward the action. The coaches of both teams, the referees, the organizers etc. ran onto the court. Then began discussions, negotiations and attempts to calm the players and the representatives of the Israeli team. It took about fifteen minutes before the game could continue.

"Cuba's team won this match, and placed third in the tournament. The match ended and the 'shorn boys'—all in the same suits—silently surrounded the small group of Moscow Jews and began to press them toward the exit and then outside the hall in a close circle, carrying them out of the gate without violence or arrests. Probably the instructions were such. The violence, arrests, prison and psychiatric clinics for those whose views disagreed came some years later.

"Twenty-four years have passed, but this picture stays in my eyes

even today. So it was that 'the most democratic country in the world' (so the Soviets called it) sought the friendship of all nations, but demonstrated their own true feelings toward the Student Games teams, and also toward their own citizens."

These are the kinds of traditions we in American were fortunate enough to have missed. We take so much for granted!

Pnina Levermore, Executive Director of the Bay Area Council for Jewish Rescue and Renewal, in a recent interview commented on the desire of Russian Jews to recapture what was lost for so long.

"Jews in the former Soviet Union make up the third-largest Jewish population on earth. And while hundreds of thousands have fled, nearly two million Jews remain. They are subject to terrible attacks of anti-Semitism, which have grown more brazen and open, and go unchallenged by the authorities. Many Jews who remain in the former Soviet Union live with the fear or hunger, poverty, illness and uncertainty about the future.

"But with all the obstacles, after seventy years of being denied their Jewish identity and living in a spiritual vacuum, Jews all over the former Soviet Union are trying to reclaim their Jewish heritage."

Despite all the obstacles Jews have encountered throughout the ages, their stubborn refusal to give up their heritage illustrates the very reason for their survival as a people.

You Can't Go Home Again

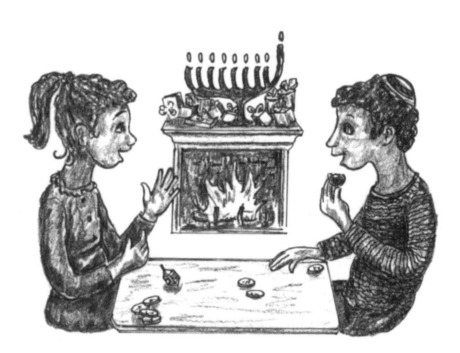

Vos iz geveyn, iz geveyn—iz nisht tu.
(What was, was—it isn't anymore.)

 —*Yiddish saying*

•

"Days are like scrolls: write on them only what
you want remembered."

 —*Bachya Ibn Pakuda (eleventh century)*

W E COME AGAIN TO THE ORIGINAL QUESTIONS. So who are we really? How did we get to be the people we are? As I mentioned in my introduction, more and more I see our generation as a bridge connecting the past to the future, a conduit without which our children may lose the precious tie to their birthright. Will they know about their heritage? Will they care?

Many people from all walks of life and from various countries and parts of the United States have shared their remembrances of family traditions. No matter what the background or geographical boundaries, many of these recollections are bound to strike a familiar chord and remind us of how small this world of ours really is.

We are living in an age of miracles. We can only imagine what marvels the coming century will bring. But we are still the products of our environment and of our genes. Each of us has been influenced by people and events too numerous and varied to name. They have shaped our lives and given them meaning.

Kirkegaard said: "Life must be understood backward, but it must be lived forward."

Sometimes, as we grow older, we think that some things were better before—and maybe some things were. But we live in the now, and this is where we need to use the lessons of the past. Comparisons may be inevitable, but comparisons may even prove useful in putting things into perspective.

I recently heard Murry Frymer, a columnist for the *San Jose Mercury News*, speak about his youth in Canada and the East Coast. He talked about a column he had written, where he reminisced about the differences between the life his parents lived and that of his wife and himself.

His parents never went to restaurants. Never. Restaurants were foreign to them, considered a supreme luxury. Instead, his mom's kitchen was the equivalent of a Catskill resort. There was always something cooking in the oven, a sponge cake cooling on the table. The smells were

rich. The menu was glorious. They ate like kings. He and his wife, how-ever, now eat at restaurants a lot. They do not consider restaurants a lux-ury at all. Their home kitchen is devoted mostly to easy-to-fix health foods. They have no time for cooking.

His parents never traveled very far by car. That would have been ex-pensive. Gasoline was not to be wasted. They traveled mostly by bus, and on outings to the beach or wherever, they carried their food with them. Trips were often adventures, to be recounted later with laughter. Murry and his wife have two cars, and they are a necessity, not a luxury. They drive in air-conditioned comfort, safe and sound in their private surroundings, listening to their stereo. They spend half their lives in their cars, in their private surroundings, listening to the stereo.

What did his parents do for fun? They went to weddings. To confir-mations. There was always a gathering of family and friends. "Every weekend, it seemed, we dressed up to go to somebody's celebration. My parents were members of immigrant associations. Everyone came to-gether frequently, for help or happiness, sharing in the births, deaths, weddings and *Bar Mitzvahs*. It was a community of peope who cared for each other.

"My wife and I are not immigrants. We live in a larger community, an anonymous one. We rarely see our relatives, the second and third generations of whom are scattered across the land. I fear that in another generation, we may not know who we are."

He also recalled that his parents did not buy a lot. Times were tough, money was scarce. Instead, they bartered. "My father, a tailor, would sew something for the shoe store owner who, in turn, provided us with shoes. My father did alterations for the butcher, who came by with fine cuts of beef. We lacked nothing, or at least so it seemed. And we got to know the shoe store owner and the butcher quite well. My wife and I, on the other hand, buy quite a bit. My wife likes to shop and our closets are full. We should be friends with the people at Nordstrom, but we are not."

People were always dropping in unexpectedly at Murry's parents' house. They would bring over some pastry and, in turn, share in their desserts. There was coffee, conversation, laughter and talk. It was the daily entertainment. For Murry and his wife, entertainment is a concert or play or movie as far away as New York, something he said his own parents could not possibly afford. Their entertainment costs quite a bit more than his parents' entertainment ever did.

"What's the point of these comparisons?" he concluded. "My par-ents were poor, though I did not know it at the time. My wife and I are

comfortably middle-class. We are able to afford much that my parents could not. So why, then, when I think of my parents' life, do I remember a time that was rich? And why, with our current gains, do I feel such losses?"

Good questions, Murry. So much of what Murry described applies to my own life experience. And life did seem rich back then. Rich in the strength of family and community and the interaction that took place.

But, of course, our memories are funny things. They are selective. Obviously everything wasn't sunshine and roses, and our recollections are colored by the emotions we feel when we think about these people who were so important in our lives. The only way we can "go home again" is in our minds. But that's good to do occasionally, too. We don't live in the past, but the past lives on in us.

When our children were in college, we went back to Chicago for my cousin Wendy Jo's wedding. We decided that it might be interesting to rent a car and take our children to see some of the places that we remembered from our youth. We drove to our old high school—a little worse for wear, but the old brick building looked pretty much the same. What wasn't the same were the signs on the shops along Lawrence Avenue. No more Hebrew; now they were mostly in Vietnamese. Other kinds of shops had replaced the familiar delicatessens, *kosher* meat markets, and Jewish bookstores.

The kinds of places we remembered had all moved further north, to the suburbs, long before. The old Terminal movie theater marquee was still there. We drove a few blocks further to our very first apartment building as a married couple. It was on Sunnyside, near Montrose Avenue. Were the streets always that narrow? Two cars couldn't navigate the road at the same time. Of course, there were never so many cars parked there when we lived there. We didn't even have our own car yet.

The old neighborhoods were next. A bad idea. You should never try to go back to the house you grew up in. It's too much of a shock. How could it look so different from the one in your head? At least Humboldt Park still looked like a park.

When our children were young, we lived on the south side, near Michael Reese Hospital, where Sid trained. At least once a month, we took them to the Museum of Science and Industry. Now that was a museum. Built for the 1893 Columbian Exposition, Julius Rosenwald later used the site to found the museum (originally called the Rosenwald Museum) in 1933. This was a place that every schoolchild in Chicago visited with his class, at least once every year. That, too, was a tradition. What a great place! Though a bit dingier, this at least was almost as we

remembered. Now we felt we were showing our children something familiar.

Grant Park, on Lake Shore Drive, with its band shell and Buckingham Fountain, which featured a light show every summer evening, was still there. The old State Street was not. They turned it into a mall. Chicago was still a beautiful and interesting city…it just didn't feel like "home" anymore. We made one last stop, for a *kosher* hot dog. What else? And then it was back to California. Things are never quite the way we remember them.

I still think about the way things were from time to time. Certain things bring me back. Every time I hear Jay Andre's theme song on the radio, I remember sitting with Sid in his car late in the evening, looking at Chicago's skyline along Lake Michigan, as we talked about our plans for the future. My mother's soup pot is another one. She made wonderful soups in this twenty-quart wonder. A whole chicken or turkey carcass could fit inside. My family always enjoys the soups my mother taught me to make. I use her old ladle, too, with the worn wooden handle. I also have my grandmother's little butter knives. I use them every day. I'm very sentimental about things like that.

My mother got rid of most of my grandmother's things when she and my father moved to California. I was heartsick when I found out. She thought they were "junk." But I still have one dining room chair of hers. I always remember our Passover *seders* and all of us crowded around the table whenever I look at this chair. I also have a carton, out in the garage, filled with faded and cracked old photographs. I've gone through and put quite a few of them in albums. Some of the people I don't recognize, and now there's no one around to ask.

My father was a home movie buff. Whenever there was an occasion, he would take movies. They were silent, of course, but thank God he did it. My mother had a box in her closet filled with narrow reels of film. When I went through her things after she died, I found it. At first, I didn't pay much attention to them. It was so much trouble to drag out the old projector and screen and figure out again how everything worked. Of course, when our children were small, we took movies, too…lots of them. They were a way to capture the moment. But it had been a long time since we had gone to the trouble of setting everything up and watching them.

One evening, when our good friends were over, we decided to watch some old movies of all of us at Lake Tahoe when our children were younger—snow movies. In the movie box, Sid found a dented reel marked, "Sid's *Bar Mitzvah*." We couldn't resist. The lights went out and

there he was...complete with *yarmulke* and *tallis*. But suddenly, a big hole started to appear in the middle of the screen. The old film was burning. Absolute panic. That did it. We made up our minds to go through every roll and have them all transferred to videotape so they would be preserved. We spent several hours going through and separating all the reels into categories—vacations, children, *Bar* and *Bat Mitz-vahs*, snow, and Cookie and Sid. (Cookie is my nickname—held over from childhood. I outgrew it, but can't seem to get rid of it.)

We popped in the one of Sid's and my childhood. They were all there. My mother and father, grandmother and grandfather, aunts, uncles, cousins. Every one of them. It was my birthday, and the *gantsa mishpochah* was crowded into my parents' small living room, singing "Happy Birthday" as I blew out the candles on my cake. Was there ever a birthday or family celebration when they weren't all there?

No, I don't think so. The *gantsa mishpochah* means the entire extended family. Not only my immediate relatives, but my grandmother's two older sisters, their husbands, their children and their children's children. How so many bodies fit into that little room, I have no idea. They were standing, but they were also talking and laughing and smiling at the camera. I couldn't take my eyes off the screen. My heart was pounding. There were tears on my cheeks. My mother was so young and pretty. My father was holding me and dancing. My cousins were playing games. I was transported.

When we came to Sid's old movies, the same thing happened. There he was, in his little sailor suit, blowing out all three candles on his cake. All of his relatives, aunts, uncles and cousins as well as parents and grandparents were there to help him celebrate his birthday. That was what we did. These movies were precious!

Every once in a while, I get the urge to watch again. They always make me cry. But they make me smile, too. Seeing myself as a little girl with golden ringlets on my head, sitting on my grandfather's lap, walking with my mother or in my father's arms never ceases to keep me enthralled. I could look at all these people now with adult eyes. Now I could really see who they were. The apartment building next to the el, the kids playing in Humboldt Park, Grandma and Grandpa in front of the tailor shop, and mother or father, walking or dancing with me in their arms—this was kind of a way of "going home again." Only now I am old enough to appreciate it.

They are mostly all gone now, these people who shaped my world. Now their memories flicker like fireflies through my dreams, at times glowing brightly and at times fading into a distant mist.

Every once in a while, something happens to make me realize how profoundly these people and events have affected me, and how richly they have touched and helped define my life. I say something, or do something, and it suddenly occurs to me that I remind me of someone else.

My daughter was talking to her son one day, and had the same insight. She called me on the telephone and exclaimed, "Mom, I'm turning into you!" How could she help it? It's in the genes. We're Jewish mothers. We can't help ourselves.

That doesn't mean fathers are exempt. Both my husband and I had to laugh a few years ago when Paul Reiser, on his old television sitcom "My Two Dads," was reprimanding his daughter and suddenly caught sight of his hand with its index finger extended waving in the air. "When did I grow my father's finger?" he cried. Oh boy, both of us could relate to that.

And then the holidays come, and all the familiar things, like going to services or breaking the fast or getting the house ready for Passover and eating the traditional foods, make us remember that we are still connected to a long line of others who have done the very same things for hundreds of years. There is a continuity between the generations. We may live more extravagantly than our parents or grandparents did, but we still carry their values and their genes.

Whether our memories are about religion or food or superstition or humor, we are a part of all that went before us, and it is a part of us. The times may change. Our lifestyles may change. But it is possible to carve our own way without compromising what we believe in. Values don't ever go out of fashion. The lessons we learned, and have tried to pass on to our children—morality, decency, truthfulness, love for others, self-respect—do not change. They, too, are part of our heritage.

And it is a heritage whose depth is like that of an ocean, teeming with an endless variety of life. Using our spoon of remembrance, it would take forever to draw out every drop. We may not be able to empty the ocean with a spoon, but with a little patience, we can continually discover and appreciate the treasures contained in this repository of our living legacy.

And when it's time for us to light the Hanukah candles, and we watch the children play with their *dreidels* and open their gifts and we sit down to eat our *latkes*, we will once again be reminded—it's tradition! It's who we are....

Life is good if you are young,

The sky is blue, the sun is bright;

A bird is singing its happy song,

And all is love and joy and light.

Life is good when you are old,

If there are young around your hearth;

And if your heart in winter cold
Is warmed by their loving hearts

—Jenny Khorol-Sharol

Glossary

In order to get a better feeling for the *tam*—or flavor—of the Yiddish language and expressions in this book, I have tried to give the phonetic spellings and definitions as they are generally used. Unfortunately, there is no real standard when it comes to the transliteration of this colorful language. The YIVO Institute of New York, the leading establishment in the world for the study of Yiddish culture, suggests certain phonetic renderings, and I have tried to follow these guidelines here, though certain words simply stick in my memory as they were pronounced by my grandparents, who were originally from the Ukraine, and may vary from what some feel is "correct." Since memory often plays funny tricks, certain words and their phonetic spellings may differ from those which some readers may recall.

As in any language, colloquial speech may make its own rules. Where concessions have been made, these are generally to make reading and comprehension as simple as possible. I have also attempted to offer "standard" definitions, realizing that Yiddish speakers from different parts of western or eastern Europe might disagree on the exact meaning of a word or phrase. I apologize for whatever errors and inconsistencies may be present.

Pronunciation Guide

a as in "ma"

ay as in "aye" or "bye"

e as in "bet"

ei as in "bite"

ey is in "hey"

i as in "bit"

o as in "or"

oy as in "toy"

u as in "full"

uh as in "but"

ch as in German "ach" or Scottish "loch"

zh as in "seizure"

g always hard as in "get" or "leg"

Other consonants are generally the same as in English. Occasionally the spelling may depart slightly from the norm. The letter "h," for example, is sometimes added after a final vowel, such as "*matzah*" or "*takeh*."

The Hebrew words which are found in this glossary are transliterated in the most popularly accepted manner. In Hebrew spellings, the

Ashkenazic pronunciation is given unless the Sephardic rendering is common.

Abi gezundt! As long as you're healthy!

afikomen The broken piece of *matzah* that is hidden at the beginning of the Passover *seder* for the children to find.

aleph-bet The first two letters of the Hebrew-Yiddish alphabet. Often used to refer to the beginning of Hebrew language instruction. (Hebrew: **aleph-beys**)

Alevei! God willing!

aufruf Ceremony held in synagogue during the Sabbath service a week before the wedding where the bridegroom is honored.

badecken Ceremonial lifting of the bridal veil before actual wedding ceremony.

balaboosteh The woman of the house, usually a household expert.

bahnkess Cupping.

Bar Mitzvah The ceremony where a Jewish boy of thirteen reads from the Torah and becomes a recognized member of the Jewish community.

Bat Mitzvah In conservative and reform congregations, the female equivalent of the *Bar Mitzvah*.

bench licht To kindle the Sabbath candles.

beshert Predestined.

bimah The pulpit, or reader's stand in the synagogue.

bocher Boy or boyfriend.

bris Circumcision ceremony, performed on the eighth day after birth of a boy. (Hebrew: **brit**)

bubbe meises Old wives' tales.

Cha-Cham Dovid Hebrew for wise man or sage.

challah Braided egg bread, traditionally served for Sabbath dinner or on holidays.

chassen Groom.

chalutzim Israeli pioneers.

chazzen A cantor who sings the liturgy in a Jewish religious service.

cheder Hebrew school.

chochma Yiddish word for wisdom.

cholent A meat and bean dish that takes many hours to prepare and was used as a staple in the old country when it could be left to warm on the stove throughout Friday night and used on Sabbath day.

chometz Leavened bread and food which cannot be used during Passover.

chuppa Marriage canopy under which the bride and groom stand during the wedding ceremony.

chutzpah Impudence, or unmitigated gall.

Diaspora The collective term for Jews dispersed all over the world in different lands, other then Israel.

dreidel Small spinning top, used in Hanukah games.

etrog A citron; one of the four spices used during Sukkot.

farblonjet Lost, confused.

fleyshiks Meat, and all cutlery, dishes and cooking utensils used for its preparation according to Jewish dietary laws.

fressen Eating with gusto.

Galitzianer Persons from Galicia, an area in southeastern Poland and northwestern Ukraine.

gefilte fish Stuffed fish.

gelt Money.

gesundheit! Good health! Usually said when a person sneezes.

gevalt Help (usually preceeded by "Oy!" as in Oy gevalt!).

Gey avek! Go away!

glaseleh tey A glass of tea.

goldene medina What people in the Old Country called America—the golden land.

gonif thief.

grogger Noisemaker, used during Purim.

gribbinis Small crisp pieces left from rendered poultry fat, eaten as a delicacy.

Haggadah The book containing the story of the exodus, read during the Passover seder.

hamantashen Small triangular, fruit or poppy seed filled pastries, eaten during the holiday of Purim.

Hamotzi Blessing said over the *challah* on *Shabbat* or before other meals.

haroset A mixture of apples, nuts, wine and cinnamon eaten at the *seder* in remembrance of the mortar used by the Israelite slaves to build Egyptian cities.

Havdallah The service marking the end of the Sabbath and separating it from the rest of the week.

Kaddish The mourner's prayer.

kalleh Bride.

kashas Questions. On Passover, the youngest child asks the four kashas.

kashruth Jewish dietary code.

kayn aynhoreh Keep away the evil eye.

keria The ritual cutting or tearing of the clothes or black ribbon worn by relatives of the deceased preceeding the funeral service.

ketuba Marriage contract, usually a very ornate scroll written in Aramaic.

Kiddush The blessing said over the wine.

Kishke Stuffed derma. (When we "feel" something in our *kishkes*, we mean that we feel it in our "guts.")

kochalayn Cottage or small room, sometimes with a kitchen, in the Catskill mountains.

Kol Nidre Prayer said on the holiest night of the year, the eve of Yom Kippur.

kosher Food prepared according to Jewish dietary laws.

kugel Noodle pudding.

kvell When your heart is bursting with pride, usually for your children.

landsman Someone who comes from one's home town in the old country.

latke Potato pancake, traditionally served during Hanukah.

L'chaim A toast: To life!

lulav Date palm; one of the four spices used during Sukkot.

machaya As in "a *machaya*" a pleasure a treat, like Grandma's *strudel*.

machetayneste Son-in-law's or daughter-in-law's mother.

machuten Son-in-law's or daughter-in-law's father.

mamele Affectionate derivative for "mother"; also term of endearment for a child.

mama-loshen Yiddish, literally "mother tongue."

mandel breit Almond slices.

maror Bitter herbs.

matzah Unleavened bread.

matzah brei Matzah fried with egg.

mazel Luck.

mazel tov! Good luck! Congratulations!

Meggillah Tells the story of Esther, read at Purim.

melamed Hebrew teacher.

menorah A candelabra with nine branches, used to light Hanukah candles.

mentsh A good, decent human being.

mezzuzah Small rectangular piece of parchment inscribed with the passages Deut.VI.4-9 and XI.13-21, and written in twenty-two lines. The parchment is rolled up and inserted into a wooden, ceramic or metal case and nailed in a slanting position to the right-hand doorpost of every Jewish residence. Also sometimes worn on a chain around the neck as a decorative piece of jewelry, announcing Jewish identity.

midrash Story or legend that has its beginnings in the Torah; often explains some part of the Torah.

mikvah Ritual bath used mainly by married women for cleansing after menstruation.

milchiks Dairy foods. Also dishes, cutlery and cooking utensils used exclusively for dairy foods according to Jewish dietary laws.

minyan The quorum of ten men necessary for holding a religious service; young boys can also be included if they are over thirteen.

Mishna The authoritative source of *halacha* (Jewish law).

mishpochah Extended family. The *gantsa mishpochah:* the entire extended family—everybody!

mishegoss Foolishness, craziness.

mishuggener Crazy person.

mitzvah A good deed.

Mogen David Star of David, a symbol of Judaism.

mohel A person trained and authorized to perform ritual circumcisions.

mulliness A tea made from dried raspberries.

nachas Joy or pride usually derived from one's children.

Ner Talmid The eternal light.

neshoma yeserah An added soul.

nu? Well, so what?

nudnik A bore or a pest.

oy! An expressive Yiddish exclamation denoting pain, astonishment or rapture.

pareve Foods that are neutral and can be eaten with either milk or meat.

patcharim Play around.

phylacteries *also* **tefillin** Little boxes attached to the head and arm by leather thongs, containing biblical exerpts from the morning prayer service.

pogrom Organized massacre of Jews.

pushke Small metal box used for donations to Jewish causes. Most Jewish houses had one or more.

rebbe Rabbi.

rebbitzen Rabbi's wife (There is no word yet for the spouse of a female rabbi).

ribbeizen Grater.

Sabra Native-born Israeli.

sandak Godfather or person who has the honor of holding the baby boy to be circumcised.

saychel Common sense.

schissel Bowl.

seder The religious home service and meal during Passover, recounting the liberation from bondage of the Jews in Egypt. Held during the first and second nights of the eight-day holiday.

Shabbat/Shabbos The Sabbath; from sundown on Friday night to sundown on Saturday. (Hebrew *Shabbat*, Yiddish *Shabbos*).

shadkhan Marriage broker, matchmaker.

shamash Candle used to light all the other candles on the menorah for Hanukah.

shandeh A shame.

shaytal A wig worn by very Orthodox married women, to cover the head for reasons of modesty.

Shema The first word in the Jewish prayer, "Hear, O Israel: the Lord our God the Lord is one!"

shep Derive, garner, as to *shep nachas.*

shitt-arein To throw in. In cooking, a little of this…a little of that.

shiva Period of mourning following funeral.

shmaltz Chicken fat.

shmatte Rag, or cheap old clothes.

shochet Person who does the ritual slaughtering of fowl, cattle or lamb.

shofar Ram's horn blown during the High Holidays.

Shomer Ha Shabbos The observance of the Sabbath.

shtetl Small Jewish village or town in Eastern Europe.

shul A synagogue.

sukkah Little temporary hut built to celebrate Sukkot.

tallis Prayer shawl.

Talmud The body of Jewish civil and ceremonial law interpreted through the Torah.

Tashlikh The ceremony of throwing one's sins into a river or stream on Rosh Hashana.

Tatele Affectionate derivative for "Father."

tefillin see: **phylacteries**

trayf Not *kosher*; ritually unfit or unclean.

Torah The first five books of the Bible. Also called the Tree of Life.

tsouris Trouble.

tzedakah Giving to those in need. More than "charity," literally "justice."

tzimmis Dessert made of sweetened carrots or noodles.

Vey! An exclamation meaning woe or pain. As in *Oy vey!*

yarmulke Yiddish word for skullcap worn by observant Jewish males. (In Hebrew **kipah**.)

yichus Good ancestry; status by virtue of family station, learning or wealth.

Yiddishkite Jewishness; the practices and customs of traditional Jewish folkways and mores.

Yiskor Memorial service.

Yontif Holiday. *Gut Yontif!* Have a good holiday!

Zai gezundt! Be healthy!

Zmiros Song of Songs.

Bibliography

Ausubal, Nathan. *A Treasury of Jewish Folklore.* Crown Pub., Inc., N.Y., 1974.

Bates, Ernest. *The Bible as Literature.* Simon & Shuster, N.Y., 1979.

Benedict, Ruth. *Patterns of Culture.* Houghton Mifflin Co., Boston, 1934.

Berkowitz, William. *Conversation with....* Bloch Pub. Co., N.Y., 1975.

Brasch, R. *How Did It Begin?* David McKay Co., Inc., N.Y., 1965

Brav, Stanley Reed. *Marriage and the Jewish Tradition, Toward a Modern Philosophy of Family Living.* Philosophical Library, N.Y., 1951.

Drazin, Nathan. *Marriage Made in Heaven.* Block Pub. Co., N.Y., 1958.

Drucker, Malka. *The Family Treasury of Jewish Holidays.* Little, Brown & Co., N.Y., 1994.

Feinsilver, Lillian. *The Taste of Yiddish.* South Brunswick, N.J., 1970.

Funk & Wagnalls. *The Jewish Encyclopedia.* N.Y., 1901-1905.

Galvin, Herman and Tamerkin, Stan. *The Yiddish Dictionary and Source Book.* KTAV Publishing House, Inc., Hoboken, N.J., 1986.

Gay, Kathlyn. *Keep the Buttered Side Up.* Walker & Co., Boston, 1995.

Goodman, Philip and Hanna. *The Jewish Marriage Anthology.* Jewish Pub. Soc. of America, 1965.

Gross, David C. *1,201 Questions and Answers About Judaism.* Hippocrene, N.Y., 1992.

Hertz, Joseph Herman. *A Book of Jewish Thoughts.* Bloch Pub. Co., N.Y., 1926.

Kushner, Harold S. *When Bad Things Happen to Good People.* Schocken, N.Y., 1981.

Levenson, Sam. *You Don't Have to Be in Who's Who to Know What's What.* Simon & Shuster, N.Y., 1979.

Nevins, Ann. *Super Stitches.* Holiday House, N.Y., 1983.

Rosten, Leo. *The Joys of Yiddish.* McGraw-Hill Book Co., N.Y., 1968.

Scholem, Gershom. *Major Trends in Jewish Mysticism.* Schocken, N.Y., 1971.

Shapiro, Rami M. *Wisdom of the Jewish Sages.* Bell Tower, N.Y., 1993.

Sogolow, Rosalie. *Memories from a Russian Kitchen: From Shtetl to Golden Land.* Fithian Press, Santa Barbara, CA, 1996.

Telushkin, Rabbi Joseph. *Jewish Humor.* William Morris & Co., Inc., N.Y., 1992.

Waskow, Arthur. *Down to Earth Judaism.* Quill, N.Y., 1995.

Rosalie Sogolow first learned of her Russian-Jewish roots growing up in her grandfather's tailor shop on Chicago's near north side. She was educated at the University of Illinois, National College of Education, and San Jose State University. She is now a teacher of English as a Second Language and Principal of the Senior ESL program of Jewish Family Service of Santa Clara County, California. She is past editor of the award-winning San Jose Hadassah *Lifeline* and is the editor of the book *Memories from a Russian Kitchen—From Shtetl to the Golden Land.* Sogolow also composes and performs music "with a Jewish soul," and together with her group Side by Side has recently recorded a collection of original songs entitled "Arise and Shine." The songs, which celebrate a full spectrum of Jewish traditions and customs, are sung in English, Hebrew and Yiddish.